The Art *of* Innovation

www.penguin.co.uk

The Art *of* Innovation

From Enlightenment
to Dark Matter

IAN BLATCHFORD
TILLY BLYTH

SCIENCE
MUSEUM

BANTAM PRESS

TRANSWORLD PUBLISHERS
61–63 Uxbridge Road, London W5 5SA
www.penguin.co.uk

Transworld is part of the Penguin Random House group of companies
whose addresses can be found at global.penguinrandomhouse.com

First published in Great Britain in 2019 by Bantam Press
an imprint of Transworld Publishers

A CIP catalogue record for this book
is available from the British Library.

ISBN 9781787632493

Book design by Bobby Birchall at Bobby&Co
Typeset in ITC New Baskerville 9.75/13.5pt
Printed and bound by L.E.G.O. SpA Italy

Penguin Random House is committed to a sustainable
future for our business, our readers and our planet. This book
is made from Forest Stewardship Council® certified paper.

1 3 5 7 9 10 8 6 4 2

Contents

Introduction

Throughout history, artists and scientists alike have been driven by curiosity and the desire to explore worlds, inner and outer. They have wanted to make sense of what they see around them and feel within them: to observe, record and transform. Sometimes working closely together, they have taken inspiration from each other's practice. They have imagined and acted on the world from different perspectives, with different goals and through different means – complementary perspectives perhaps, but fraught with tension and sometimes divergent, answering to competing pulls of subjectivity and objectivity.

The Art of Innovation: From Enlightenment to Dark Matter considers the ways in which this relationship has evolved and expressed itself through two and a half centuries, from the mid-eighteenth century to the early twenty-first. It investigates how the ingenuity of science and technology has been incorporated into artistic expression, and how creative practices have, in turn, stimulated science and technological innovation. What is it that artists do when they draw on science? Are they limited to metaphor and analogy, connected only loosely to the science itself, or can they offer ideas and themes for scientists to study? Are scientists receptive to such suggestions, and might they usefully adopt artistic methods to help them understand the world? Collaboration between the two disciplines may sometimes be oblique, but it can also be powerful.

This book is not a grand narrative of the history of science and art. It will not tell you how these disciplines have changed the world. Instead, in a series of stories we will explore the material, visual and textual dimensions of the relationship between the two at particular moments in time and as expressed in particular objects. There is sometimes a tendency to speak in grand terms of 'what science does' and 'what art does', while attempts to find some generalized common ground often end somewhat limply in vague statements about how they 'strive for the same thing in different ways'. But artists and scientists strive for many things, and both do so within the social, philosophical and technological contexts of their times. So perhaps

the big picture emerges from the small details – by looking closely at what artists and scientists have actually had to say to one another, and what has come of the dialogue.

Time and again we will see that just as scientists typically think visually and have always used artistic practice to understand and explain the world around them, so artists have observed, explored and been inspired by the ideas of science and natural philosophy. Art has been an observer, critic and friend to science, and artists have sought to keep step with each scientific advance through new ways of seeing and new tools for making.

At the heart of both visual culture and scientific practice is individual imagination. It is widely recognized that art unleashes this most powerful of human capabilities, but science too springs from the spark of creativity at its centre. 'What is now proved was once, only imagin'd,' exclaimed William Blake at the end of the eighteenth century – a truism perhaps, but one observed repeatedly in science, from Einstein's theory of general relativity to the discovery of the elementary particle called the Higgs boson. Such inspirational and imaginative leaps are not the mythical 'Eureka!' moments of science, and they do not happen in isolation from their surrounding culture.

Take the seventeenth-century physician William Harvey, famous for his work on the circulation of blood. The 'raw' data that Harvey gathered from his endless dissections took shape in his mind within the framework of the literary, religious and artistic ideas of the time. His was a Renaissance world-view in which the circle was regarded as a perfect form, and notions of cycles and order were part of the classical heritage. Harvey's thinking was formed not purely in the laboratory, but also through discussions with his extensive circle of friends and many hours of reading and contemplation at his country estate. As Thomas Wright notes in his charming and insightful book *Circulation*, Harvey was influenced by the phrases and metaphors of his time – a time when physiological ideas permeated culture and language, and the words 'circuit' and 'circuitous' were just coming into common English usage. To put it briefly, it was Harvey's culture as much as his observations that recommended to him the idea that the blood circulated in the body.

But even if the spirit of the age informs and inflects the currents of intellectual inquiry, might there also be something particular about the psyche of the individuals who make these ingenious leaps of thought? We like to imagine today that innovators are rebels. The Romantic poet Lord Byron, epitome of the creative rule-breaker, suggested that such individuals appear at first to be putting forward an 'absurd point of view', precisely because they resist convention and diverge from the consensus. It is, he said, their flashes of imagination that can open up new lines of thought. It's common enough to think of artists as non-conformists – but how does that work for scientists, who have to meet professional standards and convince their peers? Here too innovators seem inclined to break rules and conventions. Think of the mathematician Ada Lovelace, who opposed social norms for women in her time by pursuing mathematics (as her mother encouraged her to do), not to mention by developing a ruinous gambling habit (which her mother would most certainly not have encouraged). Think of the maverick environmental scientist James Lovelock, who refused to follow a traditional scientific career so that he could maintain his independence of thought. Indeed, many of science's most original minds are revered for their ability to think and see differently from others.

But this idea of the innovator as an iconoclastic rebel has to be treated with some caution. New ideas and fresh discoveries also come from the meticulous and painstaking work of artists and scientists who patiently focus their attention on careful, accurate and often repetitive observations of the world around them – from the artist John Constable, who went out to create over a hundred sketches of the sky in 1821–2, in all kinds of weather, to the X-ray crystallographers who waded through data and calculations for hours on end, often working alone, to try to understand the structure of molecules. In art and science alike, detailed and laborious work, often undertaken by teams rather than individuals, is every bit as essential as vaulting imagination and daring iconoclasm.

As our twenty stories show, we need always to see thinkers and their ideas in their own context, not in ours. We might celebrate bold inventiveness of thought today, but some prominent Enlightenment figures believed that natural philosophers were at

risk of being too confident in their own theories, mistaking them for nature itself. Samuel Johnson cautioned about a 'disease of the imagination' that only sober reason and judgement could subdue. And as the historian Christine MacLeod observes, the myth of the inventor suited the heroic narrative of progress developed by the Victorians. Rather than indulging simplistic ideas of a specific 'imaginative type' who, throughout the ages, has advanced art and science in unique ways, we need to think about how innovators emerge from, and fit into, their own society and culture.

As we contemplate the changing relationship of science and visual culture from the 1750s to the present – the period covered in this book – several recurring themes emerge. Ideas and inventions needed to be communicated, and this was often done through performance and spectacle. In the observation of nature, questions often arose about how accurate a representation was, and whether it contained elements of artifice. Science and technology challenged conventional notions of time and its passing. New patterns and forms were identified and their aesthetic value was debated. And profound changes took place in the relationship between human and machine. These themes run like threads through the whole period; but there were also shifts in general mood, tone and outlook between one part of it and another – and so we have situated the stories collected here within three eras, which we call the Age of Romance, the Age of Enthusiasm and the (current) Age of Ambivalence.

THE AGE OF ROMANCE

The Enlightenment of the eighteenth century seemed to promise a modern scientific age, imbued with novelty and excitement – and also with disruption and ambiguity. Science (as it was not yet called) and rational inquiry began to deliver empirical knowledge about the nature of the universe; and even though these discoveries could not supply answers to the practical and moral choices that arose, both 'natural philosophers' and artists believed that they could gain a material and moral understanding of the world through 'truth to nature'. Artists showed an astonishing ability to embrace, question

and make sense of scientific progress. Focusing on light and representations of nature, they aligned themselves closely with science as they sought to maintain art's relevance in a world increasingly defined by scientific innovation, technological advances and a rapidly industrializing society and economy.

From the late eighteenth century to the mid-nineteenth, scientists (as they started to be called by the end of that period) across the Western world sought knowledge that was rational, accurate, empirical and universal. The influential classification system for living organisms created by the Swedish naturalist Carl Linnaeus, which organized life on Earth into a hierarchy, suggested that nature

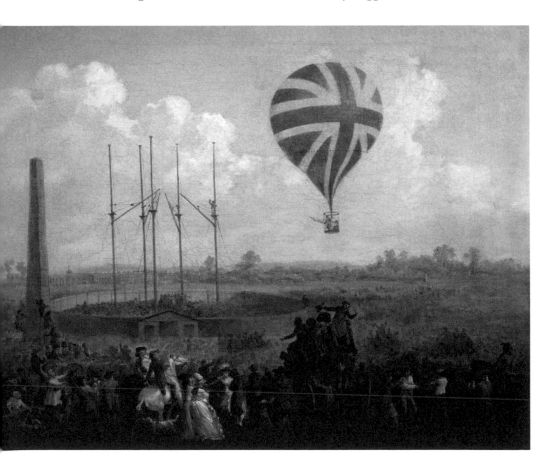

ABOVE: Julius Ibbetson's *Lunardi's second balloon ascending from St George's Fields* shows the public spectacle of ballooning that accompanied a new interest in the gases of the atmosphere.

could be understood, and to a certain extent controlled, through scientific categorization. The Linnaean scheme inspired academic, institutional and amateur scientific communities to set about classifying the world around them: not just plants and animals, but also minerals and other natural phenomena.

By the end of the eighteenth century, scientific discoveries were yielding many transformational technical developments, such as Italian chemist Alessandro Volta's electric 'pile' – an early form of battery – in 1800 and Cornish engineer Richard Trevithick's first high-pressure steam engine in 1803. In London in 1807, Humphry Davy used electricity from one of Volta's 'piles' to isolate the elements potassium and sodium for the first time. New scientific ideas were communicated to an enthusiastic public through publications, lectures and performances. Such events became a prominent feature of intellectual and social life, and a scientist who could put on a good show could become one of the stars of the day.

This was a time of lively public discussion and conversation, typically carried on at philosophical shows and societies. The Royal Institution of Great Britain was established in 1799 to diffuse scientific knowledge to all levels of London society, and its lectures and demonstrations became increasingly spectacular – and socially endorsed: such theatres of science were as much places to be seen and entertained as to be informed and instructed. Addressing a broader audience, literary and philosophical societies and mechanics' institutes were established in cities and industrial towns across Britain, while libraries, coffee-houses and lecture halls also served as venues for debates on new scientific discoveries. Yet while science aroused great enthusiasm, and great wonder, its cultural value was far from secure. Fashionable science, and those who participated in it, came in for just as much ridicule as other forms of fashion – not least from the pen of the famous satirist James Gillray.

At this time, neither 'science' nor 'art' had the more fixed connotations that both terms do today. Both implied an interest in the natural world, as well as in engineering and manufacturing. It was expected that a gentleman (and science was in the main still a gentleman's pursuit) would be knowledgeable in both fields: there

was nothing incongruous about writing both scientific papers and poetry. Between 1780 and 1837 the Royal Society and Royal Academy of Arts shared a wing at Somerset House in London. Ideas flowed between the two – and the conversation was not abstract, but very concrete.

Rationality was not, however, the only principle of the age. Romanticism was perhaps the major artistic and intellectual movement in the Western world during the late eighteenth and early nineteenth centuries. In contrast to the Classicism and Neo-classicism of the preceding period, it did not elevate rationality and order above all else, but embraced feeling. In some ways this was a reaction to the burgeoning scientific rationalism of the time, as well as to the growing industrialization of society and the landscape. In Britain, the Romantic poets glorified nature, celebrated emotion, and developed a taste for the supernatural.

It is not surprising, then, that tensions appeared between the artistic and scientific outlooks in these years. Although he was medically trained, the poet John Keats was wary of scientific categorization and reason. At a dinner party with fellow Romantic writers on 28 December 1817, Keats stated that Isaac Newton, the key figure of the seventeenth-century 'scientific revolution', 'had destroyed all the poetry of the rainbow, by reducing it to the prismatic colours'. In 1820 Keats made this criticism explicit in his poem *Lamia*, which presents science as the destroyer of imagination. Other artists, however, welcomed new modes of scientific thought. John Constable regarded landscape painting as an extension of natural science, and *The Cloud*, written by the Romantic poet Percy Bysshe Shelley and published in the same year as Keats's *Lamia*, appears to be a tribute to Luke Howard, who created the classification system that gave clouds the names we are familiar with today. For Shelley, the mutability of Howard's cloud classes was a metaphor for the cycle of nature: 'I change, but I cannot die,' he wrote elsewhere. The German writer, naturalist and polymath Johann Wolfgang von Goethe also found this new meteorological nomenclature entrancing.

In any event, artists and poets of this period seemed to feel obliged to take a position on the scientific debates and discoveries of

their time: they were actively engaged, even pushing the limits of language in the quest to express metaphysical aspects of new discoveries. So the chemist Humphry Davy, with his poet friends Samuel Taylor Coleridge and Robert Southey, employed a new 'poetical science' to explore the effects of nitrous oxide; and the mathematician Ada Lovelace used the same phrase in writing to her mother of her need for 'poetical science' in describing mathematics through metaphors as well as equations.

Classification and specialization in science demanded attention to detail – and with it, improved standards of representation. The botanist Anna Atkins captured her seaweed specimens beautifully using the new cyanotype photographic process. Many artists and scientists (to the extent that they could be differentiated) sought to distil individual, variable samples into a single idealized version of their subject: an image that represented the objective essence of the category. There was a tension in this quest to fit nature into classes and types – for in pursuing it, the task became, after all, one of being not so much 'true to nature' as true to a rationalized vision of it.

THE AGE OF ENTHUSIASM

In the second half of the nineteenth century scientific disciplines proliferated, and a new relationship emerged between the arts and the sciences. The discovery of electromagnetic waves, X-rays, electrons and radioactivity opened up new horizons in physics. The development of new materials, including plastics, synthetic fibres and advanced steels, expanded opportunities in manufacturing and engineering. The modern chemical industry was born, first to make synthetic dyes and later, as chemicals companies diversified into pharmaceuticals, manufacturing new drugs such as aspirin. Electrification brought new technologies to the home, and yielded novel forms of communication such as the telegraph, telephone and radio. It was a time of tremendous enthusiasm for what science and technology could offer, kicked off by the showcase of the Great Exhibition of 1851 in London.

These developments were accompanied by a shift in the relationship between visual culture and science. From his astronomical observations in the 1850s, the engineer James Nasmyth gleaned new insights into the surface of the moon, which he conveyed through models and imaginative perspectives that highlighted the importance of craft in mediating an understanding of what exists in nature. Using paper, plaster and photographs, he created detailed lunar images that were celebrated for their accuracy and authenticity.

Increasingly, though, scientists sought ways to eliminate the subjectivity of the observer and to replace it with the 'mechanical objectivity' of instruments that could only be operated with professional expertise. The human became distanced from the act of observation and reproduction as technology intervened: the ambition was to let nature speak for itself. Reality was no longer what humans could see, but what instruments and techniques could reveal and record: photography and X-ray imaging showed us more than the human eye alone could discern. Increasingly, scientists emphasized the importance of objectivity, in marked contrast to the celebration of experience and feeling by their Romantic predecessors.

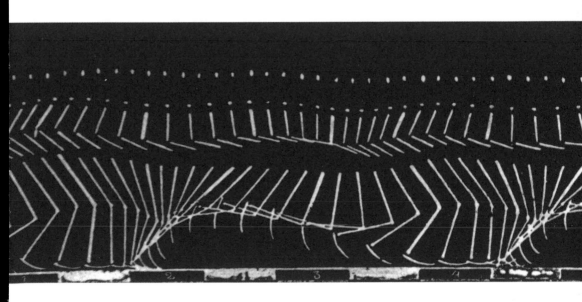

ABOVE: Étienne-Jules Marey studied the 'running man' by recording the movement of a man in a black suit with a white stripe painted on it.

These developments created a dilemma for artists: should they attempt to capture what they saw, or instead to depict what scientific techniques told them was there? The work of the landscape artist Eadweard Muybridge and the physiologist Étienne-Jules Marey played into this paradox, offering insights into movements of animals and people too rapid for the naked eye to register by using cameras to make images that captured ever shorter slices of time. The artistic movement of Modernism, in emphasizing feeling and ideas rather than 'what is real', could be seen as a reaction against this objectivity – but at the same time it focused on increasingly abstract forms and depictions of forces that echoed those discovered by science.

The sequential dissection of human movement developed by Muybridge and Marey also found echoes in the industrialization of the workplace. Beginning in the 1870s, a handful of scientists began to apply their ideas and theories to the world of work; among the most influential was the American mechanical engineer Frederick W. Taylor, who dreamed of increasing the efficiency of the production process. His approach, which he termed 'scientific management', analysed workflows and the motions of labourers, making workers objects of scientific study like mechanisms whose functioning could be optimized. Over time, scientific management was followed by industrial psychology, which sought to reconcile efficiency with the welfare and contentment of workers.

All this enthusiasm for the positive influence of science and technology was shattered by the carnage of industrial warfare on a global scale that exploded in 1914. The horrors of the First World War, with its chemical and biological weapons, its mass-produced armaments and defences – barbed wire, the machine gun and the tank – wrought death and devastation on an unprecedented scale. Such wanton, state-sanctioned destructiveness provoked revulsion and disgust in scientists and artists alike. In perhaps the most striking response to what many saw as scientifically empowered communal madness, Dadaism rejected all notions of rationality, threw off the shackles of science and technology and embraced artistic anarchy.

The unease about science and technology fuelled by the First World War has never gone away. By the 1940s there were concerns in Britain that science was 'out of control', and by the end of the Second World War there was a new and terrifying reason to think so – for the development of nuclear weapons, and Cold War tensions between the Soviet Union and the United States, had raised the prospect that scientific and technological advance could destroy the planet. All the same, that second war stimulated other technological developments that held great promise for society, from the jet engine and nuclear energy that would be 'too cheap to meter' to the rise of electronic computers and the advent of space flight.

During the Age of Ambivalence, not only have artists put the techniques and materials of science to work, they have also taken as their themes and topics the claims and the cultural position of science itself. The relationship between art and science has become complex and many-faceted: on the one hand, art has reflected a confidence in science and its ability to bring understanding and prosperity to the world, while on the other hand there persists a nervousness about the destructive forces that science has unleashed.

The period between the two world wars brought economic depression and the rise of Nazism to continental Europe, prompting a wholesale emigration of artists and scientists to Britain and America. They brought with them new ideas about form and space – and about how art and science could and should be used to help a world in turmoil. Artists were inspired by contemporary scientific concepts, including Einstein's theory of relativity, molecular structures revealed by X-ray crystallography, and the geometry of mathematical models. The Constructivist movement, popularized by Naum Gabo, and a group of artists and scientists that included the crystallographer John Desmond Bernal, shared a political ideology along with an interest in geometry, pattern and form. They found inspiration in one another's work, and believed that both art and science should be socially useful. As Gabo put it:

> Art and science are two different streams which rise from the same creative source and flow into the same ocean of the common culture, but the currents of these two streams flow in different beds. Science teaches, art asserts; science persuades, art acts; science explores and apprehends, informs and proves.

The interconnections of art and science were made explicit in 1951 at the Festival of Britain. In a series of displays about the arts, architecture, science, technology and industrial design across the country, this ambitious event set out to convey a sense of progress and optimism following the war and its austere aftermath. The Festival's director, Gerald Barry, called it 'a tonic to the nation', and it was the perfect platform for seeking a genuine alliance of the two fields. 'Festival Style' was modern and contemporary, its artists drawing on the latest and most advanced chemistry, biochemistry and physics. What they produced was both decorative and democratic, aimed at a mass consumer audience. Here was a world where art and science were united. As Jacob Bronowski, one of the period's great intellectuals, suggested, scientists and artists have always walked together, and science is just one part of 'human activity at large'. In his optimistic view, science and art form part of the same imaginative vision, and difficulties in the relationship between the two arise merely because they lack a 'broad and general language in our culture'.

Others, though, felt the twentieth century had deepened the division between the two disciplines. In a 1959 lecture entitled 'The Two Cultures', scientist and novelist C. P. Snow argued that science should be more integrated into the national cultural debate. Rather than cultural pre-eminence being accorded to literature and the arts, said Snow, the value of science should be equally recognized; and, he asserted, only with knowledge of both could one claim to have a rounded education. Snow, who had worked in the British Civil Service, was troubled that so many politicians and policy-makers lacked technological and scientific literacy. But it was hardly a compelling argument that he presented for the importance of integrating the sciences and the arts, given its narrow focus on literature and neglect of music and visual culture. Historians today

OPPOSITE: Combining scientific subjects with biblical narratives, the scientist and BBC presenter Jacob Bronowski made these Christmas cards with his sculptor wife Rita.

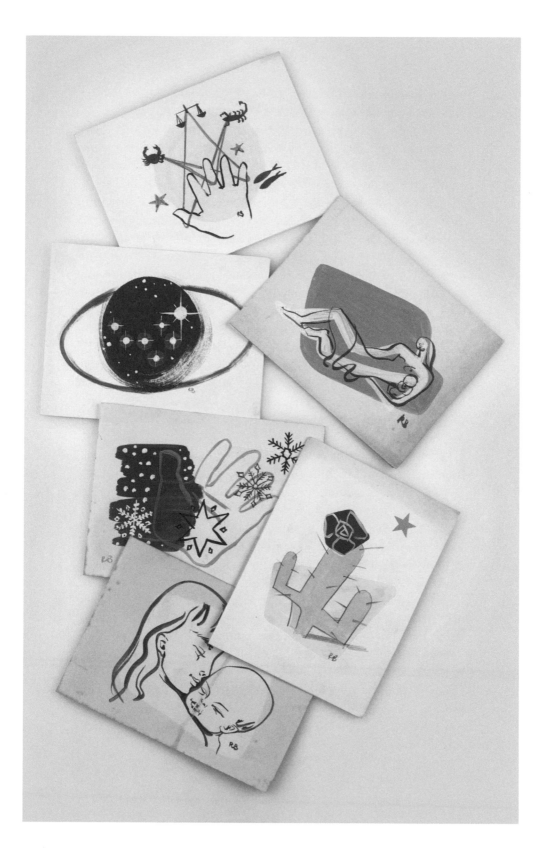

tend to dismiss Snow's position, calling it, for example, a 'simplistic dialectic, highly memorable and easily deployed in argument, [that] has contributed significant damage to dividing culture into unnecessarily fractious camps'. Snow, they say, insisted on divisions where none need exist. In his flawed attempt to unite the two cultures, he might perhaps have merely made the situation worse.

In the second half of the twentieth century, public unease with technology mounted. In particular, the increase in chemical pollutants, the expansion of transport and the growth in energy production motivated concerns about degradation of the environment. The birth of the modern environmental movement is sometimes dated to the publication in 1962 of marine biologist Rachel Carson's best-selling book *Silent Spring*, which raised awareness about the ecological dangers of large-scale pesticide use and, more generally, about humanity's impact on the Earth. The secrecy surrounding nuclear power in particular aroused widespread fear, even paranoia. Environmental science began to emerge as a discipline in its own right, and with better understanding of the interactions between the oceans, the atmosphere, the geosphere and the biosphere came new awareness of the potential fragility of life on Earth.

These ideas and anxieties were reflected in novels, films and the dominant cultural medium of the time: television. Portrayals of nuclear destruction and environmental disaster during the 1980s included *Threads*, a post-apocalyptic drama documentary made by the BBC and structured around scientific predictions of a war-induced 'nuclear winter'; the American TV film *The Day After*, a chilling evocation of nuclear conflict; and the BBC series *Edge of Darkness*, which offered a subtle, allusive and poetic take on these themes, weaving in strands as diverse as James Lovelock's Gaia theory of planetary self-regulation and US President Ronald Reagan's 'Star Wars' missile defence programme.

Some twentieth-century technological innovations seemed more benign, and offered new possibilities for artists and designers. Synthetic fabrics such as terylene, rayon and nylon generated new fashion styles and promised cheapness, convenience and comfort – until changing attitudes to such synthetics, which today are dismissed

as bad for the environment as well as vulgar, again exposed our ambivalence towards what technology offers. The Polaroid camera, too, appeared at first to democratize photography – but at what some felt was a compromise in quality. Artists, however, have sometimes found unexpected ways to put such technologies to use.

Perhaps the most radical shift in the way we conduct our lives since the late twentieth century has been brought about by the rise of the digital computer. Thanks to algorithms and artificial intelligence, the divisions between what is science and what is art, what is human and what is machine, have become blurred. Scientists increasingly rely on computer models and calculations – the capacity of computers to handle amounts of data so vast as to exceed human capacity to grasp them – in seeking to understand what their techniques reveal. The role of the human observer is now not so much to collect and analyse data as to bring 'trained judgement' to bear on them. In fields such as X-ray crystallography, medical imaging, meteorology and particle physics, the human skill is to sift and weigh up raw data, which often requires some form of visual representation – and thus an element of 'informed subjectivity' in the creation of meaning has returned to science. This trend opens up a space for artists to interrogate and criticize the meanings that are extracted. And it makes that critique ever more important.

KNOWN AND UNKNOWN

Our twenty stories span a period from the late eighteenth century to the early twenty-first. In the first and last of these, we suggest both a certain circularity and a profound contrast. Joseph Wright of Derby's painting *A Philosopher giving that lecture on the Orrery, in which a lamp is put in place of the Sun* (1766) shows the legacy of the Enlightenment: science casting knowledge and understanding like a bright light onto the faces of a family gathered around the spectacle. Light and shadow are also central to Cornelia Parker's *Cold Dark Matter: An Exploded View* (1991), in which a central bulb, like the sun in Wright's astronomical orrery, illuminates the fragments of an exploded shed. But Parker is not portraying a moment of scientific revelation;

rather, by invoking the notion of mysterious dark matter and its role in the formation of the universe, she invites the viewer to consider what is not yet known and cannot be measured or directly detected but only imagined.

During the Age of Romance, debate between the arts and natural philosophy was loud and energetic. Artists and natural philosophers alike used imagination and aesthetic responses in reflecting on the world that surrounded them. Skill in close observation of nature was vital in pursuing the plethora of new ideas about the rationality of the universe, new forms of classification, and new methods of displaying and representing the world. Science was no dry, academic endeavour, but an exciting exploration that could be communicated through dramatic talks, vibrant discussion and spectacular theatre.

The Age of Enthusiasm brought new instruments, tools and ways of seeing: devices for measuring the world with increasing accuracy, for seeing the invisible, for freezing time. As the human senses ceased to be the arbiter of reality, what was 'real' became ever less clear.

As for our own Age of Ambivalence, it is a time of contrasts, of jarring juxtapositions and persistent uncertainties. On the one hand, science and technology have brought humankind great wealth and expanded consumer choice – but these benefits have not always been as democratically distributed as was promised. This is a time of Promethean ambition: to travel faster and further, to reach for the stars. But there is a price, which is often borne by our environment here on Earth. We can gather immense quantities of data – but they can be overwhelming, forcing us to rely on computer models, approximations, algorithms and human judgement in their interpretation. It is no longer clear that data are mere pieces of evidence or recorded information about the world – might their applications be controlling us, rather than we them?

It is perilously tempting to offer reductive, simplistic formulas for how science and art are related. And after all, some generalizations do seem warranted. Both depend on curiosity, creativity, and the desire to explore and experiment. Both are conditioned by their history and their context. Both embrace or question a sense of progress. And there are undeniable differences. Scientific progress

is animated by a sense of neutral discovery and understanding, while artistic progress often comes with a desire to effect change in a particular direction. Art and science imagine and act on the world differently; their interaction can create tension and conflict, and they do not always speak the same language.

Yet from this complex relationship may spring something new: a mutual enhancement and a broader view of human experience and insight. The primary function of the arts is not to 'explain', not to 'help' the sciences do their job. Nor is it the role of the sciences to 'clarify' or 'expound' the arts. Art can illuminate the human implications of science and technology, and can supply an essential voice of criticism in the broadest sense. Science, by revealing new dimensions of nature, can provide inspiration for art; and at the same time it generates new tools and methods that, in the hands of artists, may be put to uses that scientists have never dreamed of.

We hope that by exploring some brief yet rich interactions in the history of artistic and scientific endeavour, we have highlighted the importance of both disciplines to culture and society. The twenty stories presented here all reveal the creativity and imagination that are essential for humankind in aspiring to be better, to understand, and to dream.

The Age *of* Romance

1750–1850

With the focus on the natural world, artists and natural philosophers studied the landscape, plants and the heavens. Together their observations produced idealized versions of the world, acting as images of persuasion that brought forward new ideas about rationality, order and progress. This was an era of energetic scientific talk, debate and performance.

1

The Scientific Sublime: From Darkness Comes Knowledge

Lord! What inventions, what wit, what rhetoric,
metaphysical, mechanical and pyrotechnical, will be
on the wing, bandy'd like a shuttlecock from one to
another of your troop of philosophers!

ERASMUS DARWIN, 1778,
WRITING TO MATTHEW BOULTON ABOUT THE LUNAR SOCIETY

What high hopes science induced in the eighteenth-century Age of Enlightenment! The foundations of modern science, with its appeal to reason and reliance on experiment and observation, had been laid during the previous century, and now it seemed there should be no phenomena it could not explain, no questions it could not answer. For the world, it seemed, was governed by order and reason, and all that 'experimental philosophy' needed to do was discover the laws and apply them for humankind's benefit. As the philosopher and zoologist Erasmus Darwin put it to the chemist Joseph Priestley, science, 'by inducing the World to think and reason, will silently marshal mankind against delusion, and, with greater certainty, overturn the empire of superstition'.

Nowhere is this belief in a world of logical order portrayed more gloriously than in the painting by Joseph Wright of Derby elaborately entitled *A Philosopher giving that lecture on the Orrery, in which a lamp is put in place of the Sun*. It shows a natural philosopher and his audience contemplating a device made to represent the serene, regular

movement of the heavenly bodies, which serves as a metaphor equally for predictive power and the sublime wonder of all scientific knowledge. The philosopher stands at the centre, a harbinger of light in the darkness, while women, children and men gather round to gaze at the revelatory instrument, their faces lit up by understanding as if touched by the deity. The marvellous mechanism of the orrery embodies both theory and experiment, showing how they unite to reveal the laws of the universe.

And yet, tellingly, this is a scene not of cool rationality but of high drama, where knowledge is revealed through what amounts to theatrical performance. Here art and science become allies to illuminate the mind in a union of logic and imagination. This was something new – and exciting.

WRIGHT OF DERBY

In the mid-eighteenth century, an artist's best way to a living was to become known as a portraitist of the wealthy. But Joseph Wright, after his two years of training in London with portrait artist Thomas Hudson, returned to his home town of Derby as a young man in 1753 not to produce pictures of the well-to-do but instead to become what the historian Francis Klingender called 'the first professional painter to express the spirit of the Industrial Revolution'. His paintings vividly captured a sense of the new forces at work, and of people's responses to them – wonder, certainly, but fear too.

In Wright's lifetime, technology transformed Britain. Iron production was brought under control as an industrial process, so that the metal was less brittle than that turned out under the older casting technology. The first iron bridge and factory were both constructed during Wright's career. Other factories sprang up too, reflecting the burgeoning cotton industry's demand for new ways of organizing work and drawing workers to new and growing towns and cities. Manchester, nicknamed 'Cottonopolis', became the centre of Britain's textiles manufacturing. In iron foundries and cotton mills alike, the machinery was driven by steam, breaking a centuries-old reliance on wind, water and muscle, supplying power

OVERLEAF: *A Philosopher giving that lecture on the Orrery, in which a lamp is put in place of the Sun:* Joseph Wright of Derby's painting highlights the wonder of a rational view of the universe.

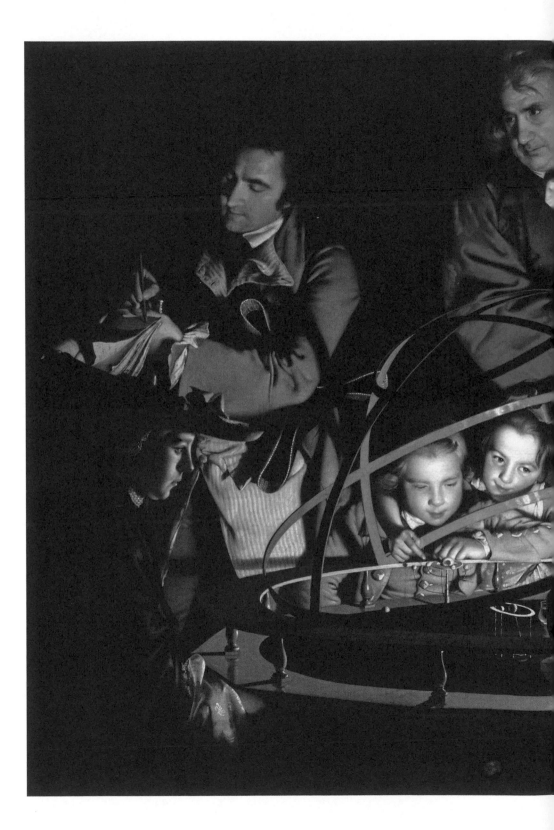

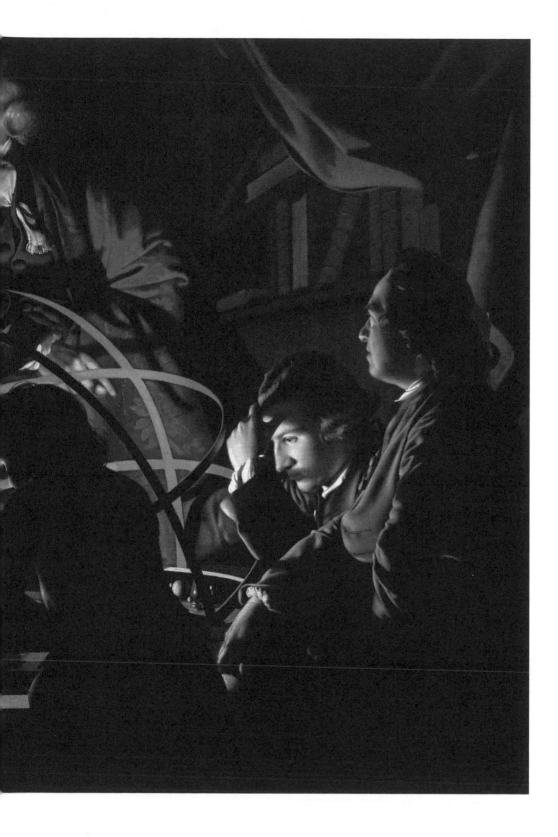

to machines wherever fuel for the engines could be delivered.

But older ways of making goods didn't vanish overnight. Factories rose alongside long-established workshops in which small-scale manufacture and craft-based working continued. The steam engine remained the young upstart rival to the water-wheel well into the nineteenth century. Industrial regions like the Black Country, Manchester and the Swansea Valley sat alongside rural areas untouched by the iron hand of change.

Derby in these years was a ferment of new ideas, visionaries, and portents of the future – an ideal place for a gifted young artist like Wright to develop his career. By 1796 Samuel Taylor Coleridge would write that 'Derby is full of curiosities, the cotton, the silk mills, Wright, the painter . . . and Dr Darwin . . . the most inventive of philosophical men' – that was Erasmus Darwin, physician and philosopher, grandfather of Charles. Close by was the industrial powerhouse of the midlands, Birmingham: centre not only of the metal trades but also of the age's pre-eminent philosophical talking-shop, the Lunar Society, which counted Darwin among its key members, along with steam engineer James Watt, buccaneering industrialist Matthew Boulton, master potter Josiah Wedgwood, and philosopher, chemist and political radical Joseph Priestley. Although Wright never belonged to the Society himself, he shared its progressive outlook and knew some of its members: he was one of Darwin's patients, and his close neighbour and friend John Whitehurst was a member. The combination of the philosophical and the practical that the Society embodied is a recurring theme in Wright's work.

THE LIGHT OF KNOWLEDGE

The historian Paul Duro has described Wright's works as being characterized by binary polarities: light and dark, reason and imagination, theory and experiment. We can see those polarities at play in the *Orrery*, Wright's best-known painting. It is a highly atmospheric scene: a scientific lecture being given to a small audience. A lecturer in red robes stands over the orrery – a mechanical model that used an elaborate system of gear wheels to

demonstrate the movements of the planets. The instrument is named after the fourth Earl of Orrery, an English nobleman who in the early eighteenth century commissioned the clockmaker George Graham to construct such a device. The revolving wheels can show astronomical events that happen on timescales of days to years: the movement of the Earth, the sun and planets; the revolutions of the moon around its axis; even the rotation of the moons of Jupiter and Saturn. Above the planets there sits an 'armillary sphere': a spherical framework of bands representing the movement of the primary heavenly bodies around the Earth.

Wright's use of light is as important to the painting as the orrery itself. It's a night scene, with a pool of light surrounded by deep, dark shadow. This light-in-darkness motif features in other works by Wright: a bar of white-hot iron being worked under a water-driven hammer, a candle illuminating a blacksmith's forge, the moon shining in a workshop window. Here, an oil lamp at the centre of the orrery illuminates the characters dramatically: some are picked out in stark contrasts, others are in contemplative semi-darkness, and one exists almost as a silhouette only.

The *Orrery*'s dramatic presentation supplies a powerful illustration of the wonder attached to science in the eighteenth century – a notion that Duro has called the 'Scientific Sublime'. In Wright's paintings, says Duro, 'man is only an observer to some sublime event'. In one of Wright's other great paintings, *An Experiment on a Bird in the Air Pump*, a pet bird is sacrificed in an experiment on the vacuum that the air pump produces in a glass vessel – and it's a glimpse of our own mortality, just as, in viewing the heavenly bodies in the *Orrery*, Duro says, 'the spectator . . . must contend with infinity'. Although Wright's depiction of the orrery is generally accurate, he has omitted its 'horizon' – the component that defines the position of planets relative to any given point on Earth. Without this vital reference point, the orrery shows a universe that is timeless and ageless – in effect, infinite.

The painting, then, illustrates the fundamental questions raised by science about mortality, infinity, the creation and the cosmos. It reflects the metaphysical changes that scientific understanding had wrought. From the seventeenth century, natural philosophers had

been calling into question the role of God in creating and maintaining the universe: supernatural explanations would no longer do, and in their place were mechanical laws revealed by experiment.

Where did this leave God? The vast majority of natural philosophers were, like other Europeans of that time, committed Christians. But their view was that God had designed the universe to run like clockwork, without need of constant intervention. The role of natural philosophers was not to make God redundant but to show how this 'clockwork creation' operated – to uncover the divine plan. Isaac Newton spoke of 'secondary causes' – mathematical laws and principles – that explain the *effects* of phenomena (like gravity), while preserving God's position as the ultimate cause. When the Scottish astronomer and lecturer James Ferguson wrote his popular *Astronomy Explained* in 1756, bringing these new ideas to the middle classes, he began it with a ringing assertion:

> Of all the sciences cultivated by mankind, astronomy is acknowledged to be, and undoubtedly is, the most sublime ... For, by knowledge derived from this science . . . our very faculties are enlarged . . . our minds exalted . . . and our understandings clearly convinced . . . of the existence, wisdom, power, goodness, immutability, and superintendency of the SUPREME BEING.

Learned associations were formed to bring together those exploring this heady new world – one of the first being the Royal Society, formed in the mid-seventeenth century. These were at first exclusive affairs, but from the eighteenth century the new discourse was opened up to a wider public through lectures and demonstrations. That process is vividly illustrated in the *Orrery*. The spectators listen intently to an explanation of the sun's gravitational effect on the solar system. The lecturer stands at the centre, radiating his new-found knowledge like the sun towards the outer darkness. One listener takes notes while apparently speaking to another seated across from him, his right arm resting on the orrery. Two children gaze in wonder at the heavenly bodies turning, while a woman and

man stare in rapt concentration. The author Joseph Addington wrote of the wonder surrounding the new science in 1721: 'There are none who more gratifie and enlarge the imagination, than the Authors of the new philosophy, whether we consider their Theories of the earth or heavens, the discoveries they have made by glasses, or any other of their contemplations on nature.'

In Wright's day this wonder was becoming shared ever more widely across Britain. Discussions about science could be heard in coffee-houses, theatres, assembly rooms and many other meeting places in Britain's increasingly interlinked society. Josiah Wedgwood captured the public mood in describing the increasingly popular demonstrations of electricity, one of the most dramatic phenomena to be investigated in the latter half of the century: 'Heaven's once dreaded bolt is now called down to amuse your wives & daughters, – to decorate their tea boards & baubles!'

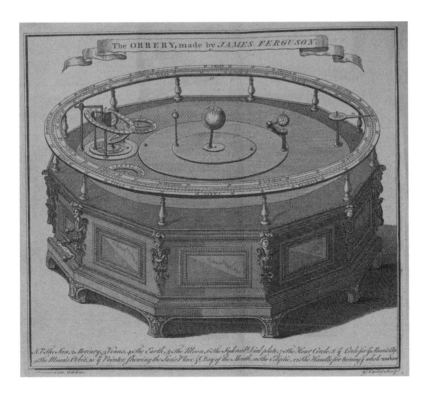

ABOVE: James Ferguson's *Astronomy Explained upon Sir Isaac Newton's Principles* brought new scientific knowledge to a wider audience.

SCIENCE AND SOCIETY, ART AND ARTIFICE

The orrery in Wright's painting is not a technical experimental apparatus but a performance piece, intended to appeal to the imaginations of those who saw it. The portrayal of the device is meticulously detailed, down to the turned pedestals supporting it, its varnished top and the heavenly bodies reflected in it. Wright had a reputation as a 'planner of images'. He prepared meticulously, researching the contents of a picture before putting paint to canvas. He may have seen an orrery when James Ferguson visited Derby in July 1762 on his tour of the country giving popular lectures, supporting the vogue for amateur astronomy and helping ordinary people without formal mathematical training to understand the works of Newton. Or he may have based his image on an engraving of his namesake Thomas Wright's 'Great Orrery' made for the Royal Naval Academy in Portsmouth, first published in the 1730s and reproduced throughout the eighteenth century.

Beyond the orrery itself, there are clues about the picture's message in other parts of it, all depicted with equal care: the clothing and hair of the members of the audience, the delicate lace, pearls and fashionable hat of the lady seated on the left, the waistcoat of the man taking notes, the fine buttons on the child's coat. These closely observed details illustrate an emerging culture of consumption among the middle classes – which was itself fed by the industrial revolution.

In other words, science was by this time intimately embedded within society among networks of trade, commerce, consumption and industry. Scientists were working in places that stood among, and might be indistinguishable from, shops, tourist sites, factories and workshops, gardens, theatres and studios. Wright's painting reflects these practical realities even as it depicts the 'scientific sublime'. The orrery is shown surrounded by people eager to signal their virtue, respectability and politeness, and seeking to advance themselves socially by taking away new-found learning to apply in the world around them. Here are the beginnings of our modern knowledge economy.

ABOVE: Using his wooden orrery, James Ferguson gave lectures and public demonstrations explaining the movement of the planets.

Wright himself was an active participant in this new society. Among his close circle was the surveyor, mapmaker and man of commerce Peter Perez Burdett, who features in three of Wright's paintings (including the *Orrery* – he is the man taking notes on the left). Burdett helped the artist plan other works and acted as an intermediary with customers – including Catherine the Great, Empress of Russia. Wright was also a member of the Society of Artists of Great Britain, a more democratic and less elitist body than the Royal Academy, and the subjects of his paintings included many members of commercial society, among them the pioneering cotton magnate Richard Arkwright. Wright was one of a breed of men who, in the words of David Jennings in a 1752 book on orreries, pursued 'a Track of Life thro' Scenes of worldly Business, yet have Souls large enough to extend themselves, now and then, beyond this little Planet, and to take a distant View of other remote Worlds'. His world wove together art, science, artisan crafts and commerce, and his *Orrery* comments on these connections. It reminds us that the 'scientific sublime' was not only closely interconnected with commerce but also depended heavily upon the immense stock of traditional skill, craft technique and worldly wisdom wielded by the artisans who manufactured not just scientific instruments such as orreries but everyday necessities like buttons and sought-after luxuries such as fine textiles – that is, on what Celina Fox has called 'the pragmatic methods of artisan culture'.

Wright might have seen himself as an artisan – his own name, after all, meant artificer, maker, manufacturer. He had a longstanding interest in acquiring craft skills: his brother Richard noted how Joseph, 'being of an active mind, would frequently spend his vacant time from school in going to different shops to see the men work & when he returned home would imitate their works and compleat them in a masterly manner such as joiners goods, chests of drawers, clocks, spinning wheels, guns &c.' He chose industrial subjects for a series of paintings – including no fewer than five blacksmith's forges and Arkwright's water-powered cotton mill at Cromford in Derbyshire. And his approach to making art was that of an artisan, with an emphasis on careful research, mastery of detail and technical

ability – skills that applied equally in the worlds of science and technology.

It was indeed artisanal skill that was generally acknowledged to be the foundation of Britain's emerging economic strength. Arkwright's patent attorney James Adair noted in 1785 that 'all the most useful discoveries that have been made in every branch of arts and manufactures, have not been made by speculative philosophers in their closets: but by ingenious mechanics, conversant in the practices in use in their time'. Forty years earlier, David Hume – though a 'speculative philosopher' himself – showed a similar respect for the practical man: 'behold this artisan, who converts a rude and shapeless stone into a noble metal; and molding that metal by his cunning hands, creates . . . every utensil for his convenience'. Wright's *A Blacksmith's Shop* (1771) shows a display not of brute force as the metal is forged but of concentration and careful judgement on the smiths' faces. An older man sits to one side ready to proffer advice, while two young boys draw close to the anvil, shielding their eyes from the sparks.

Artisans' workplaces were places not just of admirable activity but also of imaginative effect. One observer of Arkwright's Cromford Mill in 1790 wrote that 'these cotton mills . . . remind me of a first rate man of war; and when they are lighted up, on a dark night, they look most luminously beautiful'. The American traveller Jabez Maud Fisher, visiting Matthew Boulton's Soho Manufactory near Birmingham, exclaimed: 'It is like a stately palace for some Duke. The whole Scene is a Theatre of Business, all conducted like one piece of mechanism . . . The very Air buzzes with a Variety of Noises. All seems like one vast Machine.' Industry, every bit as much as science, was a source of fascination and wonder.

Wright's *Orrery* is one of the finest evocations of that wonder, and at the same time one of the most succinct commentaries on the consumption and artisanship of the age. It illustrates the changes beginning to transform Britain through the agency of science, its pool of light illuminating a microcosm of the new world emerging as intellectual enlightenment accelerated into industrial revolution.

2

Masters of Spectacle: Smelting in Shropshire

*Coalbrookdale is a very romantic spot. Indeed too beautiful
to be much in unison with that variety of horrors art has
spread at the bottom: the noise of the forges, mills etc. with
all their vast machinery, the flames bursting from the furnaces
with the burning of the coal and the smoke of the lime kilns
are altogether sublime, and would unite well with craggy
and bare rocks.*

AGRICULTURAL JOURNALIST
ARTHUR YOUNG, 1776

One of the treasures of the Science Museum is *Coalbrookdale by
Night*, a painting by the artist Philippe-Jacques de Loutherbourg.
It shows the Bedlam furnaces at the iron-smelting factory of
Coalbrookdale on the River Severn in Shropshire. Against a moody,
moonlit sky, smoke and flames billow dramatically from the furnace.
Men and horse-drawn wagons hurry to feed the fires, bring raw
materials and carry finished wares away from the factory. The
picturesque natural surroundings are threatened by the heat and
power, showing us the drama and upheaval of the emerging industrial
world. Combining visual composition, theatrical display, mystical
religion and the increasing tendency to depict both landscape and
industry in spectacular terms, de Loutherbourg's art – and this
painting in particular – shows us the birth of an industrial nation.

The artist himself personifies the turmoil and contradictions of

that moment, when what today seem outmoded and mystical ideas were giving way to reason, mechanism and the practical realities of modernity. De Loutherbourg exemplified those tensions, and also the capacity of artists and entrepreneurs to turn this time of radical change into eye-catching spectacle.

THE IRON BRIDGE

The industrial revolution was the age of iron, and Coalbrookdale was one of the iron capitals of the eighteenth century, encompassing the whole area around the Severn gorge in Shropshire now known as Ironbridge. The region was already an industrial centre in the sixteenth and seventeenth centuries, thanks to its natural reserves of coal, limestone, sand and clays, and the easy transportation that the river offered. The first ironstone extraction here was recorded in the thirteenth century, and by the sixteenth it was commonplace; but it wasn't until the early eighteenth century, when the industrialist Abraham Darby used coke to smelt the iron ore, that the industrial age really took off in Coalbrookdale.

Darby's use of coke (from the region's coal reserves) for iron smelting, rather than the traditional charcoal, boosted iron production and quality, and the Coalbrookdale plants broadened the uses to which the iron was put. Furnaces like those at Bedlam produced iron 'pigs' in sand moulds: standard-sized bars small enough to be handled and transported conveniently. De Loutherbourg's painting shows the moment when the molten iron is run off into the 'pig beds' to cool, giving rise to a particularly ferocious blaze.

The 'pigs' were used to make all kinds of domestic, agricultural and industrial items – in 1801, the year *Coalbrookdale by Night* was exhibited at the Royal Academy, an account of the region listed over 150 products on its books. Most of the pigs from these furnaces were sent to small works in Birmingham to be made into domestic and decorative products, including the artwork in iron that became a common embellishment for architectural fittings; but iron was also used for rails, bridges, boat plating and steam locomotives – all cast from the foundry in Coalbrookdale.

OVERLEAF: In *Coalbrookdale by Night*, de Loutherbourg created an enduringly dramatic image of the industrial revolution.

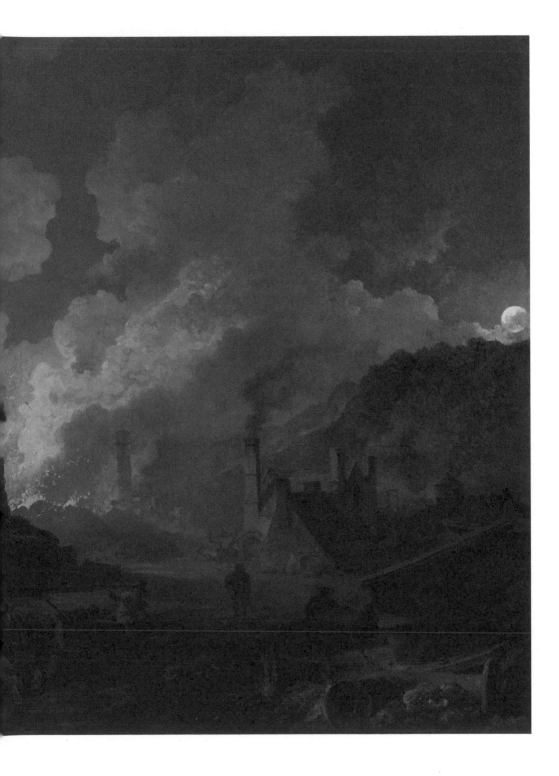

Proximity to the river had its advantages, but the Severn was also an obstacle: it had to be crossed repeatedly by goods and people, and the nearest bridges to Coalbrookdale were over two miles upstream at Buildwas and more than nine miles downstream at Bridgnorth. By the 1750s, with iron production increasing, it was clear that a new bridge was needed – and Abraham Darby III, grandson of the pioneer coke-smelter and by this time himself ironmaster at Coalbrookdale, was commissioned to oversee the building of one. The plan was for a single-span bridge, based on an original idea and designs by Thomas Farnolls Pritchard and developed in detail by the foundry foreman and pattern-maker Thomas Gregory. It was to be built entirely of iron – a sensational technological innovation. The new bridge was authorized by an Act of Parliament in 1776, and the Bedlam furnaces were enlarged to permit casting on the scale needed to produce the bridge's ribs. Building work on the bridge began that same year, and was finished in 1779. The final design uses the architecture of a masonry bridge (with its self-supporting arch), but the ironwork connections copy the mortice-and-tenon joints, dovetails and wedges of timber

ABOVE: The iron bridge at Coalbrookdale was part of the spectacle of science. This beautiful model was made to show to a London audience.

construction. Evidently, Gregory decided to stick to tried and tested methods in using this new material. Even so, no one really knew what was needed, and Gregory made the components more complex than subsequent iron bridge-builders found was necessary.

The first iron bridge in the world quickly became an industrial wonder. Coalbrookdale attracted visitors both during the construction and after its completion, and the Bedlam furnaces were one of the most popular features, being close to the bridge. (The name stems from a sixteenth-century house that stood nearby, but inevitably recalled the turmoil and inhumanity associated with London's infamous madhouse, Bethlehem Hospital, known as Bedlam.) The location combined romantic landscape with the spectacle of industry, and at a time when war was curtailing the aristocracy's customary sightseeing tours of the continent, many illustrious visitors came to Coalbrookdale instead. Strange as it might seem today, a place of heavy industry became a fashionable tourist destination.

For this was not just a working site; it was also a theatre. The area was stage-managed by the ironmasters to create an experience for visitors, with scenic walks, consciously chosen vantage-points, and carefully timed moments for display of the spectacles of casting or furnace tapping. In June 1794, the naturalist Katherine Plymley recorded a visit with friends in her diary, observing that

> the numerous fires have a fine effect . . . it is wonderful to see the vivid green of the plantations so near the smoke of the works . . . at convenient distances are placed seats which command views of a romantic country and discover how near we are to busy life; there is something in this contrast very pleasing.

The central spectacle, both visually and conceptually, was the new iron bridge. In January 1781 the bridge proprietors commissioned artist Michael Angelo Rooker to draw the scene; his engravings went on sale the following May. Usually employed as a scene-painter at the Haymarket Theatre in London, Rooker produced an image resembling a stage set, with the bridge at the centre framing the industrial activity behind, and the riverbanks tumbling in from the wings. Other artists

flocked to record the scene too, and images by J. M. W. Turner, Thomas Rowlandson, Paul Sandby Munn, John Sell Cotman and Joseph Farington helped to turn the bridge and its surroundings into a romantic vision, while writers made much of the juxtaposition of picturesque landscape and feverish industrial processing.

In 1784 Gregory made an impressive mahogany model of the structure, minutely reproducing every detail of its construction. Abraham Darby III exhibited the model in London in 1786, hiring a room (probably at 183 Fleet Street) where visitors could come to admire it. In October the following year he donated it to the Society of Arts, Manufacture and Commerce, where it joined the drawings and models submitted by hopeful inventors as candidates for the prizes awarded by the Society – and a month later won the gold medal. So the bridge was not just a spectacle to be marvelled at in Shropshire, but one that could be consumed and appreciated by fashionable crowds in London too.

MASTER OF SPECTACLE

This was just the kind of wonder on which Philippe-Jacques de Loutherbourg thrived. The son of a Swiss painter of miniatures, de Loutherbourg combined artistic and scientific interests throughout his life. From the age of fifteen he studied in Paris with painters Carle van Loo and François Joseph Casanova, specialists in detailed subject pictures and dramatic battle scenes respectively. He was also deeply influenced by the marine paintings of Claude-Joseph Vernet, who excelled at portraying the changing light and effects of different times of day. De Loutherbourg's success in France was rapid and impressive: he was appointed a Painter to the King in 1766, and in 1767 became the youngest ever member of the Académie Royale de Peinture et Sculpture – three years short of the formal minimum age of thirty. Emigrating to England in 1771, de Loutherbourg quickly became part of the London art scene, both as a regular exhibitor of dramatic oil paintings at the Royal Academy (of which he became a member in 1781) and as a revolutionary force in metropolitan theatre.

From 1771, de Loutherbourg was employed as artistic adviser at

ABOVE: *The Wonders of Derbyshire* was a huge success for de Loutherbourg at Drury Lane. His stage designs combined romantic landscapes and dramatic industrial scenes.

the Drury Lane Theatre, where he designed and painted stage sets and costumes for the age's leading actor and theatre manager, David Garrick, and the playwright Richard Brinsley Sheridan. These sets became famous for their technical brilliance, combining mechanical tricks, moving scenery, lighting and sound to startling effect. He revolutionized theatrical staging, forcing actors to create characters within a set rather than seeing themselves as individuals in front of a backdrop. Theatres became darker and more distant from the stage, drawing audiences more completely into the play as a total artwork. Previously the theatre had been more of a social event where audiences talked through the action and even sat on the stage. In 1776, the *Morning Chronicle* applauded de Loutherbourg as

> the first artist who showed our theatre directors that by a just disposition of light and shade, and critical preservation of perspective, the eye of the spectator might be so effectively deceived in a playhouse as to be induced to take the produce of art for real nature.

De Loutherbourg's main focus at Drury Lane was in producing the 'entertainments' that followed the end of the main play: dramatizations of national events or famous natural wonders, in which his mastery of light and sound, as well as perspective effects, created awe-inspiring realistic portrayals of topography, weather and events. In January 1779 the theatre staged a production called *The Wonders of Derbyshire* to show off the stage effects produced by de Loutherbourg and his technical team. The sets were based on detailed sketches that de Loutherbourg had made on a tour of the region the previous summer. Styled as a 'pantomime', this was essentially a travelogue of the wonders of the Peak District, focusing on both sublime landscapes and burgeoning industry. Its scenes included Chatsworth House, moonlight over Dovedale, a sunset at Matlock and the lead mines. 'Peak's Hole' was shown inside and out as both a picturesque landscape and an important centre for the region's rope-making industry. Famous for its romantic landscapes, its supposedly still wild and untamed inhabitants and its emerging industry, Derbyshire offered artist and audience alike many of the same qualities as Coalbrookdale. Henry Angelo, fencing master to the elite and a prominent figure in London society, commented of de Loutherbourg's dramatic rendering of the region: 'Never were such romantic and picturesque paintings exhibited in that theatre before . . . [which] gave you an idea of the mountains and waterfalls, most beautifully executed, exhibiting a terrific appearance.'

Another scene in the play focused on Poole's Hole, a limestone cave on the edge of Buxton, in which a magician spectacularly transformed a dark cave into an illuminated palace and gardens. As we saw in Chapter 1, darkness and light held many meanings in this period of 'Enlightenment' – and de Loutherbourg's eclectic brain took an interest in many of the more mystical connotations. He studied the ancient Hebrew school of thought called the Kabbalah, as well as biblical prophecies and alchemy. In 1787–9 he briefly left England with the infamous occult 'magician' who styled himself Count Alessandro Cagliostro, and on his return set up a healing

practice based on mesmerism, before eventually returning to painting around 1800. De Loutherbourg's impressive library included works by members of the Rosicrucian, Swedenborgian and Behmenist religious groups, and he joined both of the latter as well as the Freemasons in London. All were influenced by the ideas of the German Lutheran mystic Jakob Boehme, who conceived of light as a manifestation of divine love, and of human life as a never-ending cycle of movement from darkness to light, from God the Father to God the Holy Spirit. Light is a key element of all de Loutherbourg's works, whether in paint or as theatrical effect, in the form of moonlight or industrial flame.

In 1781 de Loutherbourg left Drury Lane to set up a whole new experience from his house near Leicester Square: his hugely successful Eidophusikon. Taking its name from the Greek words for

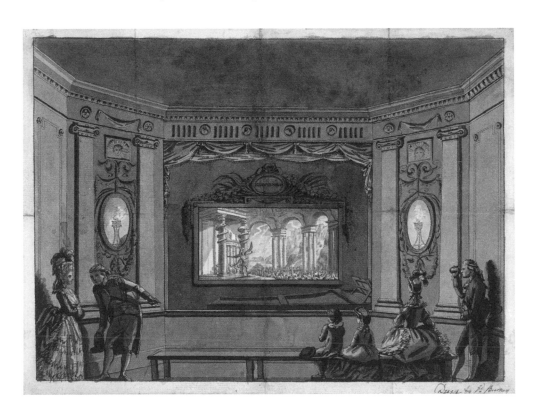

ABOVE: The Eidophusikon cemented de Loutherbourg's fame for producing 'moving pictures'. This is the only known image of a performance.

41

'apparition' and 'image', the Eidophusikon was a form of what we would now describe as immersive theatre. The space seated about 130 people at a price of five shillings a ticket. The only surviving image of the set-up, by the artist and illustrator Edward Francisco Burney, shows a small stage (about 6 feet wide, 4 feet high and 8 feet deep) separated from the audience in a recessed 'picture-frame' surround, with a harpsichord in front. Within this frame, the Eidophusikon presented a series of moving scenes in a way that gave the audience the illusion of witnessing a natural spectacle. De Loutherbourg used similar techniques to those he had perfected in Drury Lane: complex, changing light effects; layers of scenery creating perspective; technological wizardry for moving parts; and realistic sound effects, as well as live music. The scenes included sunrises, sunsets and moonrises, thunderstorms, shipwrecks and towering infernos. The *European Magazine* described the experience as a 'new species of painting' that transcended 'common painting' by adding the element of time. De Loutherbourg's Eidophusikon is often described as the ancestor of modern cinema and virtual reality, and certainly anticipated the popular nineteenth-century entertainments of the panorama and diorama.

De Loutherbourg took his talents for creating atmosphere and spectacle well beyond the stage, on at least one occasion to shocking effect. It is likely to have been through shared mystical interests that he met the young aristocrat and aesthete William Beckford, who employed the artist to design the setting for his twenty-first birthday celebrations at Fonthill in Wiltshire. It was quite a party. For three debauched days in December 1781, the house's already spectacular Orientalist rooms were transformed by de Loutherbourg into an immersive multi-sensory experience that conferred notoriety on all those who attended. The guests almost certainly participated in some kind of black mass, and Beckford used the party as a cover for both his seduction of the thirteen-year-old William Courtenay and his ongoing affair with his cousin's wife Louisa Beckford. The ensuing scandal would force him to spend the next ten years in exile. Decades later, Beckford remembered the sensual experience of the party: 'I still feel warmed and irradiated by the recollections of that strange,

necromantic light which Loutherbourg had thrown over what absolutely appeared a realm of Fairy, or rather, perhaps, a Demon Temple deep beneath the earth set apart for tremendous mysteries.'

Beckford also credited his depraved coming-of-age party with inspiring the composition of his most famous novel, *Vathek*, which he wrote in a whirlwind immediately on his return to London from Fonthill. Set in an imaginary historical version of what is today Iraq, the novel overlays an eighteenth-century Orientalist tale with the emerging genre of demonic horror. The experience also seems to have had a significant effect on de Loutherbourg himself, who on returning to London made a substantial change to the Eidophusikon for its second season, replacing the previous finale of a shipwreck with a scene from John Milton's *Paradise Lost* that showed the raising of Satan's palace of Pandemonium. This is the set shown in Burney's watercolour of the Eidophusikon, and was de Loutherbourg's only representation of a fictitious drama as opposed to a natural spectacle. Some years later the artist William Henry Pyne described the scene's spectacular effects:

> Stretching an immeasurable length between mountains, ignited from their bases to their lofty summits with many coloured flames, a chaotic mass rose in dark majesty . . . bright as molten brass, seemingly composed of unconsuming and unquenchable flame . . . the lights threw their whole influence upon the scene, as it rapidly changed, now to a sulphurous blue, then to a lurid red, and then again to a pale vivid light, and ultimately to a mysterious combination of the glasses, such as a bright furnace exhibits in fusing metals.

Pyne's description could almost apply to de Loutherbourg's painting of *Coalbrookdale by Night*.

After selling the Eidophusikon to his assistant Chapman, de Loutherbourg returned to painting, as well as to his mystical and healing endeavours with Cagliostro. In 1786 and again in 1800 he went on tours of the British countryside, passing through Wales and Shropshire and taking a particular interest in landscape and industrial processes. On one of these tours he produced four drawings of

activities and structures at Coalbrookdale; these were later acquired by Turner, who had visited de Loutherbourg's studio during the Eidophusikon period and deeply admired his mastery of light effects.

FIRING IMAGINATION

It was what de Loutherbourg saw in Shropshire on these tours that inspired *Coalbrookdale by Night* – a masterpiece not only of dramatic effect but of patriotic pride in the artist's adopted homeland, at a time when the war with Napoleonic France added new meaning to Britain's celebration of its industrial prowess. The painting vividly combines the myriad strands of skill and interest that ran through de Loutherbourg's life and career. The structure of the painting owes a clear debt to his stage sets and effects, with wings creating dramatic perspective, intense back-lighting, and the firelight and moonlight set in visual opposition. The crackling behind the clouds of flame and smoke can almost be heard, and the horse and carriage seem only momentarily arrested in their motion. It might be a scene for the Eidophusikon – by now on the road as a touring popular entertainment.

The billowing flames and smoke hint at the furnace as a site of alchemy and prophecy as much as of industry; the fire beneath the molten iron may suggest the purifying fire of the Bible, or the terrifying flames of hell. There is ambiguity, too, in the human figures in the landscape. A woman and child standing by a cottage are timeless, domestic and bucolic, but the busy male labourers at whom they stare are another matter. Ironworkers at Coalbrookdale and other industrial sites were expected to work long, hard hours during these years, producing weapons and other instruments of war. They were paid more than workers in many other areas, and were known for spending their wages on enjoying life. In the popular imagination they were both heroes and demons. There certainly seems a touch of the infernal about *Coalbrookdale by Night*. Visiting Coalbrookdale in 1801–2, the composer and novelist Charles Dibdin feared that the industrial revolution would destroy the British countryside as if by the fires of hell on the day of judgement:

If an atheist who never heard of Coalbrookdale, could be transported there in a dream, and left to awake at the mouth of one of those furnaces, surrounded on all sides by such a number of infernal objects, though he had been all his life the most profligate unbeliever that ever added blasphemy to incredulity, he would infallibly tremble at the last judgement that in imagination would appear to him.

Coalbrookdale by Night was bought by the director of the Science Museum, Frank Sherwood Taylor, in 1952 – to the dismay of the keepers of the museum's scientifically focused departments. Writing in response to Sherwood Taylor's attempt to allocate the work to the metallurgy collection, Fred Lebeter complained that 'in view of the national and international reputation of the Science Museum . . . for accuracy in portraying the past, it would be fatal to exhibit an item whose accuracy is suspect'. The painting, he said, was 'of little value in illustrating the actual progress of metallurgy'. Luckily, he was overruled by Sherwood Taylor, who said that 'this kind of representation is, to my way of thinking, what is required to supplement the more factual part of the metallurgical display and fire the imagination of the spectator'. No doubt Sherwood Taylor, a noted scholar of the history of alchemy, was pleased with his fiery metaphor. At any rate, the painting was the first of a specific 'pictorial collection' at the museum – the forerunner of today's art collections.

In a mishap heavy with irony, de Loutherbourg's original Eidophusikon was destroyed by fire in March 1800. We might be tempted to see in *Coalbrookdale by Night*, exhibited the following year, a resurrection of the artist's most famous theatrical project, emerging anew from the flames of the Bedlam furnace, purified and transformed by the new industrial processes at its heart. Combining theatre with natural spectacle, industrial drama with mystical fire, de Loutherbourg created an image that captured the nation's deeply conflicted response to the burgeoning industrial revolution – and continues to reflect that tension back to its viewers today.

3

Satirizing Science: Gillray and Laughing Gas

*Such a Gas has Davy discovered! . . . it made me laugh
& tingle in every toe & finger tip. Davy has actually invented
a new pleasure for which language has no name . . . it makes
one strong & so happy! . . . oh excellent air bag . . . I am
sure the air in heaven must be this wonder
working gas of delight.*

ROBERT SOUTHEY,
WRITING ECSTATICALLY TO HIS BROTHER TOM, JULY 1799

James Gillray was one of the most talented, prolific and biting visual
satirists of the eighteenth century. His hunting ground was small, a
patch of fashionable London stretching barely from Bond Street to St
James's. But his impact was much wider – as was his appetite for
controversy. From his desk, Gillray launched attacks on all the folly,
danger and hypocrisy that he saw among his contemporaries. In May
1802, he pointed his pen at a recently established scientific association:
the Royal Institution, founded in 1799 to combine dissemination of
useful knowledge with the amusement and instruction of the higher
ranks of society. His drawing *Scientific Researches!* shows the outcome of
a lecture at the Institution on the chemistry of gases, delivered in front
of an audience of notable men and women to explosive and humorous
effect. Yes, it's a fart joke, that trope so beloved of visual satirists – but
it's a great deal else besides. Gillray's print shows us a moment at which
new scientific ideas and experiments became entwined with radical

politics and social scandal. Visual satire offered the perfect medium for condensing these complex connections into a single image.

The full title is *Scientific Researches! – New Discoveries in Pneumaticks! – or, an Experimental Lecture on the Powers of Air*. Behind a bench laden with instruments and equipment, the Royal Institution lecturer demonstrates the latest research on nitrous oxide, now better known as 'laughing gas'. The man depicted is probably Thomas Garnett, who had been appointed as the Institution's first lecturer in October 1799, and his assistant, the young scientist Humphry Davy. They are administering nitrous oxide to one of the Institution's proprietors, Sir John Coxe Hippisley, whose expulsion of gas at the other end is being met with varying degrees of horror and amusement by onlookers, who include identifiable members of the fashionable elite, such as Lord Stanhope, Lord Gower and the poet William Sotheby, as well as female intellectuals like Frederica Augusta Locke. Some look on with rapt attention; others seem bored, or are avidly making notes. Gillray has nailed with pinpoint accuracy the typical Royal Institution audience, described by one early attender as 'men of the first rank and talent . . . blue-stockings and women of fashion'. To the right of the demonstration bench a door opens into the Repository of Models, while the Institution's manager Benjamin Thompson (Count Rumford) looks on from the side.

It's a comical, exuberant scene. But who is it poking fun at, and why?

SCIENCE ON STAGE

Scientific research as public performance has long been associated with the Royal Institution, where it was pioneered by Humphry Davy and his protégé Michael Faraday, and continues to this day with the Christmas Lectures. Davy's education had included an apprenticeship to an apothecary, and in 1798 he joined the Pneumatic Institution in Hotwells, near Bristol, run by the experimental chemist and political radical Thomas Beddoes and devoted to studying the new 'pneumatic medicine': applying gas research to the treatment of consumption (tuberculosis) and paralysis. Over the next three years Beddoes and

OVERLEAF: In *Scientific Researches!* Gillray satirizes a lecture on nitrous oxide at the Royal Institution, belittling everyone present.

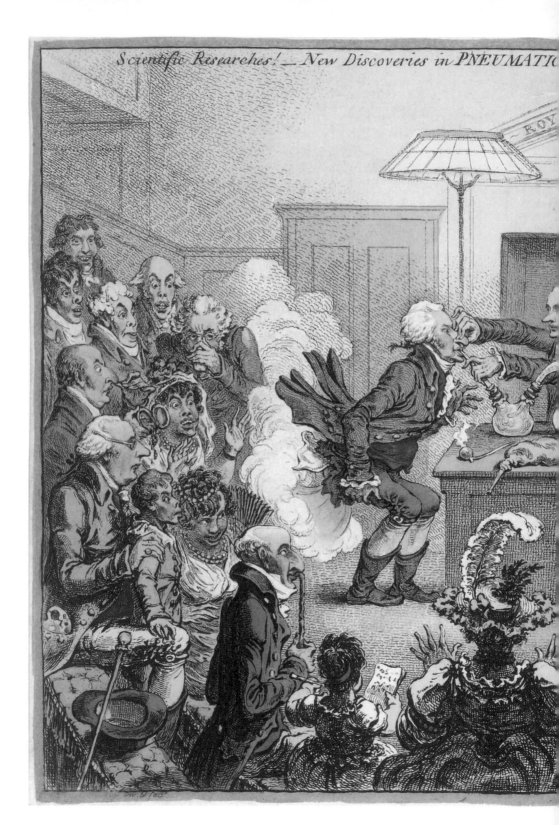

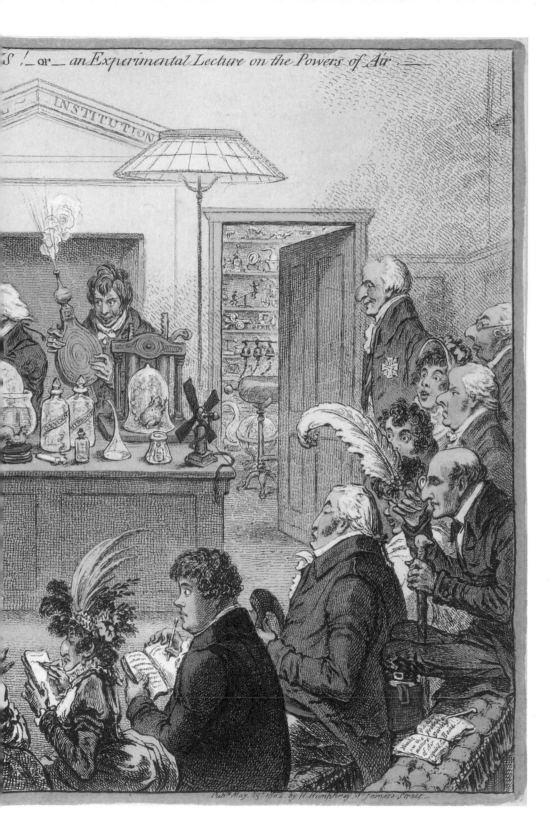

S! _ or _ an *Experimental Lecture on the Powers of Air*

INSTITUTION

Pub.d May. 23.d 1802. by H. Humphrey St James's Street

Davy experimented with a number of gases, of which they found nitrous oxide the most enticing. Making the gas was a fairly complex chemical procedure, which Gillray captures pretty accurately with the paraphernalia on the lecture bench. First you had to heat ammonium nitrate and harvest the escaping gas using a hydraulic bellows, allowing it to seep through water into a reservoir tank. This had then to be carefully decanted into a green oiled-silk air-bag, which the inventor James Watt designed specifically to enable Beddoes to dispense gas to patients.

Experimenting with nitrous oxide was considered dangerous to begin with. Until Davy first inhaled the gas in December 1798, common medical opinion held it to be poisonous. However, Davy found that the effects produced were far from noxious:

> My sensations were . . . pleasant; I had a generally diffused warmth without the slightest moisture of the skin, a sense of exhilaration similar to that produced by a small dose of wine, and a disposition to muscular motion and to merriment . . . I lost all connection with external things; trains of vivid visible images rapidly passed through my mind and were connected with words in such a manner, as to produce perceptions perfectly novel. I existed in a world of newly connected and newly modified ideas. I theorized; I imagined that I made discoveries.

You can see how it earned the popular name 'laughing gas'. Davy went on to experiment on himself repeatedly over the following months, trying different quantities and testing the effects of combining it with other stimulants (such as wine). He took bags of gas for moonlit walks down the Avon gorge, armed with a notebook to record his philosophy and poetry. There's no doubt that – like many scientists after him – he was fascinated by the effects of mind-altering drugs on his own creativity.

Beddoes and Davy expanded their experiments to take in a circle of colleagues and friends, turning the upper rooms of the Pneumatic Institution in Bristol into a 'philosophical theatre' in which doctors and patients, chemists, poets and politicians attempted to record

their experiences of the gas. Davy usually took the first inhalation, and often carried on with his own trials after the party broke up. Fellow inhalers included the Romantic poets Robert Southey and Samuel Taylor Coleridge, and Peter Mark Roget, later author of the eponymous thesaurus. All agreed that the gas created experiences beyond the power of language to convey, and that it had an uncanny power over experiences of pleasure and pain.

Given the difficulty of describing the effects of the gas, some resorted to poetry. Davy himself tried to express the experience in an unpublished poem in one of his notebooks – although he spends nearly as many lines on saying what it was *not* as he does on what it actually felt like:

> Not in the ideal dreams of wild desire
> Have I beheld a rapture wakening form
> My bosom burns with no unhallowed fire
> Yet is my cheek with rosy blushes warm
> Yet are my eyes with sparkling lustre filled
> Yet is my mouth implete with murmuring sound
> Yet are my limbs with inward transports thrill'd
> And clad with new born mightiness round . . .

Another member of the group, James Thompson, described the challenge more constructively: 'We must either invent new terms to express these new and peculiar sensations, or attach new ideas to old ones, before we can communicate intelligibly with each other on the operation of this extraordinary gas.' The wonder gas became for Davy and his companions as much what we would call a recreational drug as a substance for medical experiment.

A POETICAL SCIENCE

Both Beddoes and Davy went on to publish accounts of their researches, which were sometimes little more than personal testimonies of the effects of nitrous oxide. In the spring of 1800, Davy published *Researches, Chemical and Philosophical: Chiefly Concerning*

Nitrous Oxide, or Dephlogisticated Nitrous Air, and its Respiration. In this work, Davy noted nitrous oxide's aesthetic effects and its suppression of pain, but only as incidental benefits alongside the strong euphoric effects the gas created. The book was produced by the radical publisher Joseph Johnson, who also printed works by political thinkers such as Mary Wollstonecraft, William Godwin and Joseph Priestley, as well as Coleridge and William Wordsworth. Davy's book gave descriptions of his own experiences of the gas alongside accounts by twenty-four other subjects, including Southey and Coleridge. It was a radical combination of chemistry and subjective description – a new kind of poetic science, you might say. Throughout his career, indeed, Davy continued to write poetry, which seemed sometimes to function for him as an alternative means of expressing his findings – in stark contrast to the objectivity insisted on in scientific accounts by the Royal Society in the seventeenth century. Davy's *Researches* gained a wide readership among both doctors and supporters of experimental science, many of them outside the elites of the Oxbridge educational system and the Royal Society. The book was popular among scientific and medical bodies in the newer industrial towns, such as the Lunar Society in the midlands (which we met in Chapter 1) – and among enquiring individuals such as Thomas Garnett, an Edinburgh graduate then working in Hull before becoming the lecturer at the Royal Institution.

In mainstream circles, however, Beddoes and Davy met with ridicule and criticism. The inconsistent effects of nitrous oxide and the emotional vocabulary used to describe it led to accusations that the science was weak. Worse still, conservative critics suspected that the gas experiments were merely an excuse for intoxication and sexual licence. In May 1800, the year after Beddoes published his *Notice of some observations made at the Medical Pneumatic Institution*, the conservative *Anti-Jacobin Review* published an announcement of the book alongside a satirical poem, 'The Pneumatic Revellers' by Richard Polwhele. This ridiculed the research carried out at the Pneumatic Institution, saying that it showed 'how far a philosopher may be carried by the force of a flaming imagination'. It charged that the gas might lead to indecorous behaviour:

When I tried it, at first, on a learned Society,
Their giddiness seem'd to betray inebriety,
Like grave Mandarins, their heads nodding together;
But afterwards each was as light as a feather:
And they, every one, cried, 'twas a pleasure extatic;
To drink deeper draughts of the mighty pneumatic.

The *Anti-Jacobin Review* was founded in 1797 by three Tory politicians – the future Prime Minister George Canning, Charles Ellis and Hookham Frere – to combat the wit and ridicule marshalled for political effect by the Whig party. Its name was clearly a response to the dangers they saw emanating from the radical convulsions of the French Revolution. The *Review*'s first issue was illustrated with a frontispiece by Gillray, who from 1797 to 1801 accepted a secret pension from the Tory government that shaped his satirical attacks. He was commissioned to produce a further series of prints for the *Anti-Jacobin* in 1800, although he never did.

This was the heyday of visual satire, and Gillray was widely regarded as its sharpest and most talented exponent, specializing in personal caricature. He had not only great technical ability, thanks in part to his training as a draughtsman, but also acute powers of observation, a gift for biting wit and, in general, little political or social allegiance: everyone was fair game. As a critic in the *London and Westminster Review* observed in 1837, 'he shows us that the ludicrous is not divided by a step from the sublime, but blended with it and twined round it'.

Gillray had joined the Royal Academy schools to study engraving in 1778, and spent much of the 1780s attempting to establish himself as a serious engraver. Then in 1791 he started to work exclusively as a satirist for the print-seller Hannah Humphreys, and for the rest of his life he lived at her shop, first in Old Bond Street and then in St James's. This small area of fashionable London was the habitual resort of the rich and famous, and Gillray's prints were laden with artistic, literary and political references aimed at a learned, sophisticated and wealthy class. The Prince of Wales, the leader of the Whig opposition Charles James Fox and the playwright Richard

Brinsley Sheridan were all regular customers, and Canning considered that to appear in one of Gillray's prints was a sign of political success.

At the same time, these prints were seen well beyond the London elite. Gillray's works were hung in the shop window of Mrs Humphreys' establishment, where people came to observe and gossip about the latest political crisis or social scandal. They also appeared in the windows of other publishers or pinned to boards in the street outside. Prints were available in coffee-houses and taverns, and were regularly sent to shops and collectors outside London. They helped to build a culture of celebrity and satire, and opened the worlds of art, society, politics and science to a wider middle-class audience of commercial and professional people.

This was the world of fashion, politics, science and satire that Davy entered when he moved from Bristol to the Royal Institution in 1801 to take up the position of assistant lecturer. The Institution's aim to diffuse scientific knowledge among London's fashionable society would have been seen as one more thread in the rich fabric of plays, court scandals and political crises that filled both the newspapers and Gillray's satires. Thomas Garnett knew of the research Beddoes and Davy had done, and had included nitrous oxide demonstrations in his own lectures in 1800. The following year Davy himself delivered lectures on 'New Discoveries in Pneumatics'; among his audience on one occasion was Lady Elizabeth Holland, who recorded in her diary for 22 March 1800 an event remarkably similar to that portrayed by Gillray a couple of years later:

> They tried the effect of the gas, so poetically described by Beddoes; it exhilarates the spirits, distends the vessels, and, in short, gives life to the whole machine. The first subject was a corpulent, middle-aged gentleman, who, after inhaling a sufficient dose, was requested to describe to the company his sensations; 'Why, I only feel stupid.' This intelligence was received amidst a burst of applause, most probably not for the novelty of the information. Sir Coxe Hippisley was the next who submitted to the operation, but the effect upon him was

so animating that the ladies tittered, held up their hands, and declared themselves satisfied.

A SUBVERSIVE AIR

A major stumbling-block for Davy, Beddoes and Garnett in their work on nitrous oxide was the way pneumatic chemistry became linked to political subversion. At the time they were pursuing their researches, the revolution in France was going through some of its worst excesses, and both the revolution and the chemistry were often championed by the same people. So work on nitrous oxide became an expression of, and metaphor for, the dangers of all kinds of experiment, whether political or chemical.

The association between the scientific and the political went back some years. Nitrous oxide had first been synthesized in the 1770s by the chemist and political liberal Joseph Priestley, for whom chemistry was part of a broader moral and political vision. Priestley believed that giving people direct understanding of natural phenomena would free them from a state of ignorance that allowed corrupt authority to gain power. He was a vocal supporter of the political freedom promised (in its early days) by the French Revolution. Beddoes, too, mixed politics and chemistry. During the 1790s he published a series of pamphlets arguing that the role of doctors was to understand pleasure and pain, which included the social and political contexts of those experiences. He continued to support the revolution even after Britain had declared war on France. Both Beddoes and Priestley appeared on a Home Office list of 'Disaffected & seditious persons', for which dubious distinction Beddoes was forced to resign from his position as Professor of Chemistry at Oxford in 1793.

Conservative commentators such John Robison and Edmund Burke regarded the emotional, descriptive way in which experiments on nitrous oxide were reported as symptomatic of a science prone to 'enthusiasm' – and this was not a compliment: the term had distinctly negative connotations, associated with its use in the seventeenth century to describe dissenting religion, itself often equated with

political rebellion. So the nitrous oxide experiments became, for Burke and others, chemical symptoms of these scientists' subversive political aims. The critics wove pneumatic metaphors into their attacks, speaking of the 'fumes' and 'spirits' of political enthusiasm. Burke wrote in his *Reflections on the Revolution in France* (1790) that 'the wild *gas*, the fixed air, is plainly broke loose'. This was the gas of political liberty, and it was dangerous stuff. Priestley was often caricatured with fumes emanating from his papers, and Gillray's *Scientific Researches!* shows how easily such imagery could be used for social and political ridicule.

ACHIEVING RESPECTABILITY

Gillray's satire may well have been one of the reasons why Davy dropped nitrous oxide demonstrations from his lectures at the Royal Institution. After 1801 he turned away from this politically and socially sensitive subject to focus instead on electrical studies using the voltaic pile (a type of battery). That work led him to identify a series of new chemical elements, research that would make him a respectable pillar of the scientific community. In 1818 he became the first man to be knighted for scientific achievements, and in 1820 he was elected President of the Royal Society. The use of nitrous oxide, meanwhile, was rejected by the medical establishment, and moved into the realm of popular entertainment, spreading to American travelling shows. It wasn't until 1844 that Horace Wells, a dentist in Hartford, Connecticut, attended one of these spectacles and realized the anaesthetic potential of the gas.

Davy returned to research on gases with more success in 1815–16, when he invented the miner's lamp. Men working underground were constantly at risk from fire, because the flames in their lamps could ignite the inflammable gas that they called 'firedamp' and we now know as methane. After a series of explosions at mines in north-east England, Davy was requested by the rector of Bishopwearmouth to find a solution. Between October and December 1815 he produced a series of prototypes, culminating in the miner's safety lamp, in which a wire gauze chimney was placed around the flame:

this, without blocking the light, absorbed the flame's heat and prevented it from igniting the gas and causing an explosion. The lamp was successfully tested in Hebbern colliery in January 1816 and went quickly into production. By allowing miners to dig deeper, Davy's invention not only saved countless lives but also increased coal production. A similar design was announced at the same time by George Stephenson, a mining engineer at Killingworth Colliery near Newcastle, causing a heated priority dispute. Davy won that battle, but Stephenson would go on to much greater fame as a pioneer of one of the greatest forces of social and industrial change in Britain in the nineteenth century: the railway.

4

Observing the Air: Constable's Clouds

Painting is a science, and should be pursued as an enquiry into the laws of nature. Why, then, may not landscape be considered as a branch of natural philosophy, of which pictures are but the experiments?

John Constable at the Royal Institution, 1836

I n the late eighteenth century, natural philosophers and amateur scientists looked at the world around them to develop new understanding of nature. That might seem the obvious place to look, of course, but the 'experimental philosophy' of the previous century had tended to look to the laboratory and the controlled experiment for the acquisition of reliable knowledge. With Romanticism in the air and nature becoming celebrated as a source of wonder and awe, scientists took it upon themselves to get out more.

And so did artists. They began to leave the studio, thanks to an increasing enthusiasm for *plein air* (outdoor) painting; and they too turned to techniques of observation and record. For naturalists and artists alike, sketching, measuring and note-taking became essential preparatory tasks for efforts to communicate what these observers of nature found, whether in scientific papers or on canvas.

Among the objects of study were the skies and the weather. There was nothing new about taking an interest in clouds and atmospheric phenomena, for either scientists or artists: striking natural effects such as rainbows had featured in both activities for centuries, and Aristotle had written a treatise on meteorology. But from the

Enlightenment onwards increasing effort was being put into schemes of classification, by which means the profusion of nature might yield a rational order and logic.

We now understand clouds as visible masses of water – droplets condensed from vapour and floating in the atmosphere – and we have words to describe their different forms. However, before the nineteenth century clouds were thought of as individual, unique, unclassifiable and ephemeral. They were characterized by rather arbitrary properties such as colour, or interpreted on a somewhat subjective case-by-case basis. This all changed when the chemist and amateur meteorologist Luke Howard presented his *Essay on the Modification of Clouds* to the Askesian Society in the winter of 1802–3. The impact of Howard's work was immense. Not only did it elevate this natural phenomenon as a subject suited for proper scientific investigation; it also supplied inspiration for artists and poets.

Twenty years after Howard published his *Essay*, the artist John Constable was establishing himself as one of the finest landscape painters in Britain. He was fascinated by the sky, and in 1821 and 1822 he obsessively recorded clouds above Hampstead Heath, north of London, in over a hundred sketches and paintings. In Constable's previous work, as in that of his contemporaries, the sky was a mere backdrop to a scene. But here it became the very subject matter. Constable described the act of looking upwards at the clouds as 'skying'.

Detailed observations and illustrations were crucial to both Constable's and Howard's work. Though there is scant evidence for direct links between the two, the coincidence of their interest reflects – pun intended – something in the air: a broader social and cultural interest at the time in these and other meteorological phenomena.

CLOUD THEORY

The practice of taking weather observations had long been restricted to making measurements at ground level. Barometers (to measure air pressure) and thermometers (to measure air temperature) had been around since the early seventeenth century and were staples of

a gentleman's scientific cabinet, along with telescopes and orreries. At the end of the eighteenth century, two developments opened up the possibility of conducting investigations above ground level. First, scientific and industrial advances led to new, more accurate measuring instruments. Second, hot-air balloons began to carry passengers high above the surface of the Earth.

Meteorology was less advanced than other scientific disciplines concerned with the natural world, such as botany and geology. This was partly because it was so hard to make measurements of the atmosphere. Even so, some natural philosophers around the turn of the century were trying to figure out how the atmosphere worked. In 1793, a decade before proposing the atomic theory that made him famous, the British chemist John Dalton published his *Meteorological Essays*, which included a theory of atmospheric circulation. And between 1799 and 1802 the French naturalist Jean-Baptiste Lamarck turned his attention to clouds in his *Annuaires météorologiques*, in which he proposed five cloud types using a scheme analogous to the one developed for classifying plant species by the Swedish botanist Carl Linnaeus. Lamarck's system made little impact, though – for one thing it was written in French, which limited its audience, but it was also simultaneously complex and vague.

Luke Howard, the son of a successful manufacturer, became an apprentice chemist at fifteen and in 1794, aged twenty-one, opened a pharmacy in Fleet Street. Howard – like Dalton – was a Quaker, and some time after 1796, along with many other members of the sect, he joined the Askesian Society, founded that year by the Quaker scientist and philanthropist William Allen to discuss, debate and demonstrate scientific and philosophical concepts. The Society met in Lough Court Laboratory, near Lombard Street, and it was here in 1802 that Howard presented his *Essay on the Modification of the Clouds*.

A cloud, of course, is a transient phenomenon with constantly changing characteristics – but, as Howard recognized, this doesn't make classification impossible. His nomenclature worked because it accepted and accommodated this mutability. Like Linnaeus – and following contemporary scientific practice – Howard gave his categories Latin names. He identified three main cloud types or

'aggregates', which he called cirrus (from the Latin for a curl of hair), cumulus (heaps) and stratus (layers). At this point he departed from Linnaeus in creating another layer of classification in which these types could be combined, leading to another four hybrid types; cirro-cumulus, cirro-stratus, cumulo-stratus and cumulo-cirro-stratus (also called nimbus). Howard made his case in lyrical terms:

> If clouds were the mere result of the condensation of vapour in the masses of the atmosphere which they occupy, if their variations were produced by movements in the atmosphere alone, then indeed might the study of them be deemed a useless pursuit of shadows, an attempt to describe forms which, being the sport of winds, must be ever varying, and therefore not to be defined. However . . . the case is not so with clouds. They are subject to certain distinct modifications, produced by the general causes which affect all the variations of the atmosphere: they are commonly as good visible indications of the operation of these causes as is the countenance of the state of a person's mind or body.

Howard's theory quickly entered the public consciousness, for the essay was serialized, with illustrations of different cloud formations, in the influential *Philosophical Magazine*, edited by another member of the Askesian Society, Alexander Tilloch. And this was just the beginning. It was also published as a separate pamphlet in 1804, and in William Nicholson's *Journal of Natural Philosophy* in 1811; it was translated into French and German; and over the following decades it was reprinted in a variety of forms, contributing hugely to the emergence of meteorology as a valid scientific field.

In developing and promoting his classification system, Howard made sketches in pencil and watercolour of different cloud formations, which he used to identify patterns and refine his categories. Some of these drawings look like finished depictions; others simply outline the fast-moving clouds. These illustrations were as much vehicles of persuasion as they were evidence of observation; as much artistic 'studies from nature' as scientific data.

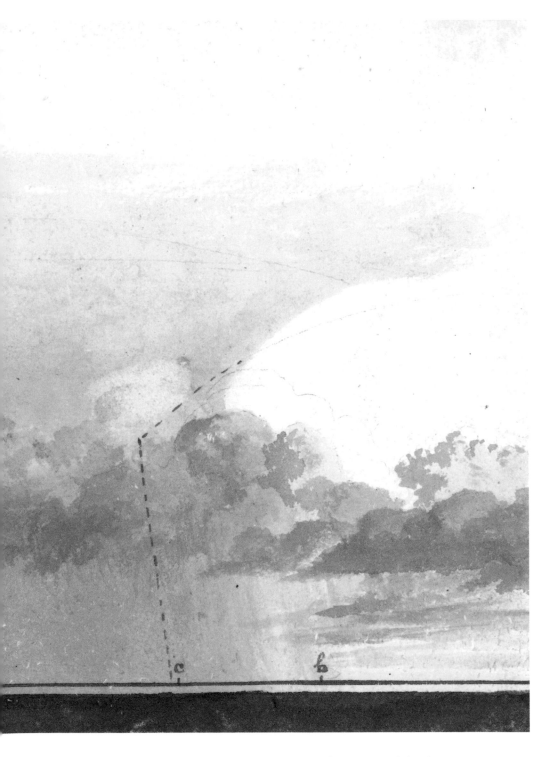

ABOVE: Luke Howard captured the transient phenomena of clouds, like these cumulus and nimbus specimens, in delicate but carefully observed sketches.

They were fundamental to Howard's research and also necessary to help communicate his nomenclature to the public. In preparing these illustrations for the essay's initial publication in the *Philosophical Magazine*, Howard worked with the etcher Silvanus Bevan; for the third edition, he collaborated with the artist Edward Kennion, who added landscapes beneath the clouds.

Howard continued to develop his meteorological studies. In taking daily observations of temperature, rainfall, atmospheric pressure and wind direction, he became a pioneer of urban climate studies. He collected data using specially made instruments, commissioning one of the earliest rain-measuring cylinders from the London firm Knight, and from 1814 using a spectacular 'barograph clock' built by the noted clockmaker Alexander Cumming to record atmospheric pressures. In 1818 and 1820 he published the first two volumes of *The Climate of London deduced from Meteorological Observations at different places in the Neighbourhood of the Metropolis*, following up with an expanded second edition in 1833. In all, he noted changes in weather meticulously for over thirty years, recording his results in tables and innovative graphics.

Howard did more than observe and classify; he challenged orthodox opinion. According to a long-established theory, clouds were composed of tiny bubbles of water enclosing a kind of elemental 'matter of fire' that made them lighter than air. Howard rightly dismissed this fanciful idea. He postulated instead that clouds are formed of globules of water or particles of ice condensed out of vapour rising and cooling. However, he could take his theory only so far: a fuller understanding of cloud formations and weather patterns requires a theory of atmospheric pressures and of gradients in pressure, temperature and buoyancy to explain the motions of air masses – and Howard didn't know about such things. Still, his contribution to the establishment of meteorology was appreciated by the scientific community, and in 1821 he was made a Fellow of the Royal Society.

Howard was inspired by the work of his contemporaries, notably Dalton, for whom he provided chemicals for experiments and with whom he shared meteorological data; in 1837 he dedicated his *Seven*

OPPOSITE: Believing that developments in science depended on accurate data gathering, Howard used equipment like this rain gauge to record changes in the London climate.

Lectures on Meteorology to Dalton. Howard's own publications in turn stimulated the imaginations of poets, including Goethe, Shelley and Coleridge. Alongside his political and literary career, Goethe was profoundly interested in the natural sciences, and published work on botany and colour theory. He became fascinated by Howard's classification and contacted the young meteorologist via a clerk at the Foreign Office in Downing Street. At first, Howard assumed Goethe's letter was a hoax on the part of the clerk; later, he proudly copied a translation of his words of admiration into one of his own notebooks. 'How much the Classification of the clouds by Howard has pleased me,' the German wrote; 'how much the disproving of the shapeless, the systematic succession of forms of the unlimited, could not but be desired by me, follows from my whole practice in science and art.' Not every artist took so positive a view of Howard's work: whereas Goethe did not see an understanding of the cloud system as a constraint on the imagination, one of his protégés, the Romantic painter Caspar David Friedrich, thought the system to be a creative restraint which would 'force the free and airy clouds into a

OPPOSITE AND ABOVE: Howard became one of the first pioneers of urban climate studies, using this ornate barograph clock to take daily recordings of atmospheric pressure.

rigid order and classification'. Goethe himself, however, not only applauded the system but penned several poems in tribute to it, including 'To the Honoured Memory of Howard':

> But with pure mind Howard gives us
> His new doctrine's most glorious prize:
> He grips what cannot be held, cannot be reached,
> He is the first to hold it fast,
> He gives precision to the imprecise, confines it,
> Names intelligently! – yours be the honor! –
> Whenever a streak (of clouds) climes [sic], piles itself together,
> scatters, falls,
> May the world gratefully remember you.

PAINTING THE LAWS OF NATURE

John Constable shared Howard's interest in the close observation and precise recording of natural atmospheric phenomena. Growing up in the Stour Valley in Suffolk – a rural landscape that inspired and featured in some of his best-known paintings, such as *The Hay Wain* – where his family milled corn and traded in coal, he would have been only too well aware of the capriciousness and potential destructive force of the weather.

Constable received early painting lessons in Suffolk from an amateur artist, John Dunthorne, but was mainly self-taught as an artist, sketching the landscape around him while working for the family firm. In 1799 he went to study at the Royal Academy; three years later, he exhibited his first landscapes there. Although now he is regarded as one of the greatest British painters, Constable's work was not immediately accepted by the art establishment; during his lifetime he sold more paintings in France than at home. He was not elected to the Royal Academy until 1829, at the age of forty-three.

Constable settled in Keppel Street, Bloomsbury, with his wife Maria Bicknell, but her ill-health led them to spend many summers outside the grime of the city in a rented house in Hampstead. Here in 1821–2 he took up 'skying' with fervour, compulsively sketching

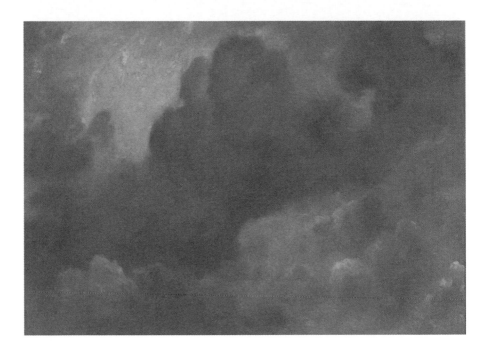

ABOVE: This *Cloud Study* demonstrates Constable's understanding of and close attention to the nature of clouds.

the clouds in all weathers. No artist before him had devoted such attention to clouds, treating them as the core subject and painting them in isolation without foreground. In numerous sketches of different formations, he invested them with a material presence. He painted quickly to capture their forms, working on paper fixed to the lid of his paint-box and spending around an hour on each sketch. Watercolour was his preferred medium, being ideal for capturing the translucency of clouds, although he also completed several larger cloudscapes in oils.

Clouds had been explored as an artistic subject before Constable, but not necessarily on the basis of first-hand observation of nature – Alexander Cozens' *The Cloud* (1770), for example, was drawn in the studio. Unlike many other Romantic artists, Constable remained close to the English landscape tradition – for some, indeed, his paintings were *too* close to nature: the Professor of Drawing at the Royal Academy said of his work, 'Every time I see a Constable, I want to call for my raincoat.' Perhaps Constable himself would have taken that as a compliment. At any rate, he saw himself as 'the man of the

clouds', believing that landscape artists needed a level of scientific understanding and that they should strive to create work that showed nature as it truly was.

Constable's 'skying' activities reflected his desire to understand as well as to depict nature – indeed, he believed that it was impossible to do the latter without the former. He methodically annotated his sketches with meteorological precision, recording atmospheric conditions, time of day, direction of view and wind force. He argued in a lecture at the Royal Institution in 1836 (itself a reflection of his scientific connections) that 'we cannot see the sky truly until we understand how it functions' – a remarkable statement of his belief that science and art must go hand in hand. As the opening quotation to this chapter makes clear, Constable saw art as itself a form of experimental science. Through his sketches he gathered evidence for his own ideas about the weather system; before his sudden death deprived him of the opportunity, he had planned to give a lecture on clouds to the Literary and Scientific Society of Hampstead.

Howard and Constable were both significant figures in a wider movement in the early nineteenth century to understand the sky, the weather and the atmosphere. Constable seems to have been aware of another meteorologist and astronomer, Thomas Forster, who was a committed disciple of Howard and promoted his theories. Forster was the first to offer an English translation of Howard's Latin terms, and adapted Howard's theories to account for different features of the weather; as part of his commitment to the 'namer of clouds', he reprinted Howard's key essay at the beginning of his own *Researches about Atmospheric Phaenomena*, which went into three editions between 1813 and 1823.

Constable's own active engagement with meteorological science is clear from his copious annotations in his copy of the second edition of Forster's *Researches*, in some of which he challenges the author's conclusions. In 1836 he commented to his friend and fellow artist (though no relation) George Constable that 'Forster's is the best book – he is far from right, still he has the merit of breaking much ground'.

From the middle of the nineteenth century Constable's artistic style went out of fashion, eclipsed by the rise of the pre-Raphaelite

movement. However, his approach inspired other artists to work directly from everyday life and to use nature as their main subject, not a mere backdrop. He was an influence on the mid-century French Barbizon School, a realist movement whose members included Jean-François Millet and Charles-François Daubigny, and also on significant later figures such as Walter Sickert and James McNeill Whistler.

SOMETHING IN THE AIR

Clouds first captured the concentrated attention of artists and scientists at a time when imaginative and rational inquiry were becoming allies; and they continued to inspire artists long after Constable stood sketching on Hampstead Heath. Clouds are key features in works of the Modernist movement and beyond, including Man Ray's *A l'heure de l'observatoire: les amoureux* (1934), Georgia O'Keefe's *Sky Above Clouds IV* (1965), Andy Warhol's installation *Silver Clouds* (1966) and Olafur Eliasson's *Small Cloud Series* (2001). Most recently they appear in Spencer Finch's *A Cloud Index* (2018), which depicts different types of clouds on a vast glass canopy above Paddington Elizabeth line station, paying homage to the work of the Romantic landscape painters – and of Luke Howard.

Howard's legacy was nothing less than the basis of a true science of meteorology. In the twentieth century the discipline he did so much to launch embraced key concepts such as atmospheric pressure and began to enable systematic prediction of the weather. As their instruments improved, meteorologists identified new layers in the atmosphere and with them new cloud types; there are now ten main groups of clouds, and those identified by Howard are still described using his terms. The science of clouds has become one of the most significant aspects of atmospheric and meteorological research, relevant to topics ranging from monsoons and tropical cyclones to polar ozone depletion and predictions of global warming, and even to understanding the climatic and environmental conditions on other planets. Far from being mere celestial decoration, they are recognized now as major components of the planetary system.

ABOVE: Spencer Finch's *A Cloud Index* is a vast and inspiring ethereal installation commissioned by Crossrail for Paddington Elizabeth Line station in London.

5

Tracking Progress:
Turner in the
Age of Steam

The nineteenth century . . . will, if it needs a
symbol, have as that symbol a steam engine
running upon a railway.

H. G. WELLS, 1901

The railway carved its tracks through nineteenth-century society, its 'iron roads' shaping ideas about modernity and progress, transforming the British landscape, capturing the artistic imagination. Was this steam-powered, iron-clad newcomer an exciting harbinger of change or a grim blight on the world? As the new Kendal to Windermere line snaked through Wordsworth's beloved Lake District in 1841, the poet wondered in dismay: 'Is there no nook of English ground secure from rash assault?'

No image better evokes the transformative power of the railway than the painting made in 1844 by England's greatest artist of the time, J. M. W. Turner. *Rain, Steam and Speed: The Great Western Railway* draws together all the elements of classic Turner in a paean to the age of locomotion. Some see it as an allegory of the old meeting the new; others as a record of actuality, re-imagined as high drama – maybe a representation of a journey Turner himself made by train. Either way, at the time it was a shocking, revolutionary image. It also illustrates the power of art to help us come to terms with change. It is

simplistic to see the great picture simply as railway propaganda; more thoughtful to relish an artist's natural zest for recording the new, without moral judgement. In a brilliant touch, a hare is depicted running in front of the locomotive as it storms across the bridge. In generations of ancient fable, the hare has been the symbol of speed; here, with this clever allusion, Turner seems to be saying: all change now, a new age of speed has dawned!

We tend to see Turner as being just as romantic in his view of nature as Wordsworth. Certainly, he was celebrated for the intensity of his engagement with the natural realm by the great critic John Ruskin in the first volume of *Modern Painters*. But Turner is not to be so easily typecast. He also embraced technological progress and took a lively interest in scientific and industrial subjects. In the early nineteenth century both the Royal Academy and the Royal Society were located in Somerset House on the Strand, and so Turner, as a member of the former, had plenty of opportunity to rub shoulders with the scientists and engineers of the latter, such as Isambard Kingdom Brunel. Turner had good contacts in scientific circles: he was commissioned by engineer Robert Stevenson to paint his Bell Rock lighthouse, he discussed pigments with Michael Faraday, and he knew Brunel's former employer the mathematician Charles Babbage. And there was nothing unusual about this; scientists and artists of the time did not see themselves as inhabiting separate spheres as so many did towards the end of the century.

Transport technology held a particular fascination for Turner. In fact, as the art historian John Gage says, he 'became obsessed with the problems and the delights of transport, to which he brought an extraordinary relish'. In 1839 he painted one of his most eloquent images of old technology giving way to new, depicting the huge veteran warship of the age of sail, the *Temeraire*, being led away like an old warhorse on its final journey to be dismantled, pulled by a tiny steam tug. And three years later, in *Snowstorm: Steamboat off a Harbour's Mouth*, he gives a foretaste of *Rain, Steam and Speed* in showing steam power pitched against the elements: nature challenged and overcome by the technical prowess of the age.

OVERLEAF: J. M. W. Turner's *Rain, Steam and Speed* was the most evocative representation of the Railway Age yet seen when it was first exhibited in 1844.

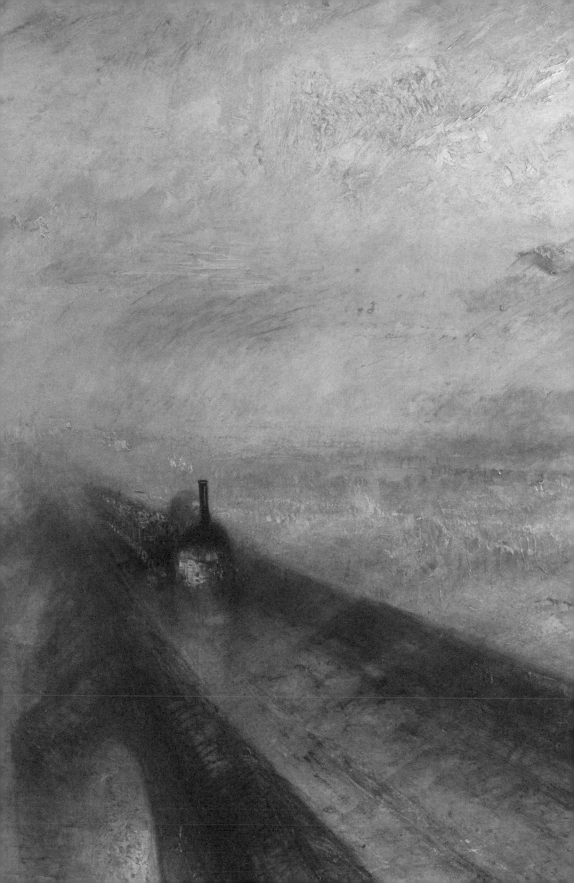

Rain, Steam and Speed first went on show at the Royal Academy at the height of 'railway mania'. After the opening in 1830 of the Liverpool & Manchester Railway – the first intercity line in the world, connecting northern England's two great centres of commerce and manufacturing – the country's railway system exploded into life as engineers, funded by eager investors, wove a circulation system of iron tracks across the land, 'manipulating the landscape on a grand scale'. In 1843 alone more than 200 railway bills were passing through Parliament, and the excitement and trauma of this new age were being felt everywhere.

At first artists seemed hardly to know how to respond to this new phenomenon, beyond the illustrative engravings and lithograph prints of T. T. Bury and John C. Bourne showing the construction, opening and early operations of the Liverpool & Manchester and London & Birmingham railways. And when those responses did come, they expressed as much fear as fascination. Around 1845 the illustrator and caricaturist George Cruikshank showed the locomotive as a monster in *The Railway Dragon*, in which a family flees as the engine bellows: 'I come to dine, I come to sup. I come, I come . . . to eat you up!' Dickens, too, writes of a 'monster train' in *Dombey & Son*, transforming all in its path as it sweeps away the old.

Rain, Steam and Speed is permeated by these tensions between old and new – and gives pride of place to the new. The future, it declares, has arrived; and the artist – like everyone else – will have to deal with it one way or another. The railway cuts an unnatural, ramrod-straight path through the landscape, and there's no stopping the hurtling train as it flies over the bridge. Dimly in the background we can just about make out an old road toll bridge, a rowing boat, a plough, all fading away into the swirling rain and mist.

SYMBOL OF DESTINY

Turner's masterpiece is no generalized depiction of the railway, but shows two specific and celebrated marvels of railway technology in a

OPPOSITE: *Cheffins's Map of the English & Scotch Railways*, made in 1845, illustrates how rapidly the railways had expanded across the country.

MAP OF THE PRINCIPAL RAILWAYS IN SCOTLAND.

CHEFFINS'S MAP
OF THE
ENGLISH & SCOTCH
Railways.

FOURTH EDITION

LONDON, PUBLISHED BY
Charles F. Cheffins, Southampton Buildings, Holborn,
Simpkin, Marshall & C.º Stationers' Court,
and
Warring Webb, Castle Street, Liverpool.

Note.

Railways already opened.
Railways that are in progress of construction,
(for which Acts have been obtained)
Railways required.

SCALE OF MILES

single image: the Firefly locomotive of the Great Western Railway (GWR) crossing Brunel's mighty Maidenhead Bridge over the Thames. The GWR connected London to the south-west of England, stretching all the way to the port of Bristol and opening up access to the industrial midlands. It was designed and planned entirely by Brunel, and represents one of his finest achievements.

Speed was the railway's selling point, and trains on this line could outpace any other means of transport on the planet at the time: the Firefly could notch up 60 mph. The passengers on this train were travelling faster than any human had ever travelled before. Many individual locomotives were named to draw attention to their speed: *Achilles, Arrow, Dart, Fire Ball, Pegasus, Greyhound.* It could be unnerving. Travelling on the GWR in 1840, Prince Albert reportedly reprimanded the railway's directors: 'You travel very fast on this line; not so fast back, if you please.' Others were exhilarated by the experience. 'When I closed my eyes,' wrote the actress Fanny Kemble to a friend after accompanying George Stephenson on a locomotive footplate on the Liverpool & Manchester line in 1830, 'the sensation of flying was quite delightful, and strange beyond description.'

Thanks to Brunel's engineering genius and sheer bloody-mindedness, the GWR set new standards, such as the 'broad gauge' track, wider than that used by George and Robert Stephenson, which allowed his trains to ride more smoothly and faster. A pioneering engineer needed a brilliant partner in locomotion design, and so Daniel Gooch, an engineer from Northumberland, was appointed by the GWR directors as their first superintendent of locomotives – just before his twenty-first birthday. Gooch's Firefly locomotive was first introduced into service in 1840, and its prestige was hugely boosted when, two years later, a Firefly called *Phlegethon* (after one of the five rivers of the underworld) was chosen to pull the first train ever used by Queen Victoria. The engine was driven by Gooch himself, with assistance (one imagines rather grudgingly) from Brunel. The journey attracted national attention.

Gooch went on to become the GWR's chairman, an MP and a baronet – as well as the chief engineer on the laying of the first transatlantic telegraph cable and the initiator of the Severn Tunnel

OPPOSITE: The railways were unsettling. In George Cruikshank's *The Railway Dragon*, the locomotive was depicted as a monster.

The Railway Dragon

ABOVE: Daniel Gooch commissioned this fabulous model of his Great Western Railway 2-2-2 Firefly locomotive from the engineer Joseph Clement.

project. But he always took deep pride in his Firefly, and around 1842 he commissioned a remarkable 1/8 scale working model from Joseph Clement, famous for having made Babbage's first 'difference engine'. It is perfect in every detail, and Gooch, though a modest man, couldn't resist having his photograph taken standing beside it. The model remained in his family until it was acquired by the National Railway Museum in 1996.

Brunel's Maidenhead Bridge, opened in 1839, was another national wonder. It had presented Brunel with a tricky challenge:

how to span the Thames, here 100 yards wide, without getting in the way of tall sailing barges. Brunel didn't want to make the track too high, so instead he built the viaduct using the largest, flattest brick arches ever made. Some feared the structure would not hold, but the bridge still carries trains today. For Turner, it represented a conjunction of two fascinations, for the Thames itself held 'a magnetic attraction for him'.

It's tempting to speculate about whether Turner and Brunel ever met. They certainly could have done, although there is no record of an encounter. One of the openings of the Thames Tunnel from Rotherhithe to Wapping, whose construction Brunel oversaw, is only 200 yards from the pub in Wapping that Turner inherited, the Ship

and Bladebone. The two men had mutual acquaintances, among them Turner's friend the Royal Academician J. C. Horsley, whose sister Mary was Brunel's wife. Turner's executor, architect Philip Hardwicke, worked with Brunel on parts of Paddington Station, and early in his career Brunel had worked under Charles Babbage, another acquaintance of Turner's.

TIMES CHANGE

The coming of the railway changed not only travel but time itself, which now had to be standardized everywhere to conform to the train timetables. As Dickens commented: 'There was even railway time observed in clocks, as if the sun itself had given in.' His fellow novelist William Thackeray confessed to feeling half in the ancient times of knights and romance, half in the modern era where the new heroes were innovators like Brunel. He belonged, he said, 'to the new time and the old one. We are of the time of chivalry as well as the Black Prince . . . We are [also] of the age of steam. We have stepped out of the old world onto Brunel's vast deck . . .'

It was all rather mystifying. Some observers could not make out what Turner's painting was intended to represent – one critic called the picture 'a chaos of affectation and confusion' and a 'downright insult to our common sense'. Thackeray himself was one of the few contemporaries to offer praise: 'Mr. Turner has out-prodigied all former prodigies . . . there comes a train down upon you, really moving at a rate of fifty miles an hour, and which the reader had best make haste to see, lest it should dash out of the picture, and be away up Charing Cross through the wall opposite.' *The Times* hedged its bets: 'The railways have furnished Turner with a new field for the exhibition of his eccentric style . . . Whether Turner's pictures are dazzling unrealities, or whether they are realities seized upon a moment's glance, we leave his detractors and admirers to settle between them.'

The question *The Times* posed – was this a work of imagination or reportage? – is still debated today. Turner is well known for depicting scenes he had experienced himself, and there are details in the painting that speak of first-hand knowledge, such as the way burning

ash and cinders fall from the locomotive's firebox onto the track below. The image captures the description of a train in full steam by the railway expert F. S. Williams in 1852: 'As the iron gullet of the monster vomits aloft red-hot masses of burning coke, the thundering, gleaming mass rushes past at some fifty or sixty, perhaps seventy, miles an hour . . . it seems to burn its way through the sable livery of night with the strength and straightness and fury of a red-hot cannon-ball.'

Turner also shows the third-class passengers crammed into box-like open carriages, completely exposed to the wild elements. That kind of transportation was already provoking arguments about safety and inequality. On Christmas Eve 1841, nine workers employed on the construction of the new Houses of Parliament, travelling home for the holiday in such carriages, were killed when a GWR train crashed at Sonning in Berkshire. Parliamentary intervention eventually led to William Gladstone's Railways Act of 1844, which obliged railway companies 'to treat third-class passengers as human beings and not as merchandise' – and that included providing roofs over their heads. *Rain, Steam and Speed* shows the last days of the open carriage.

A TEMPESTUOUS JOURNEY

It's possible the painting depicts a moment on a journey Turner himself took. Lady Simon, a friend of the Ruskins, claimed that she was travelling in a first-class compartment with Turner when a tremendous storm broke around Beam Bridge in the last stages of a journey to Bristol (then the western terminus of the GWR). 'The wind began to bluster,' wrote Lady Simon, 'the lightning changed from summer gleams to spiteful forks, and the roll of thunder was almost continuous.' Also in her compartment was an elderly gentleman who had, she observed, 'the most "seeing" eyes I had ever seen'. When the train reached Bristol the 'old gentleman rubbed the side window with his coat cuff, in vain; attacked the centre window, again in vain, so blurred and blotted was it with the torrents of rain!' Failing to get any kind of view through the glass, the 'old gentleman' – whom Lady Simon later identified as Turner – asked

permission to open the window, and for the next nine minutes leaned out of the carriage taking in the 'chaos of elemental and artificial lights and noises' that swirled around the train.

Lady Simon's account has been dismissed as being 'full of impossibilities'. But a careful comparison with the known facts about the GWR in June 1843 shows that it is in fact highly plausible. On the ninth of that month, the area around Beam Bridge suffered storms worse than even 'the oldest inhabitant' of the area had ever seen. The old Beam Bridge – which Lady Simon and Turner would, if we believe her story, have only just crossed on their way to the station – collapsed, sweeping two men into the swollen river below. The railway sustained 'considerable damage', and passengers on the late train from Paddington had to make their way to a nearby inn over a plank thrown across the broken section of the bridge.

Rain, Steam and Speed was probably Turner's last great painting. He died in London at the end of 1851 – a year that had seen the Great Exhibition attract huge crowds from across the country, most of them brought in by train. Turner was born before the railway, lived through its birth and died at its height. In depicting the GWR, he was showing the very best of a technology that was transforming the world. His astonishing ability to convey the power of the locomotive as it speeds across Maidenhead Bridge was born out of his intense curiosity and exceptional observational abilities, probably married to personal experience.

A year after Lady Simon had (perhaps) shared his railway carriage on that tempestuous June night, she went to the Royal Academy to see Turner's latest work – at which point she realized who her travelling companion had been. 'Imagine my feelings,' she remarked to John Ruskin, when she saw *Rain, Steam and Speed*:

> I had found out who the 'seeing' eyes belonged to! As I stood looking at the picture, I heard a mawkish voice behind me say: 'There now, just look at that; ain't it *just* like Turner? Whoever saw such a ridiculous conglomeration?' I turned very quietly round and said: '*I* did; I was in the train that night, and it is perfectly and wonderfully true.'

6

Plants on Paper:
The Art of Botany

Blue, darkly, deeply, beautifully blue.

ROBERT SOUTHEY, 1805

The study of plants – the pursuit that came to be the science of botany – has always been a visual activity. It's not a matter just of collecting specimens: to distinguish one plant from another, you need to look closely – to see the shape and size of the thorns on the stem of a rose, the colour of its five or more petals, the texture of its leaves. To tell one type of rose from another, you need to pick out subtle variations in features like these. And to communicate such things, until photography came along in the mid-nineteenth century you needed to be able to translate what you saw into a visual representation. That was both a science and an art: you needed to measure and depict accurately, but also to interpret and deliver images that conformed to the norms and expectations of representation. You needed to capture similarity as well as difference, and the images that resulted could be both useful and beautiful. Such inquiry also offered a socially accepted way of studying nature to a wide range of people – including women, who were otherwise largely excluded from scientific activities.

Natural history embraced many pursuits, from collecting seashells, insects or plant specimens to studying the history of rocks or of human societies and cultures. In the late nineteenth and early twentieth centuries these activities became the separate sciences of zoology, entomology, botany, geology, archaeology and

anthropology. Before that, you weren't obliged to specialize in any one field, and the boundaries between them were vague and permeable. There was also less distinction in earlier times between the professional and the amateur, and such terms didn't imply differences in expertise and knowledge. Charles Darwin was one of many who took an interest in all areas of natural history, from bees to rocks, and set about his research with the dedication of a professional, while being resolutely amateur in the sense that no one paid him for doing it.

And so natural history, and especially botany, was pursued by a broad cross-section of British society: aristocrats and mill workers, men and women, young and old. By the end of the nineteenth century things were different: science was becoming professionalized, it needed specific tools, and it wasn't clear what contributions amateurs could make – or whether they would be accepted by the scientific establishment.

CATEGORIZING NATURE

All forms of natural history involved collecting, exchanging and naming specimens. Identifying a new plant meant getting a sample of it, giving it a name and conveying your findings to other researchers. It began with the sample. Plants would be dried and pressed between sheets of paper, creating a so-called herbarium sheet. These physical records have become central to botany – especially those that are given the status of 'type specimen': a single example that defines a species of plant. Today, the Natural History Museum and Kew Gardens in London, the Muséum National d'Histoire Naturelle in Paris and the National Museum of Natural History (part of the Smithsonian Institution) in Washington DC all hold large herbarium sheet collections that cover many of the world's currently identified plant species.

After the sample came the name. By the early nineteenth century, many botanists and zoologists had adopted the classification system proposed by the Swedish naturalist Linnaeus, in which a species name is made up of two Latin words. The first of these

OPPOSITE: One of Joseph Lister's herbarium sheets, made from plants he and his wife Agnes collected during a tour of eastern Europe in 1883.

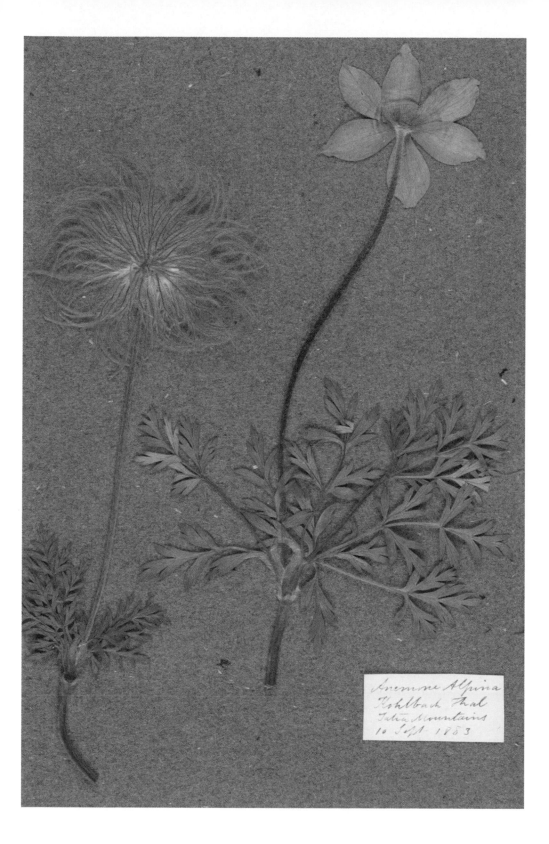

Anemone Alpina
Kohlbach Thal
Tatra Mountains
10 Sept 1853

defines the group (genus) to which the specimen belongs, while the second part defines the subgroup or species. Thus, for example, the Scots pine becomes *Pinus sylvestris* (of the pine genus *Pinus*), and the meadow buttercup is *Ranunculus acris*. The Latin name of each plant would be written beneath the corresponding specimen on a herbarium sheet.

Anyone with an interest in botany could produce a herbarium sheet. Joseph Lister, the surgeon who promoted the use of antiseptic treatments, was an avid naturalist, interested in plants not only for

ABOVE AND OPPOSITE: Pioneering photographer William Henry Fox Talbot applied his photo-etching process, photoglyphic engraving, to ferns in around 1858.

their medicinal potential but also for their own sake and for their cultural and aesthetic significance. Lister collected many samples during a tour of eastern Europe in 1883 and preserved them on herbarium sheets, labelled by hand with the Latin names. Much of the work that went into creating these herbarium sheets was done by his wife Agnes, who collaborated with Joseph in collecting the specimens, preparing them for preservation and writing the labels. She also assisted her husband in his medical work, making anatomical drawings for his publications and acting as an assistant during his experiments in antiseptics.

The problem with herbarium sheets was that they didn't travel well – they were too fragile – and couldn't be reproduced for publication. What's more, the colour of a plant specimen fades quickly when it dries. So to show a wide audience what a living plant really looked like, there was nothing for it but to prepare a drawing or painting. The tradition of botanical illustration goes back many centuries – many Islamic herbariums of the ninth to the thirteenth centuries, drawing on the work of scholars such as Al-Dinawari and Ibn Juljul, contain beautiful and carefully crafted colour images. Then, from the mid-nineteenth century, photography offered a new alternative. William Henry Fox Talbot, one of the early photographic pioneers, saw that his new art form could be used for botanical description. Some of his earliest photographic experiments included subjects such as ferns and other botanical specimens. Fox Talbot's earliest reproductive process didn't involve a camera or lens, but simply entailed placing the pressed specimen directly on a piece of light-sensitized paper – a process he called 'photogenic drawing'.

STUDIES IN BLUE

The first person to pick up on the potential of this process for making systematic botanical records was the naturalist and artist Anna Atkins. Anna's mother had died within a year of her birth, and she had a very close relationship with her father John George Children – a prominent chemist and friend of Humphry Davy – who had fostered

in her a love for art and science from a young age. In 1825 Anna married a West India merchant, John Pelly Atkins, who along with Children was friends with Talbot. When Talbot first told Children about his new invention of 'photogenic drawing' in 1839, Children was keen to work with his daughter to try making their own images. The results of these experiments have sadly been lost.

But when, a few years later, the astronomer and photographic chemist John Herschel devised a new, speedy photographic technique using the pigment Prussian blue, Atkins and Children were quick to experiment with it. Herschel's invention was called the cyanotype process. It involves mixing two chemical compounds (ferric ammonium citrate and potassium ferricyanide) in water and brushing the solution onto a sheet of paper. The mixture is photosensitive, creating a surface that turns Prussian blue when exposed to light. If an object is placed on top to act as a mask on part of the surface, the result is an image showing the shape of the 'mask' in white against a rich blue background. Hence the term 'blueprint' – a term now generally used to describe the technical plans and line drawings for which the cyanotype process came to be widely used.

In 1843 – a year before Talbot's own first published collection of photographs, *The Pencil of Nature*, began to appear in serial form – Atkins published the first ever book to include photograms (another word for photographs made without a camera). In fact, the whole book, including the preface text and captions, as well as the images of the specimens themselves, was made from nothing *but* cyanotypes. Atkins made more than five thousand photographic prints for the book, all by hand; and she undertook this labour of love, entitled *Photographs of British Algae*, not for commercial gain but for the enjoyment and enlightenment of her botanical friends. Ten years later, she produced another book of cyanotypes with her lifelong friend and collaborator Anna Dixon (a distant cousin of Jane Austen), this one entitled *Cyanotypes of British and Foreign Ferns*. These are some of the earliest and most beautifully illustrated photographic books ever printed.

The subject of Atkins' first book – algae – was a topic of increasing interest to botanists, particularly after the publication of William

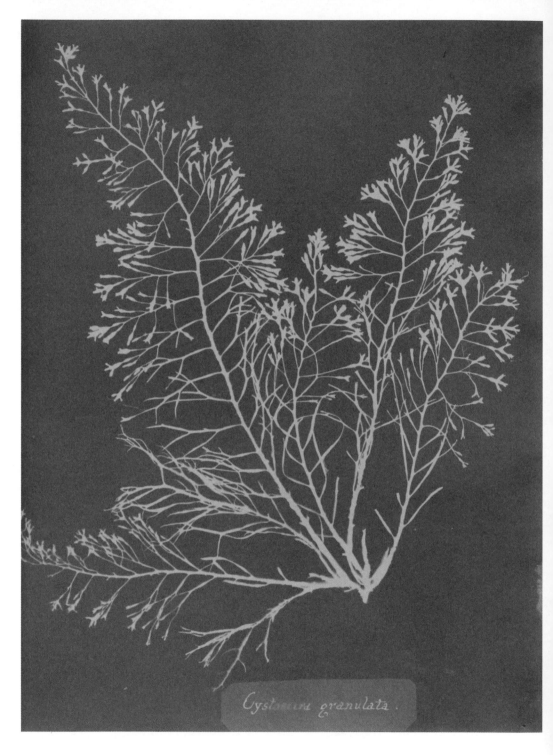

Cystoseira granulata.

ABOVE AND OPPOSITE: Anna Atkins' images of algae were created by placing the seaweed directly on the photographic paper.

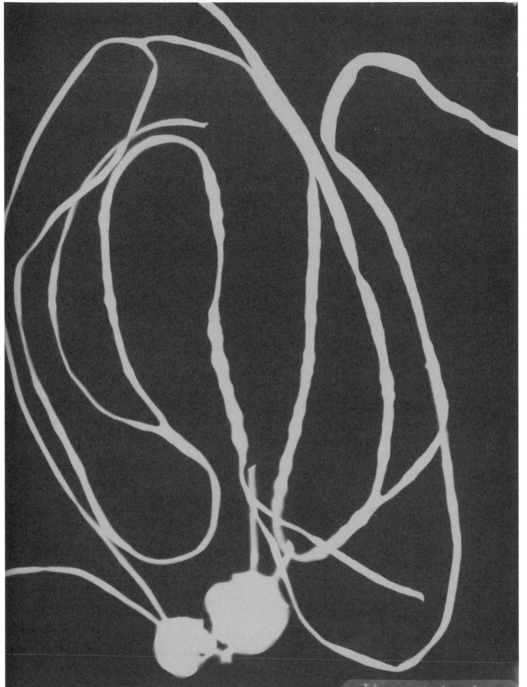

Himanthalia lorea

Henry Harvey's *Manual of British Marine Algae* in 1841. But good images of these tiny organisms were hard to create by hand. Atkins commented at the start of her book on 'the difficulty of making accurate drawings of objects as minute as many of the Algæ and Confervæ'. Herschel's 'beautiful process of Cyanotype', she explained, had allowed her instead to make direct impressions from the plants themselves. The images were received with interest and delight by Atkins' circle. The scientist Robert Hunt, an associate of John Herschel, wrote that the images 'are so exceedingly simple, the results are so certain, the delineations so perfect, and the general character so interesting' – but then somewhat undercut his praise by patronizingly noting that 'they recommend themselves to ladies, and to other travellers who, although not able to bestow much attention or time on the subject, desire to obtain accurate representations of the botany of the district'.

Yet cyanotype images weren't generally granted the status afforded to other types of photography. In the Great Exhibition of 1851, which drew six million visitors into the vast glasshouse called the 'Crystal Palace' in Hyde Park to look at new British inventions and manufactured goods from all over the world, the process was represented by just one specimen – although many others highlighted the rising interest in the art and science of photography.

Atkins' images are bold and beautiful, replicating the intricate details of the algal forms, reproducing the subtle tones that convey the transparency of the specimens and capturing the translucent veins and delicate fibres that are not easy to draw. These images are accurate contributions to botanical science, but at the same time pieces of art in their own right.

COMMUNICATING NATURE

In the decades following Atkins' first books, despite the availability of both cyanotypes and regular photographs, drawing plant specimens remained one of the most important tasks for the naturalist. To be able to translate a specimen you could see with your eyes into an image with the right proportions, colours and details

required skill and practice, and talented illustrators were in great demand. Even though drawing was an essential part of a middle-class education, few acquired the proficiency needed for this kind of work; Fox Talbot himself famously claimed he invented photography because his drawings were never good enough to match what his eyes saw. In the nineteenth century, thousands of new specialist scientific journals were established, and skilled naturalists who could turn herbarium sheets and plant specimens into drawings and engravings had no shortage of work.

One of them was Worthington George Smith, a keen naturalist who originally trained as an architect but decided to devote his skill with eye and pen to the pursuit of natural history instead, contributing images and descriptions of his own botanical discoveries to several nineteenth-century scientific journals. He was employed as a regular artist for the popular and long-running periodical *Gardeners' Chronicle* – a journal consulted by most naturalists, including Darwin, for up-to-date observations and discoveries in the botanical world. Smith not only made drawings of plants described by contributors but also turned these into engraved images for printing.

For most of the nineteenth century there was no mechanized way to turn a drawing – or a photograph, for that matter – into a printed image. The most common method was to carve the drawing into a block of wood, which would then be set alongside the text in a printing frame, allowing them both to be printed on the same page. As a skilled naturalist, draughtsman and engraver, Smith could produce illustrations that were both accurate and pleasing. The pictures he made for the *Gardeners' Chronicle* were all that most naturalists would ever see of new specimens; the herbarium sheet and original drawings stayed in the hands of the artist or in a museum collection.

For many naturalists and painters, these pictures of plants were intended to advance botanical science, for example by accurately rendering their reproductive organs – a critical aspect of the way they were classified. But the paintings made by the adventurous Marianne North had a different goal: to show plants in their natural context. She wanted to understand the world through its flora. For

FIG. 20.—GROUP OF DROSERAS AT MESSRS. VEITCH'S.

A, Drosera dichotoma. B, Drosera capensis. C, Drosera spathulata. D, Drosophyllum lusitanicum.

fourteen years in the 1870s and 1880s she travelled on her own, circumnavigating the globe twice and producing over 850 botanical paintings in the places she visited. For North there was no need to collect and preserve plants; her paintings *were* her herbarium sheets.

North had a background much like that of Atkins. She too had a very close relationship with her father, the Liberal MP for Hastings, Frederick North. (Her mother died in 1855, when Marianne was in her twenties, having made her daughter promise never to leave her father.) Frederick, like John George Children, encouraged his daughter's interest in and knowledge of both art and science. Later he helped her to make connections with some of the best-known scientists of the period – links that became particularly helpful later in her life when North was seeking to display her botanical work. And he instilled in her a sense of adventure, taking her on a tour around Europe in 1847–50. 'My father often took me on expeditions,' North recalled, 'starting by rail, and then plunging in to forests, over hills and valleys, where we met pretty roe-deers, hares, or foxes . . . all was apparently so calm and peaceful, though at that moment great revolutions were hatching all over Europe.' North and her father continued to travel widely together until his death in 1869. 'For nearly forty years he had been my one friend and companion,' she wrote, 'and now I had to learn to live without him, and to fill my life with interests as best I might.' She decided 'to devote myself to painting from nature, and try to learn from the lovely world which surrounded me'.

Having returned from her world travels, North canvassed her friends and colleagues for a place to display her paintings. Among the acquaintances she had made through her father was Joseph Dalton Hooker, the director of Kew Gardens – one of the most important sites for plant science in the world. Hooker agreed to offer North a space at Kew where she could (at her own expense) build a gallery for her work. The result is a building packed, wall to wall and floor to ceiling, with richly detailed paintings of plants, depicted in their natural settings, from around the world. The experience of visiting the North Gallery (which is still on the same site in Kew Gardens) is very different from that of reading Atkins'

OPPOSITE: Worthington George Smith contributed images of the botanical world to the popular and long-running periodical *Gardeners' Chronicle*.

cyanotype book or looking at Smith's illustrations in the *Gardeners' Chronicle*. The gallery is exactly as North intended it to be: an overwhelming feast for the eyes, vibrant with colour and stuffed with images of flora from across the planet. The paintings are not ordered 'scientifically', for example according to plant taxonomy, but are grouped by geographical area. That kind of thing was not the norm for botanical illustration at the time, and so many botanists dismissed North's work. But now we can see that the paintings invite the viewer to explore larger questions: where the plants have grown, what kinds of animals and insects use them, and how they are cultivated for human use. In North's paintings, plants are not specimens but living members of an ecosystem.

In the nineteenth century, finding a new plant or flower was just the start of the process of botanical research and curation. Ultimately, to be a natural historian was to be part of a community that exchanged, commented upon and appreciated well-crafted plant images. These images didn't all have the same meaning or purpose, but they did share one thing: they represented the importance of participation in and sharing of knowledge through imagery – a pleasure that is still felt by anyone looking at these pictures, many generations after they were made.

OPPOSITE: Intrepid explorer Marianne North travelled the world to make her paintings of plants in context.

3

The Age *of* Enthusiasm

1850–1940

New tools and techniques for observation brought with them
novel forms of truth and enabled previously unseen phenomena
to be revealed. This was a period of exciting new consumer
products and rousing social change. But these devices also began
to distance the observer from the act of observation. They
appeared to capture time, giving rise to a new focus on human
efficiency – and prompting both fascination with, and rejection
of, science and technology.

7

Reaching for the Moon: The Truth about Photography

*I cannot imagine any subject more glorious to feast the
mind's eye upon, than to wander, in thought, amid
the fearfully grand scenery in the moon . . . not an indulgence
of 'mere wild fancy', but a most legitimate exercise
of reason, and most legitimate powers [sic]
of the imagination.*

JAMES NASMYTH, 1853

A t the bustling and epoch-defining Great Exhibition in Hyde
Park in 1851, James Nasmyth – who had made his fortune with
the invention of the steam-powered hammer – was awarded a prize
medal for the work he had on display. But it was no mechanical
invention that won Nasmyth this honour; the award was for a
monumental painting, six feet square, of the moon.

Nasmyth was an engineer, and astronomy was only a hobby for
him – but it was a passion too; and he was also an accomplished artist
and photographer. Using all these skills, in 1874 he published a
book entitled *The Moon: Considered as a Planet, a World, and a Satellite*,
containing twenty-one images of the lunar landscape, with its craters
and mountains – many of them photographs. The reader could
imagine himself standing on the moon's very surface and gazing into
the dark sky, in which the planet Earth hung overhead.

Since the Enlightenment of the previous century, there had
been a prevailing belief that by closely observing the physical world

one could also uncover moral truths – that there was intrinsic value in 'truth to nature'. And what, many people argued, could be more true, more faithful, than the photograph, untainted by human preconceptions? Photography seemed to offer science an objective eye.

But did it really? A closer look at how Nasmyth made his images of the moon – both photographic and artistic – raises questions about just how objective these representations are. They seemed to put the observer in the picture, his skill central to its production – but how true to life was that picture? Nasmyth's images of the moon appeared at a pivotal moment when new forms of visual imagery and representation were forcing scientists and observers of science to ask new questions about the relationship between art and science – between claims to 'truth' and the demands and the power of aesthetic judgements.

ARTIST AND MECHANIC

In his autobiography of 1883, Nasmyth declared his overriding maxim to be that 'the eyes and the bare fingers are the two principal inlets to sound practical instruction in mechanical engineering' – you see and you make. Nasmyth, always both artist and engineer, had grown up in an interdisciplinary family. His father, the landscape artist Alexander Nasmyth, was also a talented amateur engineer who had his own workshop at the family home in Edinburgh and who invented, among other things, the bow-and-string bridge in 1794 and compression riveting in 1816. Alexander took great care to instruct his children in drawing. Of the eleven who survived to adulthood, seven became artists, including the eldest brother Patrick and all six sisters, who supported their father's school. Alexander's unorthodox methods involved throwing bricks or pieces of wood down on a surface at random so that his pupils learned quickly to capture the outline and shading of a shape. James recalled how he quickly developed what Alexander called a 'graphic language', which could convey as much as, if not more than, words.

In the company of two school friends whose fathers ran businesses,

the young James witnessed industrial chemistry and engineering at first hand. He started to build small steam engines in his father's workshop; these he was able to sell, spending the proceeds on drawing classes at Edinburgh University, where he also attended classes in chemistry and mathematics. At the age of nineteen, he was commissioned by the Scottish Society of Arts to build a steam carriage to carry eight people, which was successfully trialled on the roads around Edinburgh in 1827–8. In 1829, Nasmyth moved to London to become an assistant in the Lambeth workshop of Henry Maudslay, then the leading engineering toolmaker in the country. By the time of Maudslay's death two years later, James was ready to return to Scotland to develop his own enterprise.

After two years building up the stock of tools he needed, in 1834 he opened for business in Manchester, supported by a group of industrialists including his brother George. By 1836 he was successful enough to lease land at Patricroft on the outskirts of the city, where in 1839 he created his most renowned invention: the steam hammer, which he patented in 1842. He continued to exploit and improve his design, and by 1856, aged forty-eight and in possession of a large personal fortune, he was able to retire to Kent and focus on his passion for astronomy. He bought a house at Penshurst, which he named Hammerfield, and here he designed and built his own telescopes and observing devices, including a 20-inch speculum (astronomical mirror) and a turntable that made long hours of observing easier by allowing the viewer to track the moving stars with a telescope while simply sitting next to it.

OBSERVING THE NIGHT SKY

Nasmyth was first attracted to the skies by the Great Comet of 1843; but it was the moon that held his attention. He made nightly observations, producing meticulous and beautiful drawings of what he saw, as he explained in his autobiography:

> I made careful drawings with black and white chalk on large sheets of gray-tinted paper, of such selected portions of the

Moon as embodied the most characteristic and instructive features of her wonderful surface. I was thus enabled to graphically represent the details with due fidelity as to form, as well as with regard to the striking effect of the original in its masses of light and shade. I thus educated my eye . . . and at the same time practised my hand.

Just as Galileo, two centuries earlier, had concluded from shadows that the moon has topography like our own planet, so Nasmyth realized that seeing the moon was all about observing light and shade. He consulted the latest lunar map, published by Wilhelm Beer and Johann Heinrich Madler in 1837, but found it difficult to match their line drawings with the three-dimensional, shaded objects that he saw through his telescope. He decided instead to depict the moon as if it were illuminated across its surface, showing the highlights and shadows of mountains and craters. The result was

ABOVE: James Nasmyth observed the moon nightly, making endless drawings of its surface features from different angles.

the extraordinary, prize-winning painting displayed at the Great Exhibition. Visitors were reportedly captivated not only by the 'novelty' of the image but also by 'the accurate and artistic style of [its] execution'. Prince Albert was delighted by Nasmyth's moon and asked him to show his drawings to Queen Victoria after the Exhibition had finished.

By the time Nasmyth published that moon picture in his 1874 book, it was not by any means his most spectacular image. A photographic reproduction of the painting was set opposite a line map that allowed readers to identify features on the shaded and illuminated surface. But the book also contained photographic plates that were yet more unusual and ground-breaking, showing close-up images of specific lunar features in remarkable detail – something that the astronomical photography of the time could never have achieved. They gave the reader a real sense of this craggy, pitted world.

Contemporary scientists and artists alike praised Nasmyth's images for managing to be both spectacular and truthful. 'Rarely if ever, have equal pains been taken to insure such truthfulness,' enthused astronomer Norman Lockyer, reviewing the book in his new journal *Nature* (founded in 1869). 'The illustrations to this book are so admirable,' he went on, 'so far beyond those one generally gets of any celestial phenomenon, that one is tempted to refer to them first of all. No more truthful or striking representations of natural objects than those here presented have ever been laid before his readers by any student of Science.'

That was praise indeed from one of the leading astronomers of the day. But artists were bowled over too. The Royal Academician Philip H. Calderon wrote to Nasmyth to enthuse:

I have been up in the moon . . . As soon as these few words of thanks are written I am going up to the moon again . . . The photographs took my breath away . . . Only an artist could have said what you say about the education of the eye and of the hand. You may well understand how it went home to me.

Calderon added, 'I could not understand how you did them', and exclaimed that 'your explanation of how you *built* the models from your drawings only changed the wonder to admiration'. For that was indeed what Nasmyth had done. Working from his detailed drawings, he moulded plaster models of lunar craters and then photographed them outside in bright, raking light to create the shadows. As he explained in the book's preface:

> These drawings were again and again repeated, revized, and compared with the actual objects, the eye thus advancing in correctness and power of appreciating minute details, while the hand was acquiring, by assiduous practice, the art of rendering correct representations of the objects in view. In order to present these Illustrations with as near an approach as possible to the absolute integrity of the original objects, the idea occurred to us that by translating the drawings into models which, when placed in the sun's rays, would faithfully reproduce the lunar effects of light and shadow, and then photographing the models so treated, we should produce most faithful representations of the original.

The models drew on observations of each feature taken on different nights and at different times, so that the shapes and shadows could be compared. What's more, Nasmyth compared them to his drawings and models of the mountainous landscape around Naples to make a comparative argument for how the features had formed – a recognition that the moon experienced geological processes just as the Earth did.

Plaster was a useful medium in this period: relatively cheap, widely available, easy to mould and handy for making replica casts of objects. James's approach was clearly derived from the practice of his father Alexander of using plaster models as guides for landscape painting, often working from sketches he had made years earlier.

At this time, too, plaster casts were the standard medium for studying famous sculptures. Almost every schoolboy, and certainly every aspiring artist, learned to draw by copying casts of classical

sculpture. In the 1860s the South Kensington Museum (the forerunner of the V&A and the Science Museum) was formed in the wake of the hugely successful Great Exhibition. Its first director, Henry Cole, believed that copies of famous artworks should be made available to museums across the world so that everyone could have access to them – hence the creation of what are now the V&A's cast courts. The production of plaster replicas as 'exact copies' therefore anticipated the role of photography as another medium valued for its authenticity and objectivity.

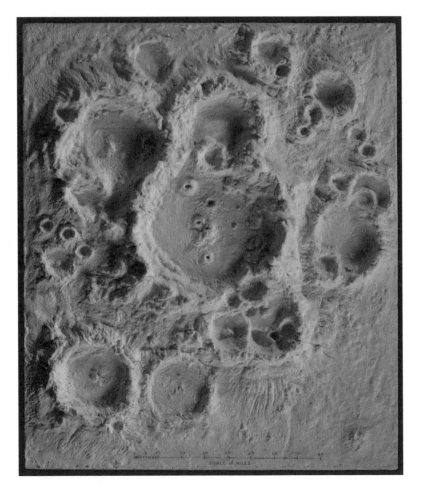

ABOVE: Nasmyth modelled the lunar surface out of plaster, working from his drawings. Here he compares craters to the size of Mount Vesuvius.

The photographs in Nasmyth's book were printed as 'Woodburytypes', using a relatively new photo-mechanical process that reproduced depth of colour particularly well and allowed the images generated to be printed using permanent carbon-based ink and standard industrial printing processes. Although Nasmyth had been producing and photographing models of the lunar surface since the 1840s, it was only in the 1870s that he felt photographic printing technology had become sufficiently advanced to do the images justice. It is partly for that reason – and also because of the way photography combined visual and manual skills, the twin founding principles of his own work – that he had followed the development of such techniques with great interest. He commented in his *Autobiography* that

> photography, both in its interesting processes and glorious results, becomes a most attractive and almost engrossing pursuit. It is a delightful means of educating the eye for artistic feeling, as well as of educating the hands in delicate manipulation.

The book used other methods of reproduction as well as Woodburytypes: some images were 'heliotypes', generated by an early copying method, and there were also drawings by Nasmyth reproduced as lithographs and chromolithographs (coloured prints). It may be that Nasmyth was experimenting to see what worked best. The first edition of *The Moon* sold out quickly, and a second edition appeared the same year; a third was produced in 1885 in which all of the photographs were Woodburytypes.

The careful and complex production of Nasmyth's images makes the publication of *The Moon* a pivotal moment in the history of scientific imagery, and raises fundamental questions about how far it may be said to represent 'the truth'. The invention of photography in the nineteenth century is often said to have encouraged scientists to move towards objectivity in visual representation: the photographic image allowed phenomena to be shown unmediated by the interpretation or imagination of the observer. But while Nasmyth's

photographs looked convincingly like the real thing – and were praised in those terms by Lockyer – in fact their production involved multiple layers of mediation, being taken from drawings and paintings based on models that were themselves interpretations of telescopic observations. What they actually represent is the beginning of what is now a long and well-established tradition of 'artists' impressions' of other worlds, images which attempt to meld scientific accuracy with the stunning and spectacular traditions of sublime landscape art.

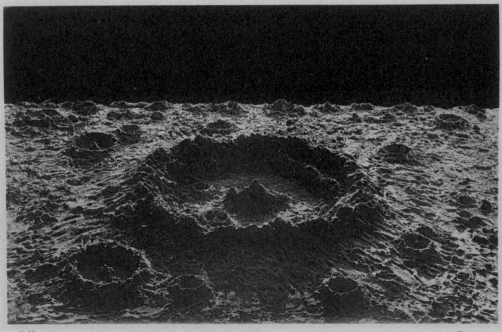

PLATE XXI.

J. Nasmyth.

Heliotype

NORMAL LUNAR CRATER.

ABOVE: Photographed in strong, raking sunlight, Nasmyth's models created compelling images of the lunar surface.

This tradition of 'astronomical imagining' is prefigured especially strongly in the final images in *The Moon*. The view presented in the last three plates is not down towards the surface of the moon, but up from it – as if the viewer is standing on the moon and looking back at the Earth. Nasmyth devoted two chapters to that experience, explaining the moon's relationship with the Earth. He wrote with fervour about the contrast between the barren lunar landscape and that of the verdant Earth. The moon, he said, 'has taught us of a world in a condition totally different from our own; of a planet without water, without air, without the essentials of life develop-ment, but rather with the conditions for life destruction'. From the moon, the seas of our planet 'would appear (so far as can be inferred) of pale blue-green tint, the continents parti-coloured . . . The permanent markings would be ever undergoing apparent modification by the variations of the white cloud-belts that encircle the terrestrial sphere.' Here the Earth appears as rather a fragile, sensitive planet, with resources that the population takes for granted. The final chromolithograph imagined the Earth seen from the lunar surface during an eclipse: a dark disk surrounded by the glowing edges of the sun. The tone here soon became familiar in the imagery of science fiction.

All this foreshadows the responses of the Apollo 8 astronauts when they first saw the Earth from moon orbit in 1968, hanging in the black sky over the pitted lunar surface. Astronaut William Anders described

> the Earth coming up on this very stark, beat up lunar horizon, an Earth that was the only color that we could see, a very fragile looking Earth, a very delicate looking Earth. I was immediately almost overcome by the thought that here we came all this way to the moon, and yet the most significant thing we're seeing is . . . the Earth.

This image, now widely known as *Earthrise*, has become one of the

OVERLEAF: Nasmyth imagined standing on the lunar surface looking back at the Earth. His work inspired later sci-fi writers and artists.

most famous of modern times. And yet, like Nasmyth's views of the moon, it is not quite what it seems. The photograph was originally taken at a right angle to the standard view, so that the moon's surface sits vertically to the right of the Earth. It was only by turning the photograph clockwise that it was made to echo the moon rising above the surface of the Earth. So in this framing it is not an exact representation of the astronauts' experience.

Earthrise reminds us that, for nearly all of us, our experience of both the moon and the Earth has been and will always be mediated through images produced using complex technologies and through human choices in how they are presented. Perhaps it is the imaginative distance, as well as the physical distance, that continues to make the experience of the moon so wondrous to us on Earth.

OPPOSITE: William Anders took this powerful image of the Earth while orbiting the moon. Known as *Earthrise*, it is usually shown rotated.

8

Dyeing to Display:
Variety and Vibrancy

*It is rich and pure, and fit for anything; be it fan, slipper,
gown, ribbon, handkerchief, tie, or glove. It will lend lustre to
the soft changeless twilight of ladies' eyes – it will take any
shape to find an excuse to flutter round her cheek – to cling (as
the wind blows it) up to her lips – to kiss her foot – to whisper
at her ear. O Perkins's [sic] purple, thou art a lucky
and a favoured colour!*

CHARLES DICKENS, 1859

By the midpoint of the nineteenth century, Britain was at the
peak of its industrial eminence. As the first nation to experience
the industrial revolution it had gained a head start, and was now
proud to claim the superiority of its industries. Chief among them
was the manufacture of textiles, which had been transformed by
mechanized weaving, especially of cotton and wool. Once a cottage
industry, textiles production was now carried on in factories
employing hundreds of labourers. Since the turn of the eighteenth
century, the amounts of cotton imported into Britain had increased
almost eighteenfold. Most of it came from the United States and the
West Indies: arriving at Liverpool, from there it was taken to
Manchester, the great centre of the textiles industry, and its
neighbouring towns, where the cotton was bleached with chlorine
or bleaching powder, and then dyed, usually after it had been made
into cloth.

Most of the dyes used were extracts of plants and lichens. The two
most important were indigo, extracted from the *Indigofera* plant

cultivated in plantations in India, and madder red, made from the roots of the madder plant that was grown in France and the Netherlands. What distinguished these dyes, apart from their strong colours, was that they did not tend to fade quickly in sunlight. As the textiles industry expanded, so public demand for its products grew, and manufacturers were always on the lookout for new dyes.

They looked to the burgeoning science of chemistry. Chemists had begun to study the substances in plants, identifying pharmaceuticals such as morphine, derived from the opium poppy, and caffeine, the stimulant in coffee. These compounds belonged to a group of substances called alkaloids, which had been shown by the methods of chemical analysis introduced and developed by the German chemist Justus von Liebig to contain the elements carbon, hydrogen and nitrogen.

One of Liebig's students, August Wilhelm von Hofmann, was given the task of finding out what chemical compounds were contained in coal tar, a sticky black substance produced as a waste product during the extraction of gas from coal for gas lighting. Hofmann isolated one of these, called aniline, and began to study its properties.

Later in his career, by which time he was the first director of the Royal College of Chemistry in London, Hofmann wondered if aniline might be used to make the alkaloid quinine, which was known to have anti-malarial properties. Quinine was in great demand to defend against malaria in the tropical colonies of India and elsewhere, but it was available only as an extract of the bark of the cinchona tree; an artificial source would be of immense value. Liebig's methods of analysis suggested that quinine might be made from a compound derived from aniline, called allyl toluidine. In 1856 Hofmann suggested to one of his own students, the eighteen-year-old William Perkin, that he try converting allyl toluidine to quinine. During the Easter holidays, Perkin gave it a try in the makeshift laboratory he had rigged up in a shed at his family home at Shadwell, east London.

It didn't work. All Perkin got was an unpromising red sludge. But he didn't give up. He now tried the same reaction with aniline itself – and got more sludge. Only this time the sludge was black.

Perkin didn't simply discard this residue, as many might have done. He dried it to a powder, and studied its properties. When dissolved in methylated spirit, the powder produced a solution of a rich purple colour.

Though Perkin didn't know it, the same experiment had probably been done before – by the German chemist Friedlieb Ferdinand Runge in 1834. If so, Runge had failed to do anything with the result. But Perkin realized at once that this purple colour might be of value to the textiles industry. He dipped a piece of white silk into the solution and found that it took up the purple colour. Now he needed a specialist opinion; so he sent samples of the purple-coloured silk to the dyeing firm Pullars in Perth, Scotland. They were impressed. Yes, they replied; there would certainly be a market for the dye – if it could be made cheaply enough.

Could it, though? In deciding to find out, Perkin was taking a bold and unusual step. For the academic scientist it was the acclaim of one's peers that mattered, not the vulgar allure of commerce and the money to be made from it. Hofmann took a dim view of Perkin's decision to quit the Royal College and enter the dye-making business. Perhaps he had not forgotten the example of another student, Charles Mansfield, who a year earlier had tried to set himself up as a commercial distiller of the coal-tar extract benzene and had been burned fatally when his still caught fire.

Perkin perhaps drew confidence from his father George's business acumen. George Perkin had started out as a carpenter and boat-builder, and had then benefited from the enormous expansion of London's population – from one million in 1815 to three million in 1860 – by setting himself up as a house-builder. Perkin senior had both the experience and the funds to construct a factory for making the purple aniline dye – and also, crucially, a lack of any prejudice against a son's desire to go into industry.

OPPOSITE: This sample of mauveine dye was prepared by William Henry Perkin.

OVERLEAF: The Perkin factory at Greenford needed good transport links to bring in large quantities of coal tar and nitric acid.

Perkin and Sons (William's elder brother Thomas joined him in the enterprise) needed a site away from a population centre, to avoid problems with emissions and odours from the factory, and with good transport links, for bringing in ingredients such as coal tar and nitric acid. They found the ideal spot at Greenford Green, near Harrow in the far west of London, and bought their site from the landlady of a local pub. The real challenge was to get the raw materials for the dye – aniline in particular – at low cost and in adequate quantities. Aniline itself is present in coal tar in only relatively small amounts, but Perkin figured out how to make it from benzene, of which there is more, in reaction with nitric and sulphuric acids, and with another processing step. No one had produced an industrial chemical using a multi-step chemical process before; but Perkin got it to work, and by 1859 the factory was producing aniline purple dye on a large scale.

THE POLITICS OF COLOUR

Now he needed a catchy trade name. Purple had a long association with wealth and power, most notably in the form of the Tyrian purple made from an extract of Mediterranean shellfish in Roman times and used to dye the robes of the Emperor and senators. Perkin's first thought was to trade on this high-status association by calling his dye Tyrian purple. But then he changed his mind, realizing that there was more glamour these days in French *haute couture* than in ancient Roman history. The Empress Eugénie, consort of the French Emperor Napoleon III, was one of the pre-eminent fashion icons of the time, and she had a taste for purple. In the mid-1850s she popularized a purple dye made from lichen, and also helped to promote enthusiasm for another called murexide, made from guano. Eugénie adopted the Perkins' new purple with gusto in 1858, and Perkin therefore decided to sell it under a French name: *mauve*, the word for the mallow flower. Strong dyes like this were shown off to great effect by the contemporary fashion for the crinoline, a voluminous cage worn under the petticoat over which great swathes of coloured material could be displayed. Queen Victoria gave her own royal imprimatur to the new dye after being presented with a

ABOVE AND OVERLEAF: Clothes like this jacket and skirt were produced with Perkin's mauve after the Empress Eugénie and Queen Victoria made the colour fashionable.

bolt of mauve-dyed silk by Perkin. It became *the* colour of the 1850s and 1860s, to the extent that *Punch* saw fit to satirize it in 1859: 'Like the other form of measles, the mauve complaint is very catching: indeed, cases might be cited, where the lady of the house having taken the infection, all the family have caught it before the week was out.'

GARISH AND GAUDY

Contemporary art critics didn't share this taste for bright, strong colour. In a book published posthumously in 1840, the German polymath Johann Wolfgang von Goethe suggested that vivid, gaudy colours were preferred only by 'savage nations, uneducated people and children'. The true aesthete looked for more subtle shades. The French intellectual and self-appointed judge of good taste Hippolyte Taine snobbishly condemned the colours he saw English women wearing in Hyde Park in the 1860s as 'outrageously crude', and mocked the combination of hues sported by one well-to-do Englishwoman: 'violet and poppy-red silks . . . grass-green dresses with flowers, [and] sky blue scarves'.

In Britain, design reformers of the 1860s and 1870s, led by William Morris and John Ruskin, lamented the industrial methods by which the new colours were produced. The garish factory-made dyes derived from aniline – other hues soon followed Perkin's mauve – exemplified what they saw as the dehumanization and commodification of traditional art and craft. The division of labour used in factories, they argued, deprived the working class of the fulfilment of seeing a product created from start to finish. The use of artificial materials added to the estrangement from nature and the environment. Ruskin in particular wanted to create opportunities for people in the industrial working class in cities such as Sheffield to gain access to works of art and the beauties of nature.

Morris was, all the same, an industrialist of sorts himself, with his own company that produced his famous floral wallpaper and textile designs – some of them dyed with a toxic, arsenic-based green pigment. Instead of using exotic foreign plants, large and vividly coloured, in these designs, Morris preferred the smaller, more discreet native plants that could be found in British hedgerows. The 'hideous but bright' synthetic dyes typically used to depict exotic flowers in textile designs were, he wrote in 1882, guilty of 'destroying all beauty' in the ancient art of dyeing.

C. F. A. Voysey, one of the most prominent and influential designers of the Arts and Crafts movement, rejected the harsh colours of synthetic dyes while still using refreshing, bright colours in clear combinations. In his compositions inspired by nature, Voysey looked for tonal harmony and clear, simple lines. He aimed to 'raise the colour sense from morbid sickly despondency to bright and hopeful cheeriness' – an objective that was still exerting its influence well into the twentieth century.

Many of Voysey's later designs were produced by Alexander Morton and Company, first established as a weaving enterprise. Alexander's son Sir James Morton and James's wife Beatrice Emily Fagan were both disciples of the Arts and Crafts movement. James Morton was wary of the new dyes – not least because he had seen the way some of them faded after being displayed for just one week in the shop window of Liberty's in London. 'The fading of the new dyes

is a change into all kinds of abominable and livid hues,' he grumbled. He had a point: some of the new aniline-related dyes didn't last well. Morton sent coloured textiles to his brother-in-law Patrick Fagan, a civil servant working in India, who put them to the severe test of exposure to the harsh Indian sunlight on his roof, resulting in fade-resistant ranges. For him, the permanence of the dye was a priority, even if this limited the colour palette that had been rapidly widening for consumers since Perkin's discovery of mauve. Chemical dyes began to mimic natural dyes, with the dye manufacturers looking for colours that were less brash and intense, echoing the aesthetic of the Arts and Crafts movement, if not its spirit.

CONSPICUOUS CONSUMPTION

For a short time Perkin and Sons had a monopoly on aniline dyes, and they got rich. But soon enough others were in the game. In 1859 the French chemist François Verguin, based in the major textiles city of Lyon, created a purplish-red dye that he called fuchsine (perhaps following Perkin's lead of naming dyes after flowers). When French forces defeated their Austrian opponents at the town of Magenta in Italy that year, Verguin patriotically renamed his dye after the site of the battle – prompting the Empress Eugénie to switch her allegiance to this French magenta, securing its popularity. Soon after this, a blue aniline dye was introduced to both the French and British markets.

Even August Hofmann had soon overcome his dismissive attitude to the aniline dyes and begun to study them himself (sometimes approaching his former student for chemicals). He had in fact made the fuchsine dye too, but wasn't able to purify and isolate it. He did, though, succeed in creating a range of aniline violets in 1863, and these too caught Eugénie's highly desirable fancy. Aniline mauve – now relatively costly, and not terribly good at sticking to cotton – began to lose its allure.

Throughout the 1860s, the natural dyes madder and indigo continued to hold their own. After all, they lasted well, and they were cheap. But chemists were now wondering if these dyes too could be

ABOVE: Charles Voysey rejected harsh synthetic dyes but designed cloth woven with bright natural colours.

made synthetically, avoiding the complication of having to cultivate the source crops, sometimes in far-off lands. Their colours typically come from just one or two light-absorbing molecules; the challenge for the chemist is to create these from simple ingredients. For madder red, this colorant is a compound called alizarin. Perkin began his attempt to synthesize it in the late 1860s, and he succeeded at much the same time as two German chemists, Carl Graebe and Carl Liebermann, made alizarin working under the distinguished chemist Adolf von Baeyer in Berlin. Graebe and Liebermann also collaborated with Heinrich Caro, a chemist employed by the dye manufacturers Badische Anilin- und Sodafabrik or BASF.

Synthetic alizarin dye – in which the 'core' of the alizarin molecule was constructed from another coal-tar extract, anthracene – replaced natural madder within a decade, leading to the collapse of the madder-cultivation industry. But this time Perkin did not reap the benefits. Alizarin was a success, but the market was now highly competitive, and Perkin was not confident he could staff his business with scientifically trained personnel in the way companies like BASF were starting to do: there were too few qualified scientists in Britain, and it was difficult to recruit them from Germany. On top of this, questions were beginning to be asked about the pollution caused by the production of such dyes, and their safety for workers, or when worn, or even ingested. In 1874 Perkin sold the Greenford Green factory to the rival dyeing firm of Brooke, Simpson and Spiller – who sold it themselves two years later to another coal-tar company, Burt, Bolton and Heyward. Overseas competition was now making it hard for British companies to survive in the trade.

The coal-tar palette was soon expanded to include green and black along with reds, blues and purples. And in the late nineteenth century a new class of synthetic dye was added: the azo dyes, in reds, oranges and yellows. The choice of colours was now huge, and contemporary fashions became ever more vibrant. With the introduction of the sewing machine, too, clothing was democratized; no longer were bright garments the preserve of the rich. Women of all classes could make their own clothes from paper patterns, and the department stores stocked the latest fashions ready-made for

those who could afford it. The rise of fashion magazines such as *Harper's Bazaar*, founded in the United States in 1867, and *Myra's Journal of Dress and Fashion*, launched in Britain in 1875, helped to spread new styles quickly.

As for mauve, it had had its day: by the end of the century it was a colour for the elderly. The connoisseur aesthete Oscar Wilde drove the final nail into its coffin in 1891: 'Never trust a woman who wears mauve . . . It always means they have a history.'

ABOVE: The weekly fashion magazine, *Le Moniteur de la Mode*, promoted mauve to women in June 1865.

131

9

Capturing Time:
Vision versus Realism

We have become so accustomed to see [the galloping horse] in art that it imperceptibly dominated our understanding, and we think the representation to be unimpeachable, until we throw off all our preconceived impressions on one side, and seek the truth by independent observation from Nature herself.

EADWEARD JAMES MUYBRIDGE, 1898

Does a galloping horse take all four legs off the ground at once? It seems a fairly straightforward question, but the human eye can't resolve the motion of a horse fast enough to answer it reliably. Even less can we see directly how the motions of a horse cycle through its gait, or hope to capture an accurate image of any instant of that movement in a painting. In the nineteenth century a small group of innovators brought the latest technology to bear on the matter – and, in doing so, opened up a previously unseen world of ultra-fast change.

The leading figure in this field of high-speed photography was Eadweard James Muybridge, a landscape photographer who coupled artistic skills to scientific methodology and technical ingenuity. Muybridge showed both how to freeze time in photographs and how then to re-animate these frozen images, both for scientific analysis and for entertainment.

Time and change were problems for early photographers. When the pioneer Louis Daguerre used a shoeshine man and his customer for his 1838 image of the Boulevard du Temple in Paris, he had to get the pair to stay put for minutes so that they did not simply vanish

ABOVE: Oscar Gustav Rejlander added airborne balls to an existing image in *The Juggler, c.*1865.

like other strollers in the long exposure of what looks otherwise like an eerily empty street.

These early photographers called any image that contained movements captured in exposures of around a second or less an 'instantaneous photograph'. But of course even that wasn't truly instantaneous, as the chemist and photographer Sir William Abney pointed out towards the end of the century: 'A photograph taken by a flash of lightning', he wrote, 'is not instantaneous for the exposure takes a time which is not beyond the limits of measurement.'

The problem was that the 'wet plate process', which involved the preparation and development of the light-sensitive chemicals in the wet state, on a photographic plate, at the point of taking the picture, was fundamentally at odds with the aim of getting a clear, sharp image of motion. The photographer Valentine Blanchard did manage to capture 'snapshots' of London street scenes in the 1860s, but on the whole photographers had to resort to artifice – as for example when the botanist John Dillwyn Llewelyn used stuffed animals in dynamic poses; or when the Swedish–British photographer Oscar Gustav Rejlander created composites, inserting airborne balls into an image of a juggler with outstretched arms for his photograph *The Juggler* around 1865.

MOTION PHOTOGRAPHY

Thanks to improvements in the sensitivity of photographic emulsion (so that less light needed to be captured) and faster shutter speeds, photographers gradually came closer to getting 'instant' images. Eadweard Muybridge was the first to be able to make that claim with real justification.

Muybridge (who had started out with the conventionally spelt forename Edward and the family name Muggeridge) had moved from England to America in 1830, at the age of twenty, establishing himself as a photographer in San Francisco in the 1850s. After a brief return to England to learn the so-called wet collodion process, he consolidated his reputation in California as a leading landscape and architectural photographer. In 1872 the former state governor,

Leland Stanford (who later set up Stanford University), asked Muybridge if he could use photography to settle an argument about whether a trotting horse ever lifts all four feet from the ground at once. Muybridge took images at the Sacramento racecourse and the following year pronounced that yes, it does.

Muybridge's work suffered a setback in the 1870s when he killed his wife's lover – an act eventually judged 'justifiable homicide' – and retreated to Central America for a time, but back in California later that decade he returned to the challenge of photographing a galloping horse. Rejlander had previously written of his own attempt:

> Given a horse and rider, take a point near or on a sandy or dusty white road, 150 yards off . . . then I would have a battery of cameras and 'quick acting' lenses ready charged and loaded. The signal given, the rider starts some distance off the focussed point and at the moment of passing it – bang! With a strong wrist and sleight of hand, the exposure and covering is done.

Muybridge installed such a battery of cameras at Stanford's stock ranch in Palo Alto: twelve of them, all with high-quality lenses, directed at a 50-foot stretch of track set against a white background marked with vertical lines. Each camera had an electromagnetically controlled shutter designed by Muybridge that could deliver exposures as short as 0.001 seconds. The shutters were triggered by the breaking of thin threads across the track as the horse galloped through them. The results were still little more than silhouettes, but they were novel enough for Muybridge to sell them commercially in 1878, and to publish them in popular-science outlets such as *Scientific American* and the French magazine *La Nature*.

Muybridge refined his methods, adding more cameras and linking them by clockwork to take images at precise and controllable intervals. He presented his work in the 1881 book *The Attitudes of Animals in Motion*, and invented a device called the Zoopraxiscope that used a kind of magic lantern to project images painted from the photographs (with some modifications to avoid distortion) onto a

rotating glass disk to give the impression of actual movement: one of the first motion pictures.

His relationship with Stanford soured after the publication in 1882 of a book entitled *The Horse in Motion* by Stanford's physician J. D. B. Stillman, which used Muybridge's images with scant attribution. But by then Muybridge was securing his reputation with well-received public lectures throughout Europe – including at the Royal Institution in London in March 1882:

> He showed his photographs one after another on the screen by the aid of an electric lantern, and modestly explained them in clear but plain language. In this way the demonstration was at once rendered entertaining as well as interesting. This pleasing display was the essence of life and reality. A new world of sights and wonders, was indeed, opened by photography, which was not less astounding because it was truth itself.

Muybridge's results forced artists to revise the traditional conventions of representing animals in movement. There was some resistance. An article in *The Century Illustrated Monthly Magazine* in July 1882, written in response to *The Horse in Motion*, argued that

> the picture which shows it as our poor eyes must see it is really the truthful one for the purposes of art. So must it be with the horse in motion. We must see him on the canvas as we see him in life, not as he is shown when his movements are divided by the five-thousandth part of a second.

W. G. Simpson, writing in *The Magazine of Art*, agreed: 'Art is not copying but the transfiguring of nature . . . If you copy nature literally as a photographer does you kill her. Suppose that photography could take a horse at full gallop, the horse would run no more.' Which came closer to the truth – the scientific techniques of high-speed photography, or the human observer's own visual impressions?

Others, though, welcomed the new insights. The French artist

Ernest Meissonier, famous for military paintings that paid great attention to detail, invited Muybridge to show his work to other artists at his studio, and not only based his own paintings on Muybridge's images from that point on but even revised earlier works to be consistent with them.

SCIENTIFIC PHOTOGRAPHER

While in Paris, Muybridge met Étienne-Jules Marey, a physiologist who also used sequences of high-speed photographs (a method that became known as chronophotography) to record the movements of humans, birds and other animals. Marey had realized the potential of these techniques after seeing Muybridge's work in *La Nature* in 1878, and in 1881 he invented a 'photographic gun', which took twelve pictures a second around a circular plate on a hand-held device rather like a rifle. It was inspired by a device created by the astronomer Jules Janssen in 1874 to photograph the transit of Venus across the sun. Marey used his invention to study the movements of birds and bats, supplementing the photographs with drawings and sculptures.

In 1882 Marey went one step further, developing a 'chrono-photographic camera' with a rotating disc shutter, capable of exposing a single fixed plate at ten frames a second with shutter speeds of around one-thousandth of a second. He used it to photograph people moving in front of a black backdrop, dressing his subjects in black clothes marked with white lines along their limbs: an approach that anticipated the motion-capture technology now widely used to create animated beings based on human actors in films such as *The Lord of the Rings* and the remake of *Planet of the Apes*.

Marey's images appeared superimposed on one another on the single plate. But after the invention of photographic film on a paper roll, images could be taken one after another in separate frames, and in 1888 Marey showed the Académie des Sciences in Paris images of motion taken in this way at twenty frames per second. Film on celluloid (one of the first plastics) allowed for yet more improvements, as it was both flexible and highly light-sensitive. And it was, of course, celluloid film that made the motion picture – cinema – possible.

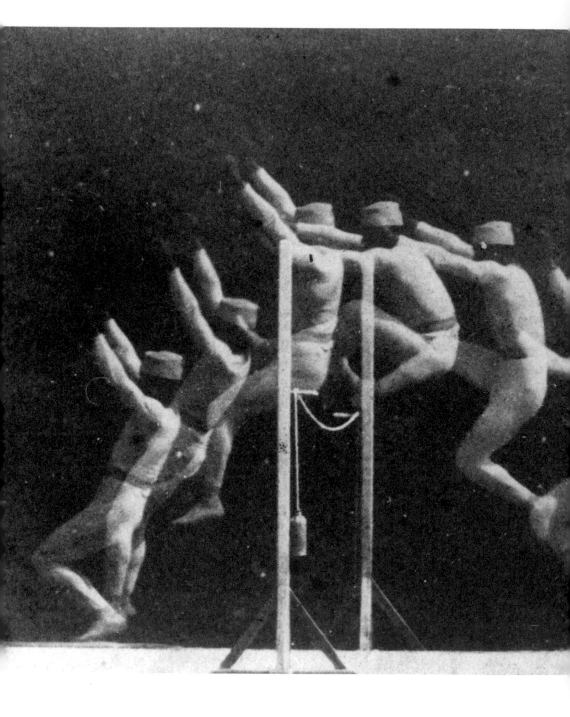

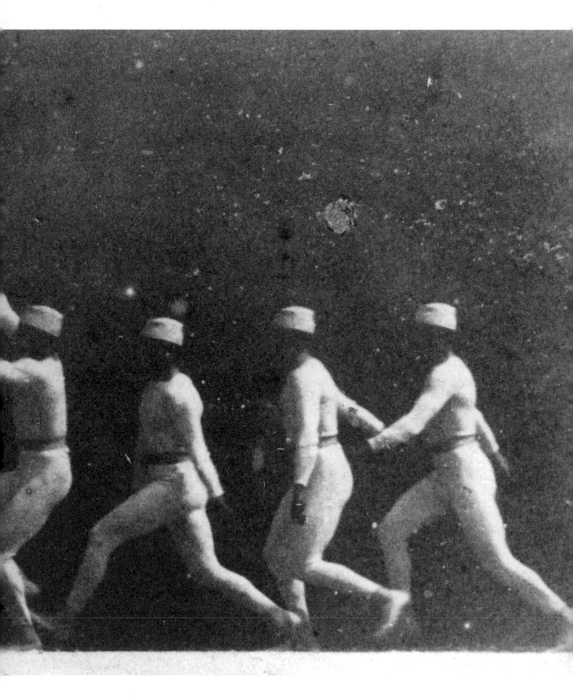

ABOVE: Étienne-Jules Marey considered his work on human movement, such as a man jumping a wall, to be scientific.

Thanks largely to Muybridge, interest in capturing motion photographically was increasing around the world. When he returned to the United States from Europe, he received a new commission from the University of Pennsylvania to continue his work under guidance from a committee of scientists, who hoped it might deliver new insights into diseases and dysfunctions of human movement.

Muybridge was now using four banks of up to forty-eight cameras which, by simultaneous electrical release, could photograph a subject from several angles.

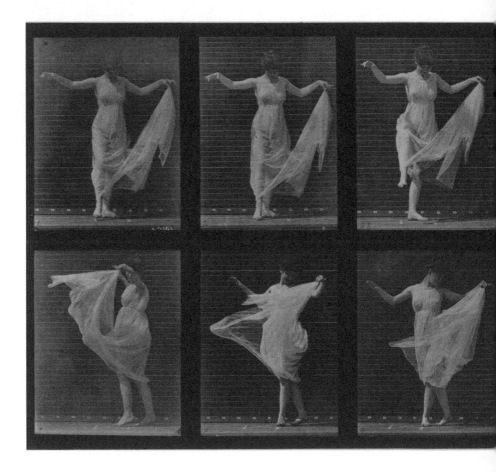

Between spring 1884 and autumn 1885, he produced 100,000 images of animals (from the local zoo), students and teachers (including himself). The photographic materials available by the mid-1880s were of much better quality and easier to handle than those used earlier, so that he could produce much more detailed images rather than 'mere silhouettes'. In 1887 he published the eleven-volume *Animal Locomotion: An Electro-Photographic Investigation of Consecutive Phases of Animal Movement, 1872–1885*, which sold for a staggering $600. It featured 781 plates of 19,347 individual images.

These images, while scientific in intent, were full of narrative interest. The models run, dance, chop wood, box and throw water

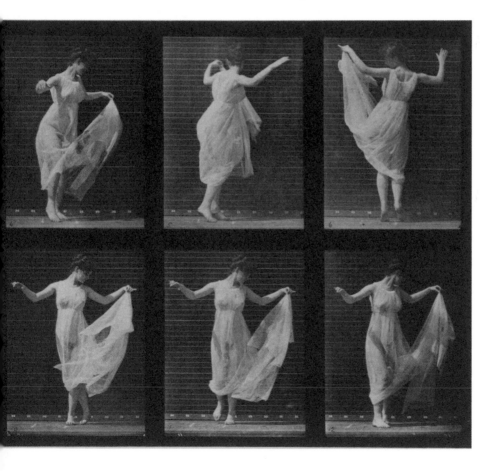

ABOVE: This sequence of a woman dancing shows how Eadweard Muybridge considered his audience's interest when taking photographs.

over each other. They also reflect the gender and social stereotyping of the time: younger, unmarried females appear naked, while older, married women of some social standing are always clothed.

These are not – and were not intended to be – fully objective records. Like any other photographer, Muybridge edited and manipulated his original material: frames would be left out or replaced with others, sometimes simply because negatives had been lost. Muybridge was quite open about this intervention, evidently seeing nothing amiss in it.

In 1889 Muybridge appeared at the Royal Society in London, to great acclaim, with a lecture called *The Science of Animal Locomotion in Relation to Design in Art*. 'When the animals were shown on the screen in actual motion it "brought down the house",' one viewer recorded. 'Nothing could be better.' Muybridge was using his Zoopraxiscope for displaying moving images, with an artist under his direction painting sequences of silhouettes on glass discs, but already it was being superseded by projectors that used true photographic images rather than hand-drawn ones. At the 1893 World's Fair in Chicago he exhibited a Zoopraxiscope specially built for an estimated $6,000, but it did not prove such a draw as he had hoped – perhaps by that time audiences had higher expectations of the entertainment available from the new techniques.

Muybridge eventually returned to his birthplace, Kingston-upon-Thames, having retired from active photography but continuing to lecture with his Zoopraxiscope. He also produced two more books, *Animals in Motion, an Electro-Photographic Investigation of Consecutive Phases of Animal Progressive Movements etc.* (1899) and *The Human Figure in Motion, an Electro-Photographic Investigation of Consecutive Phases of Muscular Actions* (1901). Muybridge died in Kingston on 8 May 1904.

A CONTRADICTORY PROJECT

The work of Muybridge and his contemporaries testifies to our desire to freeze a moment in time – for posterity, for scientific examination, for art or for entertainment. At the heart of this desire is a contradiction. We want to represent movement as it happens, while

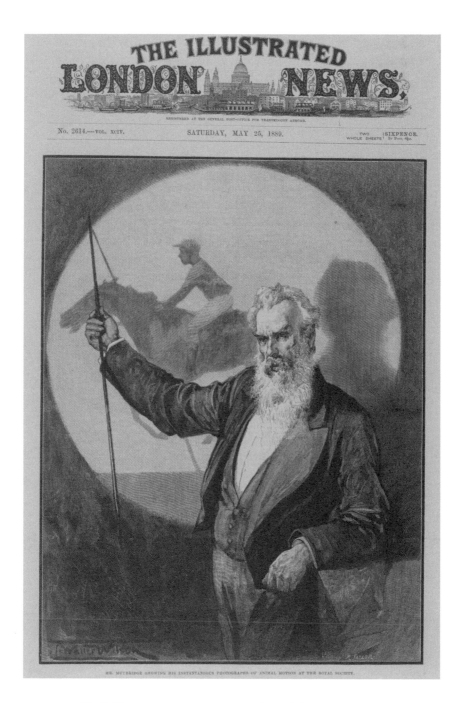

THE ILLUSTRATED
LONDON NEWS.

REGISTERED AT THE GENERAL POST-OFFICE FOR TRANSMISSION ABROAD.

No. 2614.—VOL. XCIV. SATURDAY, MAY 25, 1889. TWO {SIXPENCE
WHOLE SHEETS} By Post, 6½d.

MR. MUYBRIDGE SHOWING HIS INSTANTANEOUS PHOTOGRAPHS OF ANIMAL MOTION AT THE ROYAL SOCIETY.

ABOVE: Muybridge was a showman, presenting his instantaneous
photographs of animal motion at the Royal Society in 1889.

at the same time bringing that moment to a standstill so that it can be analysed and understood. What kind of 'truth' is captured by such techniques, if they show things that can never be directly experienced? The *British Journal of Photography* pinpointed that dilemma when it stated in 1882 that 'artistic truth is not necessarily mathematical truth'. The artist's goal is not simply to strive for realism or scientific accuracy – as art more broadly was starting to illustrate.

Despite this paradox, or perhaps because of it, Muybridge and Marey had a direct impact on other artists, most notably their contemporary Edgar Degas. Degas had painted many equestrian canvases by the time *Animal Locomotion* was published, but on the whole he chose not to depict horses at full gallop. Muybridge and Marey may well have changed Degas' attitude towards painting movement: in a notebook of 1879 the painter mentioned *La Nature*, the French journal where Muybridge and Marey's photographs were published, as well as the two men's names. It is possible that he was among those present at a lecture Muybridge gave at Marey's home in Paris, and he is known to have produced drawings from Muybridge's photographs of horses. Some of Degas' late pastels showing the sequential movement of dancers, such as *Three Dancers, Landscape Scenery* (1893–95), seem to bear the imprint of the photographic studies of the time.

Marey's influence can also be seen in some avant-garde works of the early twentieth century, such as Giacomo Balla's 1912 painting *Dynamism of a Dog on a Leash* and Marcel Duchamp's *Nude Descending a Staircase, No. 2*. One is a work of Italian Futurism, the other of French Cubism, but they both show moving objects as a superposition of limbs or figures at different moments.

Decades later, in the 1950s, Francis Bacon responded very differently to Muybridge's impersonal photographs, in work that played on and drew out the hidden sexual or spiritual lives of the photographer's anonymous subjects. Some of Bacon's paintings directly 'quote' individual frames from Muybridge's series, taken out of context by being cut from books. In *Figure with Left Arm Raised (No. 1)*, probably painted in the late 1950s – a direct quotation from a fencing sequence in Muybridge's *The Human Figure in Motion* – Bacon

seems fascinated by the physical suspension and contortion, the stress on the body, that Muybridge depicted. Bacon also reads a homoerotic charge into Muybridge's nude models – in *Two Figures* (1953), for example, the wrestlers photographed by Muybridge become figures in embraces and postures of what look like gay sex. Sometimes Bacon places these figures in what appear to be 'cages', recalling the metric grids in Muybridge's photographs.

As well as influencing generations of artists, Muybridge made the first successful analysis of motion by photography, and projected the first motion picture. His work, and the work of his associates such as Marey and Ottomar Anschutz, was a direct stimulus to the pioneers of cinematography such as Thomas Edison. He anticipated not only today's motion-capture technologies but the popular cinematic trope of mutable time, from the slow motion of martial-arts and action films to the speeded-up 'bullet time' of the *Matrix* movies.

10

Celebrating Speed: Mobility and Modernity

We have had many pleasures in the way of
travelling, but we have never yet experienced such
exhilarating enthusiasm or such complete recreation.
What once was impossible has become possible, and
distance is no longer the barrier to the refreshment of
country life or contact with kindred spirits.

CYCLIST, 1895

The end of the nineteenth century was marked by a series of spectacular inventions: the telephone, radio, cinema, aeroplanes, high-speed vehicles. Not only did they transform notions of time, distance, speed and mobility, these technologies also started to erode gender and class barriers. Yet of all the age's innovations, it was the humble bicycle that probably had the greatest impact. It became a joyful symbol of the new modernity, offering not just physical but also social mobility. Bicycles challenged the strict hierarchies of the late Victorian period: for the first time, women and the working classes could go to places they hadn't been able to reach before, enjoying an independence of travel previously restricted to the wealthy.

Cycling wasn't just for fun. In the new towns and cities, people needed to travel longer distances to work than they could easily cover on foot, and the bicycle became a vital means of transport for the commuting classes. It also became a symbol of progress, and it

was associated with 'radical' women such as those campaigning for suffrage (who were commonly ridiculed for their new fashions and freedoms).

Society was in flux, and the extraordinary pace of change was quickly reflected by writers and artists across Europe and America. The bicycle was one of the icons of this transformation.

DESIGNING SAFETY

Early bicycle designs weren't for the faint-hearted. There was good reason why the 'velocipedes' developed in France by Pierre Michaux and Pierre Lallement, lacking any suspension and with iron-shod wooden wheels, were known as 'boneshakers'. And the penny-farthing, with its high front wheel, demanded impressive feats of balance. Introduced in the 1860s and 1870s, these devices showed that fast human-powered transport was possible, but it's no surprise that their appeal was confined to rather daring riders with an appetite for races and competitions. In this first wave of adventurous enthusiasm, velodromes were built in towns and cities across Europe and the United States, and hundreds of cycling clubs sprang up.

But it was only when the 'safety' model was designed, and when bicycles became more affordable, that they became a technology of the masses. The 'safety' bicycle was the culmination of thirty years of experimental design, mainly in France and Britain. It brought the rider closer to the ground by using two similarly sized wheels, and it was more stable, thanks to a chain-driven rear-wheel drive and the placement of the passenger seat more or less directly above the pedals – features of most bicycles today. Later designs had pneumatic tyres, which made the ride much smoother.

The development of the safety bicycle drew on contemporary advances in engineering and metallurgy, using ball-bearing rotors, suspension wheels and light steel tubing for the frame. So bicycle manufacture gravitated towards centres where these techniques and materials, and the skills to use them, were already in good supply – chief among them Coventry, which became the heart of the British bicycle industry. The city already had a skilled labour force, thanks to

its silk-weaving and sewing-machine industries, and some of this industrial equipment could be adapted to bike manufacture. It was here, in 1885, that the inventor John Kemp Starley patented his improved Rover safety bicycle – the first commercially successful model.

Starley, a Londoner, had excelled at mathematics and engineering at school, and aged eighteen had moved to Coventry to work with his uncle James Starley, building cycles for the Ariel company. After working for several other bicycle manufacturers, he started his own company with support from cycling enthusiast William Sutton – and it was at Starley and Sutton Co. that he designed the Rover. It was a huge success, providing a template for safety bicycles across the world that still influences bicycle design today.

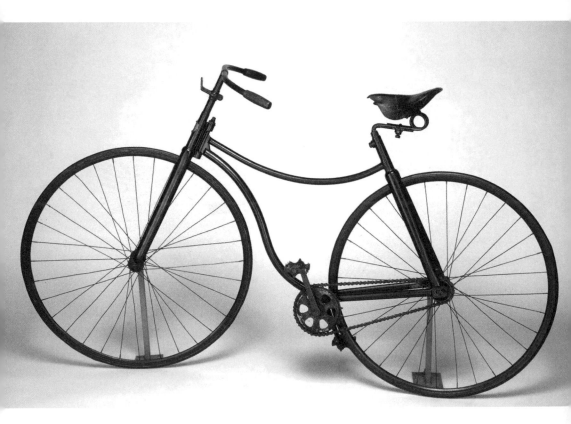

ABOVE: John Kemp Starley's Rover 'Safety' model changed the course of bicycle development, setting the trend for technical developments and commercial production.

Cycling was initially the preserve of the aristocracy, since they were the only ones who could afford expensive, custom-made bicycles and tricycles. Well-to-do young men and women showed off their new toys in public parks, and paid for private lessons to master the wheeled machines. Tricycles were aimed at elderly people – and at women, whom they enabled to escape their stifling everyday environments and explore new social spaces: as one historian puts it, 'the tricycle was not so much used by women to go somewhere, but rather to get away'.

As bicycles became cheaper and more readily available, they were no longer an exclusive plaything of the rich. With hundreds of manufacturers competing to market a range of designs (including tricycles and tandems), the rise of mass production and the emergence of second-hand markets, bicycles became affordable to women and the working classes. The result was a bicycle boom right across Europe in the 1890s – with implications for more than physical travel. These were not lost on *The Times*, which commented in 1892 that 'there is no question that the bicycle is a social boon – one might almost say in some respect a social revolution'.

Travel writers used the bicycle to explore. The husband-and-wife team Joseph and Elizabeth Robins Pennell, for example, wrote about and illustrated their trips around Canterbury, France and Italy in the 1880s and 1890s. Cycling journeys weren't constrained by train timetables and didn't incur the expense of keeping or hiring horses. Men and women would travel alone or in groups, creating more parity between the sexes and relaxing gender norms. Bicycles also had everyday uses, enabling people to travel further and more easily between work and home, or to transport goods and deliver services.

Starley himself was keen to point out the extra power the bicycle gave its rider. In an 1898 paper for the Royal Society of Arts he explained (using a little artistic licence) that 'cycling gives to the cyclist, in point of speed or distance, what is equivalent to three pairs of legs, as it enables a man to travel three times as far as he can walk, for if he can walk three miles within the hour, he can cycle nine miles within the hour, with much the same expenditure of energy'.

The bicycle boom coincided with the women's suffrage movement sweeping across the Western world, and cycling featured strongly in these campaigns for social change and equal rights. The American civil rights leader Susan B. Anthony wrote in 1896: 'I think [the bicycle] has done more to emancipate women than any one thing in the world. I stand and rejoice every time I see a woman ride by on a wheel. It gives women a feeling of freedom and self-reliance. It makes her feel as if she were independent.' Cycling in full dress, petticoats and long skirts could be uncomfortable and dangerous; so bloomers and convertible clothing were designed to make it easier. Such fashions, of course, challenged Victorian ideas of femininity, prompting opponents of social change to disparage 'militant feminist' cyclists. Critics, including doctors, claimed that cycling was dangerous for women – that it could encourage inappropriate sexual liberation and damage women's bodies, specifically their child-bearing capacity. Yet female cyclists persisted in the face of such criticism.

For writers and artists, many of whom were enthusiastic cyclists, the bicycle came to embody the modern age. To Arthur Conan Doyle, Ernest Hemingway and F. Scott Fitzgerald, bicycles epitomized mobility, social progress, new ideas. The American essayist

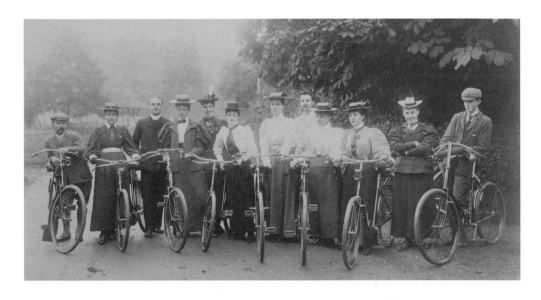

ABOVE: The bicycle became a symbol for the emancipation of women, offering new freedoms and greater mobility. Bicycle clubs, like this group in Chelmsford, sprang up around the country.

Christopher Morley claimed that 'the bicycle surely, should always be the vehicle of novelists and poets'. H. G. Wells, another cycling enthusiast, captured this sense of liberation in his 1896 novel *The Wheels of Chance: A Bicycling Idyll*. His protagonist Mr Hoopdriver, a shop worker from London, sets off on a bicycle holiday along the south coast of England. He feels released from his working-class status, noticing how gentlemen passers-by greet him as if he were one of them. Riding a bicycle is an act of emancipation; Wells is said to have remarked that 'every time I see an adult on a bicycle I do not despair for the future of the human race'.

CELEBRATING THE MACHINE AGE

The love of speed that welled up around the turn of the century is reflected most clearly in the Italian Futurist movement. Futurism was influenced by new technology, growing nationalism and the avant-garde culture spreading across Europe in the early 1900s. It was a highly politicized philosophy that rejected, even despised, Italy's traditional heritage. The Futurists believed that tradition held Italian culture back, whereas they longed to take it forward into a future shaped by technological advance. As the prime architect of the movement, F. T. Marinetti, proclaimed in his 1909 *Futurist Manifesto*, 'we declare that the world's splendour has been enriched by a new beauty: the beauty of speed. A racing automobile with its bonnet adorned with great tubes like serpents with explosive breath . . . a roaring motor car which seems to run on machine-gun fire, is more beautiful than the Victory of Samothrace.' For Marinetti, that famous marble statue of the messenger goddess Victory, carved in the second century BC and considered one of the glories of ancient culture, represented the antithesis of the Futurist ideology.

Marinetti presented his manifesto on the front page of the Paris newspaper *Le Figaro* on 20 February 1909. Its first statement declared that 'we intend to sing the love of danger, the habit of energy and fearlessness'. Such emotive language inspired several artists, including Giacomo Balla, Umberto Boccioni and Carlo Carra, to sign the 'Manifesto of the Futurist Painters' in 1910, and to call for

the 'triumphant progress of science' to pull Italy into the modern age. The group developed a radically new artistic vocabulary that reflected the twentieth-century experience of movement and dynamism. Over the next five years the Futurist ideology made its influence felt in all art forms – painting, sculpture, architecture, photography, film, music and more.

For all its iconoclasm, Futurism built on earlier artistic movements, including Divisionism, Impressionism, Symbolism and Cubism. The last of these, championed by Pablo Picasso and Georges Braque, challenged traditional concepts of time and space by representing several perspectives of objects simultaneously on a flat canvas. The Futurists added other dimensions to the Cubist approach, seeking also to convey movement and speed and to incorporate new technology. They were influenced by the high-speed photography of Eadweard Muybridge and Étienne-Jules Marey, which – as we saw in the previous chapter – captured human and animal movements in superimposed or sequential images. Balla, who had seen Marey's work at the 1900 Paris Exhibition, showed movement as superimposed postures, as in *The Hand of the Violinists* (1912), while Boccioni attempted to capture the essence of motion using colour and shade to highlight lines of force, notably in *The City Rises* (1910) and *Dynamism of a Cyclist* (1913).

Futurist art became increasingly abstract, often blurring the human form with machinery. That was, after all, just what the bicycle had done – Starley's design in particular aiming to couple human to mechanical motion as efficiently as possible, making the vehicle almost an extension of the body and giving the cyclist what he had called 'three pairs of legs'. Perhaps this is why bicycles appeared prominently in other Futurist works, including Natalia Goncharova's *The Cyclists* (1913) and Mario Sironi's *The Cyclist* (1916).

In Italy the 'safety' bicycle had been developed further at the end of the century by Edoardo Bianchi, who ran a small mechanical-repair shop in Milan. As in Britain, it became a symbol of personal mobility for the masses. During the Libyan war in 1911 it was also introduced as a military vehicle, and Bianchi won the contract to supply the Italian army. This conflict was celebrated by the Futurists,

and Marinetti went to the front line as a war correspondent. Other European countries, too, experimented with bicycle infantry – the machines were, after all, easy to manoeuvre and cheap to manufacture and maintain. Army cyclists had been involved in scouting, patrolling and supporting communications as far back as the Franco-Prussian War, and were also used in the Second Boer War and the First World War, although the bicycle's role, like that of the horse, has often been obscured by a concentration on tanks, motorcycles and other fuel-driven modern machines.

When Italy entered the First World War in May 1915, many of the Futurists were quick to volunteer for active service, and several joined the Lombard Battalion of Volunteer Cyclists and Motorists. But now their bellicose rhetoric was confronted with the true horrors and dangers of war. Boccioni was killed in August 1916, thrown off a horse while training with an artillery regiment near Verona. By the end of 1916, many of the key figures had died or left the movement, and the first period of Futurism came to an end. Unsurprisingly, given its ideological slant, it resurfaced with the rise of Mussolini; indeed, Marinetti contributed to the *Fascist Manifesto* and continued to advocate a Futurist ideology until his death in 1944.

After the First World War, the bicycle was replaced in the popular psyche by new symbols of modernity. Cars and aeroplanes promised faster speeds and more exhilarating experiences. Bicycle manufacturers continued to produce pedal-powered vehicles but also expanded into motorized technology. The bicycle was now no longer 'modern' but mundane. All the same, it remained the most popular form of transport until the 1960s, when the motor age finally delivered on its early promise.

Yet the bicycle has never been wholly eclipsed, and with growing concerns about the environmental impact of the internal combustion engine there is now another resurgence in its popularity. In a national survey in the UK in 2005, the bicycle was voted as the greatest invention of all time. Whatever else such polls might mean, that one surely attests to our enduring affection for this human-powered machine.

ABOVE: *Dynamism of a Cyclist* demonstrates Umberto Boccioni's use of lines to convey speed and movement through time and space.

11

Rejection of Rationality: Art as Protest

The beginnings of Dada were not the beginnings of art, but of disgust.

TRISTAN TZARA, 1922

The First World War traumatized Europe. The mass slaughter it inflicted called into question the very existence of a supposedly civilized society. There was talk of existential crisis, a feeling that nothing could be taken for granted and that the early twentieth century had undermined the calm certainties of the nineteenth. Was this really where the supposed Age of Enthusiasm had led us?

The movement begun at the Cabaret Voltaire nightclub in Zurich in 1916 reflected this mood of uncertainty and disjunction. It was here that the avant-garde performers Emmy Hennings and Hugo Ball created Dadaism – beginning, so the story goes, with the symbolically violent act of stabbing a knife randomly into a dictionary to choose a name.

Ball, in his *Dada Manifesto* of 1916, implied that 'dada', an internationally recognized word with a variety of meanings in a variety of languages, should not be assigned any single definition; it is transient, malleable, placeless. The movement was equally fluid and international, exerting a powerful influence over artists in cities from Berlin, Hanover and Cologne to Paris and New York. What these groups shared was a commitment to the irrational, the unexpected and the inexplicable in art, and a rejection of the

senseless death and destruction they had witnessed. Hans Arp, co-founder of the Cologne Dadaists, wrote that, 'revolted by the butchery of the 1914 World War, we devoted ourselves to the arts. While the guns rumbled in the distance, we sang, painted, made collages and wrote poems with all our might.'

DADA AS TRAUMATIZED NATION

The collective experience of devastation inspired Dadaist art forms ranging from performance art to sound poetry, sculpture, painting and collage. The aesthetic aspects of the work took second place to the concepts it communicated; art, Ball said, offers 'an opportunity for the true perception and criticism of the times we live in'. Dadaists were experimental, provocatively re-imagining what art and artistic production can and should be. Using unorthodox materials and chance-based processes, they infused their work with irreverent spontaneity. Dada was a dynamic intellectual revolt, and its tools were humour, parody and self-aware irony – all underpinned by the belief that the only sanity in the face of such a lunatic world was unreason.

You can understand why. The First World War claimed the lives of more than ten million soldiers and an estimated equal number of civilians; over twice as many were seriously injured in the conflict. This unprecedented loss of human life and health was a consequence of mechanized warfare, including technological innovations in weaponry, mass communication and transportation. On top of the devastation wrought by the war itself, the German economy was left in a fragile and dangerous state by the punitive settlement imposed on the country in the wake of its defeat in 1918.

By that point the Berlin Dada group had firmly aligned their aims with anti-war sentiment. Echoes of postwar trauma can be heard in the language of their manifesto: 'Life appears as a simultaneous muddle of noises . . . with all the sensational screams [of] its brutal reality . . . Dada is the great rebellion of artistic movements, the artistic reflex of all these offensives, peace congresses, riots.' Whether they fought in the trenches or escaped military service, an entire generation of German artists and writers was scarred by first-hand

experience of the brutality of the war. The Dadaists' outrage at the senseless slaughter led many to abandon the Expressionist, utopian imagery that prewar artists had favoured, and opt instead for violent and fragmented depictions of a mechanized society. The machine took on a new and horrifying presence. Berlin Dadaists saw the wondrous potential of modern technology as it penetrated everyday life, but they also recognized its dangers. Nowhere is this more potently expressed than in the work of Otto Dix, a key figure in Berlin-based Dadaism. For Dix, Berlin – the capital of the Prussian militarism that had driven the war – was now a victim, represented in his work as a marginalized and mistreated veteran of conflict, fractured by war in body and mind.

DADA AS MUTILATED BODY

More than two and a half million disabled or permanently injured soldiers returned to Germany from the battlefields, making disability and disfigurement more visible in public than ever before. In Britain, war wounds were a taboo subject, discussed openly only in medical contexts. But in Germany it was another story. Progressive and left-wing artists and writers, the Berlin Dada group among them, used disability caused by combat as a powerful symbol with which to denounce the military and capitalistic system that had failed them, exposing the hypocrisy behind the legitimization of war.

Otto Dix's painting *Card Players* (1920), often regarded as the most significant anti-war work by a German artist, shows three former soldiers disfigured almost beyond recognition, their damaged body parts replaced by fantastical versions of contemporary prosthetics. In reality, the men could not have possibly survived injuries like these. The soldier on the right uses his one remaining leg to hold his playing cards, since he has no arms. Two of the men have artificial jaws. These prosthetics are mixed up with chair legs, while the contortions of limbs are anatomically impossible, forcing the viewer to look closely to figure out how everything fits together, to determine what is human and what is lifeless – and to confront their feelings of disturbance or disgust at what they see.

Why are these old soldiers playing card games? What else can men so disfigured do? They are no longer able to be productive citizens in society. Disabled veterans were often marginalized and dismissed as 'welfare cases', treated as inferior by the bureaucracy. Germany's disabled veterans did in fact receive relatively generous benefits immediately after the war compared to their British counterparts; but they typically complained that their communities did not honour or respect their sacrifices, or help them to re-integrate into society.

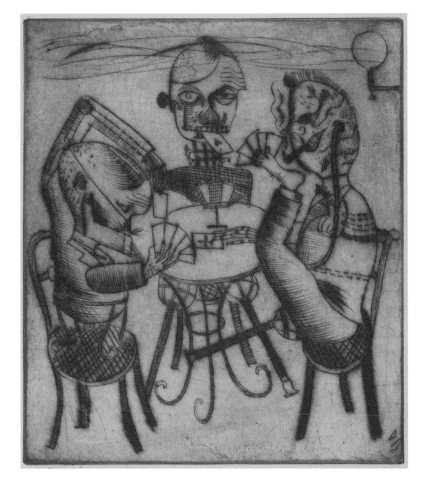

ABOVE: Otto Dix's *Kartenspieler* (*Card Players*) violently immortalizes the unprecedented horrors inflicted by mechanized warfare on the physical body and economic condition of German society.

Dix showed that war dehumanizes people. These characters have been stripped of their senses: they are deaf, blind and more machine than human. What other result could you expect from sending soldiers with archaic protection to face advanced weaponry? Technology rips them apart, and then technology patches up what remains.

DADA AS SOCIAL OUTCAST

Hostility towards disfigured war veterans – towards everyone and everything, indeed, that was deemed ill, disabled or ugly – was made worse by the development in the late nineteenth century of a national cult of health and beauty in Germany. Its impetus was utopian – the search for the ideal healthy body and lifestyle. Many people became vegetarians, nudists or body-builders; others turned to 'alternative' medicine. These ideals were not destroyed by the war, but when they resurfaced they came with darker connotations. There was a sense that that war had killed or damaged the healthiest young German men, sharpening prejudices against those deemed 'unfit'. Advocates of eugenics – the idea that 'bad genes' should be weeded out of society – were opposed to squandering national resources on individuals who were considered congenitally weak or inferior in some way. The tone was chillingly captured in the title of an influential leaflet published in 1920 by the psychiatrist Alfred Hoche and the jurist Karl Binding: *Permission for the Annihilation of Lives Unworthy of Life*. Newspaper articles complained of 'plagues of beggars' who offended the public with their very appearance.

Postwar Germany was the land of the Weimar Republic, presided over by an unpopular, weak and impecunious government. Urban living conditions were among the worst in Europe: cramped and unsanitary, they were hardly conducive to the rehabilitation of disabled veterans, who often had no choice but to resort to begging and appeals to charity. At the same time, presenting yourself as a former soldier was one way to win public sympathy (and thus larger donations), and an investigation by welfare officials in 1919–20 discovered many imposters driven to deceit through desperation.

OPPOSITE: Max Beckmann's print series *Die Hölle* (*Hell*) depicts the social disintegration and political chaos of Berlin immediately after the First World War.

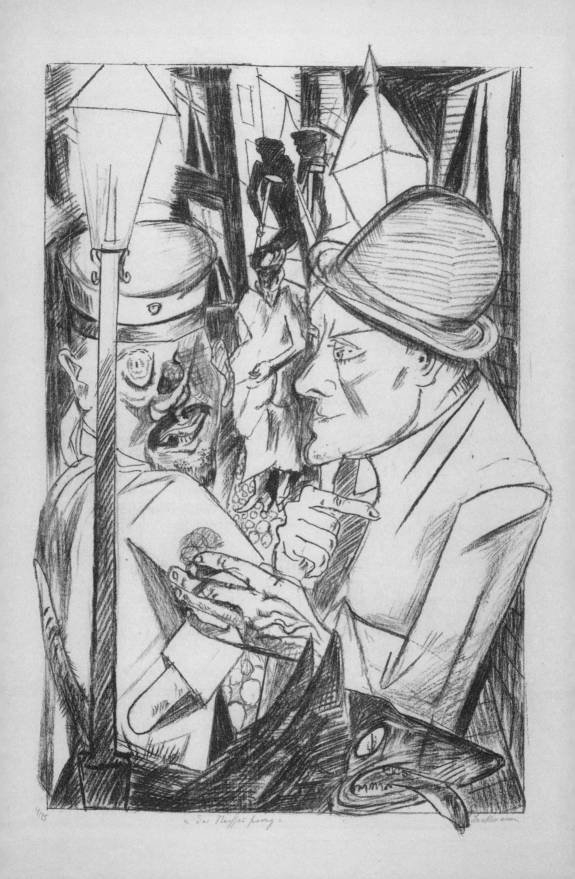

4/25 = Der Nachhauseweg = Beckmann

Most disabled veterans did not in fact have visible injuries; for many, the scars were psychological. But most of those depicted in art and literature displayed terrible disfigurations and afflictions: amputated limbs, grotesque facial wounds, bodies trembling from nervous shock. To serve their symbolic function, the injuries had to be readily apparent.

The language of the Dadaists was one of fragmentation, dismemberment, a literal breaking apart of social norms and taboos. They fractured conventional artistic modes of presentation, for example using montage, sound poems, photographs of everyday ephemera, 'ready-mades' (found objects repurposed as art), symbolic machine–human assemblages.

A series of ten lithographs by the Dadaist Max Beckmann, simply called *Hell*, presents postwar Berlin as a violent and lawless society in chaos. Here is the nightmare side of the modern metropolis, populated by rapists and syphilitics, prey to institutionalized violence and all the worst impulses of human nature. Beckmann confronts the viewers with this brutal reality to shock them out of their complacency. One image in this series, *The Way Home*, shows two figures beneath a street lamp: a veteran with a severely deformed face, and Beckmann himself, gripping the soldier's mutilated arm with one hand while pointing 'the way home' with the other. But how will this veteran, almost eyeless now, ever find his place at 'home' in the new Weimar society?

These prints were destined for private rather than public display, making it easier for their audience to assimilate messages contrary to the official patriotic propaganda. With their savage imagery, Dix and Beckmann were setting out to shock the bourgeois sense of propriety, and to expose the hypocrisy of a society that manufactured outrage at the eccentricities of their movement. What kind of civilization, they asked, gets worked up about the ultimately insignificant antics, provocations and obscenities of a few anarchic bohemians, while tolerating a war that had caused millions of deaths and untold suffering, great cities full of poverty, vice, violence and crime, and regimes in which the worst seemed able to rise to the top? Their art was crafted, and administered, as a kind of cathartic shock therapy.

Yet there *were* efforts to reintegrate the wounded back into productive labour – after all, the ailing German economy needed all the help it could get. The medical community recognized that prewar artificial limbs were all but useless in the workplace, and set out to design better versions. Doctors and engineers turned to the theories and practices of *Arbeitswissenschaft* (the scientific management of work), which regarded the human body as an animate mechanism that could be fine-tuned for efficiency and

ABOVE: Extensive home repairs demonstrate the lengths to which people would go to keep a limb they felt comfortable with – or when they could not afford a replacement.

made to work like – and alongside – industrial machinery (we'll return to these ideas in the next chapter). The development of artificial limbs concentrated on improved prosthetic arms rather than legs, since most professions did not require complex leg-work. In effect, disabled German soldiers were rebuilt, recycled and 'improved'.

Dix recognized that the machine was not the classless instrument of a better world, as Modernists liked to claim, but could become an instrument and symbol for the control of one group of people by another; a tool not only of militaristic authoritarianism but of profit-seeking capitalism. The prosthetic lower jaw of one of Dix's card players bears the label 'Lower jaw: prosthesis brand: Dix' – the person has been rebranded as product. In 1920 the Dadaist Raoul Hausmann published an ironic prose piece entitled *Prosthetic Economy: Thoughts of a Kapp Officer*, in which he asserted that Germany needed workers with prostheses because artificial limbs never tire, so they could work twenty-five hours a day.

Satire it may have been, but some people were seriously arguing at the time that prostheses for workers with missing limbs might be designed to maximize efficiency. By breaking down each job or profession into a series of requisite movements – along the lines of *Arbeitswissenschaft* – doctors could determine which particular functions a worker was unable to perform because of the loss of an arm, and then develop a 'work-arm' that could accomplish them. Thus prosthetic design depended on one's class and occupation. One popular labourer's arm – the Siemens Arm – physically bound disabled bodies to their machinery to ensure efficient, smooth production. White-collar workers who worked predominantly with the head rather than manually might be given a non-functional 'cosmetic' arm. The Carnes Arm, meanwhile, enabled the wearer to perform more precise movements such as 'tying a necktie, picking up coins from a flat surface, riding a bicycle and taking banknotes out of a wallet'. It was expensive to buy and maintain, so this was a 'middle-class' arm.

We can therefore read Dix's *Card Players* as card-playing man-machines, compelled to keep on playing their game the way they

OPPOSITE: This disabled German soldier wears a special prosthetic arm fitted with a tool for carpentry work.

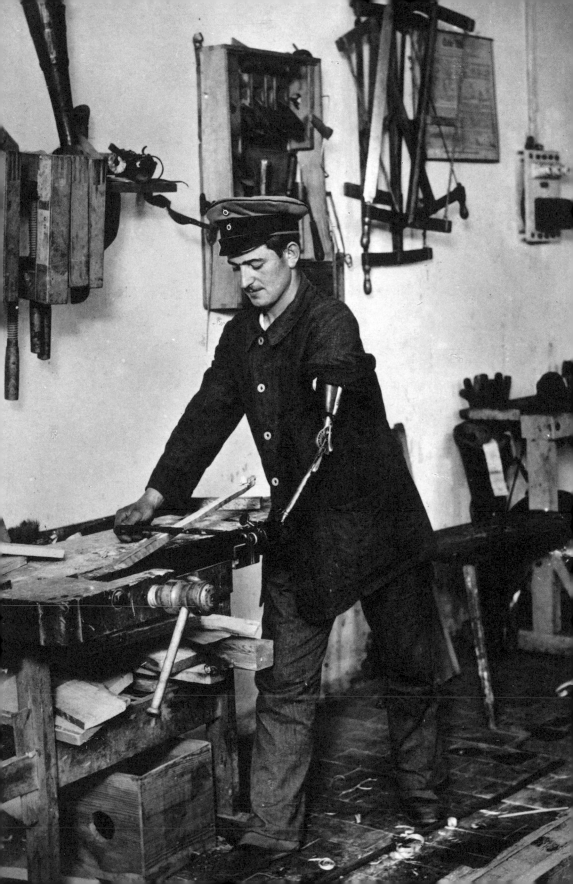

have always played it – much as societies might be compelled to go on fighting wars in the way they always have. It was a merciless image of grotesque, repellent men who had learned nothing from their war experiences, indistinguishable from the militarists, industrialists and bourgeoisie who had brought about the war and the ensuing social chaos.

DADA AS REMEDY

It was perhaps the French painter Francis Picabia – one of the key figures in introducing Dada to New York – who made the most extensive use of machine imagery. In works such as *Alarm Clock* (1919) – a deadpan and somewhat abstract representation of the cogs and springs of clockwork – he offers a sardonic comment on the mechanization of human life in the modern world and the ultimate absurdity of the machine. The machine, he said, had changed from a 'mere adjustment [to] the very soul' of human life.

The Irish scientist John Desmond Bernal, who took a close interest in the social role of science, wondered whether the replacement of human body parts by machinery might not even need to wait for the opportunities provided by war injuries. We might, he wrote in 1929, eventually get rid of 'the useless parts of the body' and replace them with mechanical devices: artificial limbs and sensory devices that would do a much better job. In the end this cyborg existence would mutate into a kind of 'brain in a vat' hooked up to a distributed system of engineered devices in lieu of a body:

> Instead of the present body structure we should have the whole framework of some very rigid material, probably not metal but one of the new fibrous substances. In shape it will be rather a short cylinder. Inside the cylinder, and supported very carefully to prevent shock, is the brain with its nerve connections, immersed in a liquid of the nature of cerebro-spinal fluid, kept circulating over it at uniform temperature. The brain and nerve cells are kept supplied with fresh oxygenated blood through the arteries and veins which

connect outside the cylinder to the artificial heart–lung digestive system – an elaborate, automatic contrivance.

Presented without irony, this suggestion would have confirmed the worst fears of the Dadaists. For the disillusioned artists of the German Dada movement, the war confirmed that the nation was in the grip of corrupt and nationalist politics, repressive social values, and unquestioning conformity of culture and thought. The Berlin Dadaists in particular regarded their government as a machinery of the state that trampled the spirit and left people exposed to exploitation, their bodies disposable or replaceable. Machines destroyed and dismembered people, but 'progress' in prosthetic technologies and improvements in the efficiency of modern production methods meant that disabled veterans could be plugged back into the machine as optimized new parts. Was technological advance an instrument of oppressive destruction and confinement or a liberating force? The question would be a constant source of political and cultural tension.

12

Humans in the Industrial Machine: Smokestacks in Salford

I look upon human beings as automatons . . .
because they all think they can do what they want but
they can't. They are not free. No one is.

L. S. LOWRY, 1970

As Britain was transformed by industrialization in the late eighteenth and nineteenth centuries, artists, writers and social commentators began to wonder where the boundary lay between human and machine. New methods for increasing the efficiency of industrial workers, and for measuring and standardizing their labours, made the workers themselves objects of scientific study. Ever since the mechanization of the cotton mills, people working in factories had come to seem increasingly like cogs in a machine. Where was this dehumanization heading?

L. S. Lowry's 1922 painting *A Manufacturing Town* showed one answer. As smoking chimneys blacken the pale sky, uniform dark-clad figures scurry by or stand rigidly in the street like robots (the Czech word, meaning 'labourer', had first been used to denote an artificial humanoid by Karel Capek just two years earlier). This was one of Lowry's first works to receive public recognition, being featured in a supplement of the *Manchester Guardian* for Manchester Civic Week in 1926. That event was arranged by the Manchester Corporation in part to promote workers' pride in their city and to engage the electorate during the politically volatile period following

the General Strike earlier that year. But what sort of message did Lowry's picture send out to the workforce?

THE INDUSTRIAL LANDSCAPE

Lowry produced a huge body of work over almost six decades, focusing largely on the industrial scenes he observed in and around his home town of Pendlebury in Salford. Factory chimneys loom large in these paintings, drawing out smoke from the furnaces of the steam engines that drove machines for spinning cotton, weaving cloth and forging metal. These 'Lowryscapes', recognizable at a glance from their muted palette and naive style, have come to serve as enduring symbols of Britain's industrial heritage.

Yet there is no consensus on the attitude to industrialization that they depict. Some see them as a record of catastrophic change, in which destruction of the landscape and environment goes hand in hand with a crisis in public health in the industrial towns and the reduction of the human to mere mechanism. Seen through this lens, they capture the downside of the industrial revolution described by Arnold Toynbee in the 1884 work that coined the term: 'Side by side with a great increase of wealth was seen an enormous increase of pauperism; and production on a vast scale, the result of free competition, led to a rapid alienation of classes and to the degradation of a large body of producers.'

But by the early twentieth century the world of Lowry's paintings – of smokestacks and workers hurrying to and from the great mills – was in fact a world on the wane. Lancashire's skyline had begun to erupt with smoking chimneys and towering cotton mills a century and a half before Lowry picked up a paintbrush. Some of his largest-scale works of the 1950s, made as Britain's manufacturing sector went into decline, show a decaying industrial infrastructure left over from Manchester's heyday. So perhaps, some say, Lowry's urban landscapes and street scenes are nostalgic, even romantic, observations of a way of life lost along with Britain's industrial supremacy.

Some people have focused on the loneliness and isolation they see in Lowry's paintings: the figures often seem disconnected from one

OVERLEAF: *A Manufacturing Town* by L. S. Lowry. Such 'Lowryscapes' have become enduring symbols of Britain's industrial heritage.

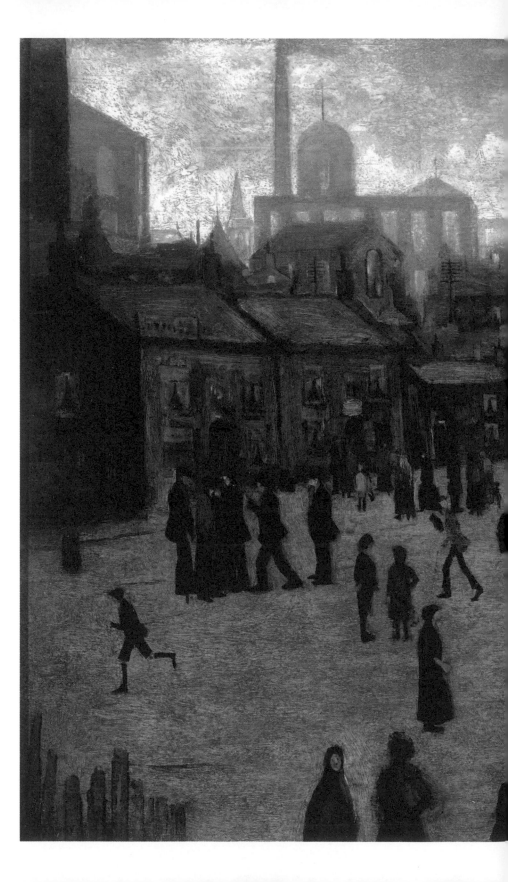

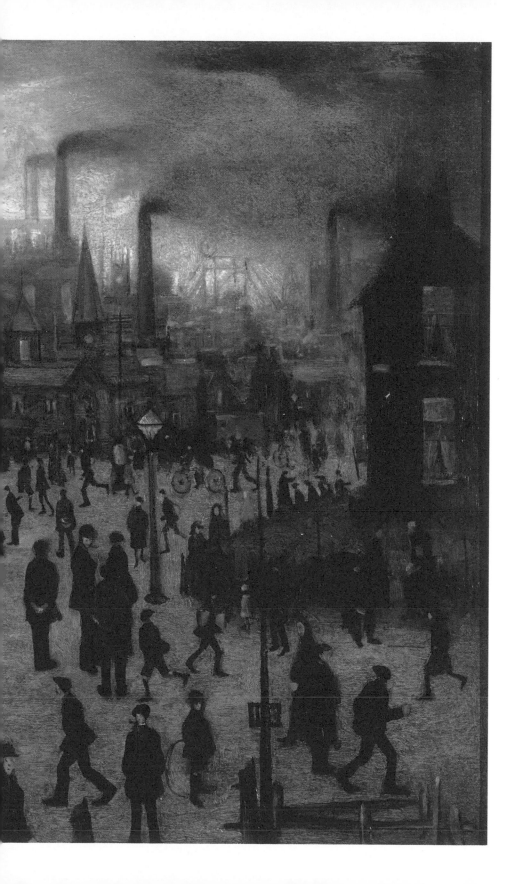

another, despite their physical proximity, and the viewpoint of the painter himself is that of an outsider observing from the fringe. Others see the works as political commentaries on the social impact of industrialization, exploring issues of labour and class more than dehumanization and squalor. The critic Howard Spring says that 'his pictures evoke for me the whole tragic sense of frustration that the Industrial Revolution clamped upon the land'. Marxist art historians T. J. Clark and Anne M. Wagner, curators of the 2013 retrospective of Lowry's work at the Tate, argue that his paintings portray the 'whole cramped pattern that the new industrial technology wove into workers' lives'; and another Marxist art critic, Francis Klingender, even claimed that, by showing the effects of industrialization, Lowry was hoping to 'inspire the struggle against the system responsible for them'.

Then there are those who insist that Lowry had no sense of political mission, only a desire to represent scenes that others had dismissed as unworthy of attention. Lowry himself said of his work that 'my ambition was to put the industrial scene on the map, because nobody had done it, nobody had done it seriously'. He was an enigmatic figure who left us few clues about his intentions; and his paintings remain just as ambiguous.

Having said all that, it's hard to get away from the sense of these undifferentiated, sketchily painted workers as ants, or drones, or mere machine parts – or, as novelist Jeanette Winterson has put it, 'clones for the industrial machine. Units. The means of production.' They show, Winterson says, 'what happens to a human being when they are forced to couple with the machine'. The theme of repetition and uniformity is emphasized in the rows of identical mill windows and identical terraced houses – in fact, one can even argue that every Lowry painting looks very much like the others.

The impact of mechanization on people was a cause of concern right from the dawn of the machine age. James Phillips Kay entitled his 1832 book *The Moral and Physical Condition of the Working Classes Employed in the Cotton Manufacture in Manchester,* and wrote in it of the masses of textile mill workers 'yoked together with iron and steam . . . chained fast to the iron machine which knows no weariness'. 'When the engine runs,' he declared, 'the people must

work.' For Kay, the factory operative's life was one of dull, unending drudgery and incessant mechanical repetition. Friedrich Engels' polemic against the injustices of capitalism, *The Condition of the Working Class in England in 1844*, described the physical and mental strain on mill workers who toiled repetitively at the machines' pace. Engels saw factory employment not as real work but as 'tedium, the most deadening, wearing process conceivable'.

THE RHYTHM OF WORK

One of the most striking aspects of industrial labour was the tyranny of the rhythm set by the factory machine. Winter or summer, rain or shine, dark or light, it was not the season of the year or the time of day but the factory clock that told workers when to work and when to rest. Mechanization brought about a complete transformation in the relationship between work and time. The factory clock is a constant presence in Lowry's paintings; there it is in *Going to Work*, *Coming Home From the Mill* and in *Early Morning*, looming like a dictatorial master above the sprawling, scurrying crowds.

Charles Dickens' *Hard Times*, published in 1854, is one of the most direct and memorable fictional responses to the industrial age. The author's description of its setting, Coketown – a place of 'machinery and tall chimneys, out of which interminable serpents of smoke trailed themselves' – could almost be a description of a Lowry painting. The town's workers toil monotonously, day in, day out, treated by factory owner Mr Bounderby as machines without agency or feeling. In Samuel Butler's utopian 1872 novel *Erewhon*, machines have been outlawed because of the threat they posed to humanity, and all mechanical progress has been halted. In the town of Erewhon there is a museum that displays what remains of the industrial age: cases full of broken machinery, 'fragments of steam engines, all broken and rusted . . . a cylinder and piston, a broken fly-wheel, and part of a crank'.

Erewhon gets a mention in a 1921 article in *The Engineer*, one of Britain's foremost technical journals covering developments in manufacturing and industry. The article does not accept the simple

'catastrophic' account of industrialization, which had by then become unfashionable. Its concern was instead with the rise of 'scientific' management techniques, which the author deplored as destructive of workers' well-being and as stultifying to their minds and bodies – just as the machines themselves were in Butler's novel.

This approach to management began in the 1890s in the United States, and one of its leading proponents was the mechanical engineer Frederick Taylor, who argued that industrial efficiency could be improved by treating industrial processes scientifically. For example, Taylor broke down each job into its component parts and timed each with a stop-watch, then rearranged them in the most efficient sequence. Meanwhile, engineers Frank and Lillian Gilbreth studied the motions involved in a task, often by photography, and considered how their number might be reduced. The 'time-and-motion study' was born.

Many British firms, worried about the country's industrial performance in the early twentieth century, began to implement these allegedly scientific management practices. Their employees weren't impressed. Reporting in 1934 on a strike of 700 wireworkers at the Manchester engineering firm Richard, Johnson and Nephew following the introduction of methods to measure their productivity, the *Manchester Guardian* said that workers found the system 'antisocial'. 'I seemed to break into a cold sweat and my nerves shook,' said one after being observed in this way. The secretary of the International Federation of Textile Workers Associations claimed that time studies like this would 'make the workers merely a machine'. The techniques shifted control of production from shop-floor workers to management, and critics objected that they curbed workers' skill, initiative and agency, reducing them to mere units of production.

Despite all objections, scientific management remained in vogue for decades, and can still be found in some industries. In 1974, Richard, Johnson and Nephew commissioned artist Geoffrey Key to make crayon drawings depicting company employees at work operating machinery to produce barbed-wire and chain-link fences. Around this time the company attributed a 57 per cent rise in profits to improved factory efficiency. Key's images are ambiguous: an

artistic celebration of industrial labour, they also bear the legacy of the controversial time-and-motion studies and show the workers as faceless and almost robotic.

THE PRODUCTIVE HUMAN

As the new science of psychology became prominent in the early twentieth century, some efforts to improve industrial efficiency did acknowledge the human dimension of workers. Industrial psychology, which gained momentum in Britain in the 1920s and 1930s, was keen to distance itself from the scientific management movement. Charles Myers, an experimental psychologist who founded the National Institute of Industrial Psychology in 1921, claimed that industrial efficiency could be achieved with principles that aimed 'not to press the worker from behind, but to ease the difficulties which may confront him'. Industrial psychologists argued that changes in working patterns should be based on the scientific study of the relationship between the individual and the job, so that not only productivity but also worker satisfaction could be optimized. Rather than trying to make humans work like machines, industrial psychologists wanted to study workers as humans.

In 1922, Rowntree's Cocoa Works became the first firm in Britain to employ an industrial psychologist – Victor Moorrees. Founded in 1862 by the Quaker Joseph Rowntree, the firm had always had a paternalistic approach to business which emphasized the industrial and social contract between employer and worker. Joseph Rowntree believed passionately in the welfare of his workforce. Employees, he said, should 'never merely be regarded as cogs in an industrial machine, but rather as fellow workers in a great industry'. He transformed the small cocoa business into a major confectionery manufacturer, and as the firm grew it implemented formal policies of industrial welfare. Many of these, including the pension scheme and the eight-hour working day, were championed by Joseph's son Benjamin Seebohm Rowntree.

Seebohm Rowntree even created a psychological department at the works. A scientifically minded man himself, he had studied

OLD
METHOD.

1. Hands to
Stamp

2. Stamp down.

3. Release stamp, catch buds,
drop them into box

NEW.
METHOD.

1. Hands to
Stamp

2. Stamp down

3. Stamp up slightly

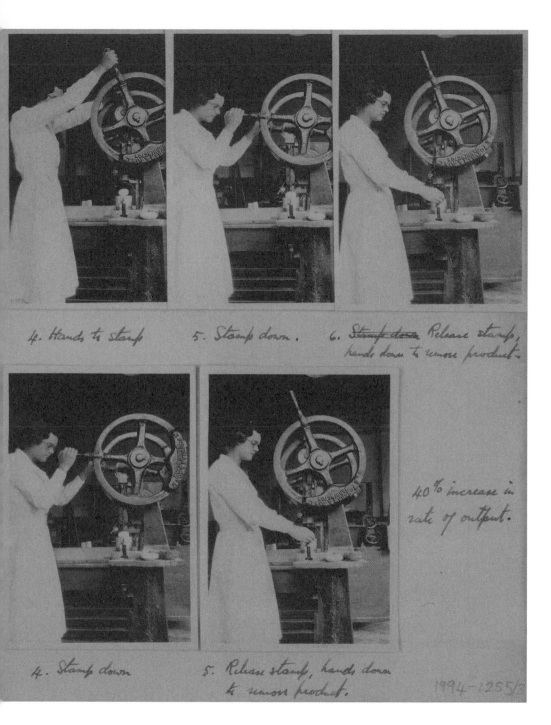

4. Hands to stamp

5. Stamp down.

6. ~~Stamp down~~ Release stamp, hands down to remove product.

4. Stamp down

5. Release stamp, hands down to remove product.

40% increase in rate of output.

1994-1255/2

ABOVE: A female worker operates a hand press. This motion study is said to have increased productivity in such work by 40 per cent.

chemistry at Owens College in Manchester and then headed the Welfare Department at the Ministry of Munitions, set up in 1915 to advise on industrial fatigue and conditions affecting the efficiency of workers in munitions factories during the First World War; and it was there that he first became interested in scientific management theory. He believed that improving the welfare of workers was not only morally right but could also increase industrial efficiency, as well as ease the industrial unrest that arose in Britain after the war's end.

Seebohm Rowntree became chairman of the family firm in 1923, heralding a period of experimental industrial management at the works. That year, he claimed that Rowntree's administration combined humanity with management science, in pursuit of both efficiency and welfare. Yes, Rowntree workers were trained in methods that allegedly removed barriers to efficiency; but before they were even employed, psychological testing was used in the selection process to identify individuals deemed more likely to be happy in their work – and therefore more productive. In the early 1920s, Moorrees devised wooden 'formboards' into which cut-out, coloured wooden shapes could be slotted. Applicants were tested to see how many pieces they inserted in the correct sequence in three minutes – an indication, it was thought, of their aptitude for chocolate packing. By 1932 the industrial psychology department had tested nearly six thousand potential chocolate packers using the test, which remained in use for three decades.

In 1930 Rowntree's appointed Nigel Balchin, an industrial investigator at the National Institute of Industrial Psychology, to work alongside Moorrees. Balchin changed packing methods to eliminate chocolate waste, and demonstrated that packing by hand worked better than automated, conveyor-belt processes. These experiences fed into Balchin's first novel, *No Sky*, in which a young Cambridge graduate carrying out work studies for a large engineering firm has to cope with the plan of a suspicious factory steward to make employees work deliberately slowly, distorting the results of time studies. It's reasonable to imagine that Balchin's fiction reflected tensions he encountered at Rowntree's, where the company received complaints and created regulations to protect workers who

ABOVE: The formboard devised by industrial psychologist Victor Moorrees was used to select chocolate packers at Rowntree's.

were unable to adapt to new methods. For while industrial psychology acknowledged that humans were not machines, the ultimate goal was still improved productivity.

In the age of the call centre and the Amazon warehouse, concerns about worker welfare in the face of demands for ever higher productivity remain pressing. They were explored in a touring exhibition of 2013 by the conceptual and installation artist Jeremy Deller, entitled – in a phrase from the *Communist Manifesto* – *All That Is Solid Melts Into Air*. Much of Deller's work focuses on people's everyday lives, exploring themes of class, power and social experience in an approach that has been called 'fundamentally egalitarian, unswervingly turned towards the popular and democratic'.

In *All That Is Solid Melts Into Air*, Deller presented artwork, objects, photographs, music and film that traced the legacy of industrialization and its impact on British society and popular culture. Among the objects is a clock with two faces made for a silk mill in Macclesfield in 1810: one face showed real time while the other showed 'mill time', as if the mill had become a separate universe. Its hands were connected to the silk mill's water wheel, moving only when the water wheel turned. If the water wheel stopped, 'mill time' too was suspended, and the lost production time would have to be made up by the workers, ruled by the pace of their machines.

Deller makes the point that not much has changed, pairing the Macclesfield clock with a digital wrist-worn device for today's warehouse employees that tracks their work rate and transmits the information to managers. Society, Deller implies, still lives in the shadow of industrialization. His work, like Lowry's, offers cautionary observations about the treatment of the human as a unit of production in capitalism's pursuit of maximum productivity.

OPPOSITE AND OVERLEAF: This double-dialled clock was installed at Park Green mill in Macclesfield, around 1810, to ensure workers kept up the required productivity rates.

13

Form of Knowledge: The Mathematical Model as Muse

The consciousness and understanding of volume and mass, laws of gravity, contour [sic] of the earth under our feet . . . these are surely the very essence of life, the principles and laws which are the vitalization of our experience, and sculpture a vehicle for projecting our sensibility to the whole of existence.

BARBARA HEPWORTH, 1937

In the mid-nineteenth century, instruction in some areas of mathematics, particularly non-Euclidean geometry (which moved geometry beyond a 'flat' model towards its application in a spherical or curved world), often used models made from wood, brass and string as visual aids. These objects were much more effective than two-dimensional images for communicating the shapes of complex three-dimensional surfaces. But as well as being educational tools, they had aesthetic appeal in their own right. In the twentieth century they came to be seen as inspirations to artistic imagination and creativity, and as symbolic of the functional value of art for society. Sculptors such as Barbara Hepworth and Henry Moore found in these models a stimulus for their own three-dimensional work.

Abstract mathematics, in particular the field of algebraic geometry (which explores curves, surfaces and shapes defined by mathematical equations), received increasing attention in the nineteenth century, and models were used to develop ideas, convey knowledge and support teaching. Model-making became particularly common in the 1870s, using a variety of materials including plaster, cardboard and string. These objects didn't in any sense *prove* theorems, but they helped to guide intuition and share meaning.

In the latter part of the century mathematicians began to construct alternatives to Euclidean geometry, which had been dominant for two millennia. Euclidean geometry explores the properties of objects on flat planes and in uniform three-dimensional space – where, for example, parallel lines never converge or diverge, and triangles have inside angles adding up to 180 degrees. In non-Euclidean geometry, these things might not be true: space is no longer flat, and new rules apply. Around 1830 the mathematicians Nikolai Lobachevsky and Janos Bolyai independently published theories on non-Euclidean geometry, and their work gained prestige when it attracted attention and support from well-respected mathematicians including Carl Gauss and August Möbius. The ideas were further developed by the German Bernhard Riemann, who in 1854 postulated the existence of curved space and founded the field that became known as Riemannian geometry. His ideas played an essential role in Einstein's theory of general relativity nearly sixty years later, in which the force of gravity was represented as a consequence of the curvature of space and time.

The use of models in geometry goes back to the end of the eighteenth century and the pioneering work of the French scientist Gaspard Monge. His theory of descriptive geometry in 1794 sought to 'represent [. . .] with exactitude, within drawings that have but two dimensions, objects that have three'. He illustrated his approach using objects created by stretching strings across curved frames. In mathematics these are called 'ruled surfaces', and they have the property that through every point there is at least one (and

sometimes more than one) straight line which lies on the surface. Examples of such surfaces are cones and cylinders. Descriptive geometry had important practical applications for construction, both military and civil, and it was taught in polytechnics and universities across the Western world.

In 1829 one of Monge's students, Théodore Olivier, helped to found the École Centrale des Arts et Manufactures in Paris, an

ABOVE AND OVERLEAF: Théodore Olivier designed a series of intriguing string models. These examples were constructed by Fabre de Lagrange, which could be distorted and rotated to provide a variety of geometrical configurations.

institution for training engineers in science and mathematics. There, and also at the Conservatoire National des Arts et Métiers and the École Polytechnique, he lectured on descriptive geometry and mechanics. Olivier developed ingenious string models with movable components, which allowed students to visualize a wide variety of surfaces simultaneously by using different-coloured strings, weighted with lead beads hidden in the wooden bases.

These models were widely admired, and quickly caught on. Olivier sold sets to schools and universities across the world, many of them in the United States. There are still some examples of them at West Point and in the Conservatoire National des Arts et Métiers. The models were manufactured at first by Pixii, Père et Fils, and later by the firm's successor, Fabre de Lagrange, who built a set for the Science Museum collection. These beautiful objects could be arranged to show a variety of surfaces with exotic and evocative names: hyperbolic paraboloids, conoids, skew helicoids, staircase vaults and intersecting planes. They became part of the Science Museum collection after being displayed at the 1872 International Exhibition in London.

As well as being handy teaching aids in schools and colleges, models like this were used to communicate ideas within mathematical societies, and became symbols of national prestige at global fairs, featuring for example in the German mathematical exhibit at the World's Columbian Exposition of 1893 and at the Third International Congress of Mathematics in Heidelberg in 1904.

But this enthusiasm waned after the First World War as mathematical theories became more abstract and moved away from three-dimensional representations of space. The models became historical curios, and were displayed as such in art galleries and museums. There they began to reach another audience: avant-garde artists, who found in them not guidance for abstract thinking but inspiration for exploring shape and form.

GEOMETRY AND CONSTRUCTIVISM

In the 1930s, two artistic movements became interested in geometric models: Surrealism and Constructivism. Both were interested in the

meaning of form and space, and they looked at the mathematicians' models as they might look at sculpture. Artists studied the models themselves, where they could be seen in public collections, and illustrations of them in encyclopaedias and mathematical texts, in some cases adopting the mathematical descriptions as names for their pieces.

It's hard to know who was the first to incorporate strings and mathematical forms into sculpture. The Surrealist Max Ernst was already making works involving geometry when he introduced the American photographer and visual artist Man Ray to the models at the Poincaré Institute in Paris in the 1930s. Here Man Ray took a series of photographs of the stringed models, which he published in the influential French art and literary journal *Cahiers d'Art* in 1936. For the Surrealists, these objects represented another way to surprise and stimulate the visual sense.

It was the Russian artist Naum Gabo who put the stretched-string model firmly on the artistic map. Gabo became aware of mathematical models while studying natural sciences and engineering at Munich Polytechnic. Later he joined the Constructivist movement, which began in Russia in the early twentieth century and drew heavily on Cubism, Futurism and science. Artists, Gabo argued in 1925, should 'transfer the constructive thinking of the engineer into art'; an aeroplane, he said, 'contains all the elements of a new sculpture'.

When Gabo emigrated to Britain in 1936, he settled in Hampstead, north London, among a colony of established artists and intellectuals including Barbara Hepworth, Henry Moore and John Nash. He brought with him the Constructivist ideas he had developed in Germany, and created sculptural forms inspired by scientific instruments and mathematical structures. He also made motor-powered objects, which some see as the first kinetic sculptures. In Britain Gabo continued to be influenced by new technical breakthroughs, and he incorporated new materials like Perspex, celluloid and nylon into his work (thereby inadvertently creating something of a nightmare for future conservators). In works such as *Construction on a Line* (1935–7) and *Construction in Space with Crystalline Centre* (1938–40), Gabo used intersecting and overlapping translucent planes to create complex spaces.

ABOVE: This is one of Hepworth's first sculptures featuring strings and influenced by mathematical forms. These motifs became a common feature in her work.

CONSTRUCTIVISM IN BRITAIN

Henry Moore and Barbara Hepworth were both interested in geometrical figures and the forms that emerge from mathematical objects in space. As they developed these ideas, they initiated the movement known as British Modernism. Hepworth and Moore first met at Leeds School of Art in the early 1920s, and both went on to study sculpture at the Royal College of Art in London before consolidating their artistic relationship when they settled in Hampstead.

Hepworth may have seen mathematical models during her travels in Europe as a student. She was also introduced to a collection held at the University of Oxford by the architect John Summerson in 1935. These she described in a letter to her husband, the painter Ben Nicholson, as 'some marvellous things . . . working out of

mathematical equations – hidden away in a cupboard'. Her own first stringed piece, made in 1939, was carved from solid plaster with most of the form hollowed out and painted ultramarine blue, a white-painted exterior and red strings threaded across the void. Some of her subsequent works of this type, such as *Sculpture with Colour and Strings* (1961), were cast in bronze, and the strings became steel rods, as in *Winged Figure* (1962), which was mounted on the John Lewis department store in London's Oxford Street. Her figures became so famous that illustrator Quentin Blake depicted Hepworth threading a work in an image for *Punch* magazine in 1954.

As an art student in the early 1920s, Henry Moore was an avid visitor to the London museums: the British Museum, the V&A and the National Gallery, but also the Geological Museum (where he inspected mineral shapes) and the Science Museum, where he was introduced to Théodore Olivier's models. In 1968 Moore recalled: 'Undoubtedly the source of my stringed figures was the Science Museum . . . I was fascinated by the mathematical models.' He explained that 'it wasn't the scientific study of these models but the ability to look through the strings as with a bird cage and to see one form within another which excited me'. In the late 1930s he sketched these models and made a small number of wooden stringed figures which he later cast in bronze.

Moore was not alone among the artists of these years in finding stimulus and inspiration in the museum's collections. In 1936 the London Transport Board published two posters designed by Edward Wadsworth to promote the South Kensington museums – a commission that provides a good example of the enthusiasm among both commercial and civic bodies in the interwar period for using the work of modern artists. In fulfilling his brief, Wadsworth was inspired by the forms he found within the Science Museum collections. The posters, printed in bold colours, featured a model of a late-nineteenth-century cubic surface (one representing a mathematical equation containing cubed variables) alongside a marine screw propeller from 1843.

Moore and Hepworth, unlike Gabo, sustained an interest in natural forms and materials as well as mathematical shapes

OPPOSITE: Henry Moore was inspired to incorporate strings into his work after drawing the mathematical models on display at the Science Museum.

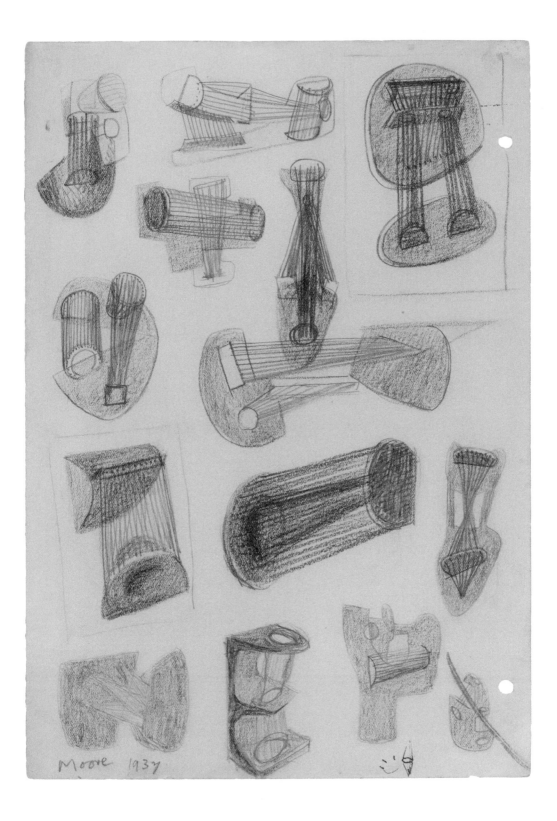

Moore 1937

ABOVE: The abstract forms of the Science Museum's mathematical models inspired Edward Wadsworth's design of this poster for the South Kensington museums.

and metallic materials. They also followed new discoveries in science, especially through their friend John Desmond Bernal: eminent crystallographer, Communist sympathizer, and enthusiastic and vocal advocate of science as the chief agent of positive change in society – as expounded in his 1939 book *The Social Function of Science.*

At the University of Cambridge, where he was appointed the first lecturer in structural crystallography in 1927, Bernal made significant advances in X-ray crystallography – the use of X-rays to deduce the atomic structures of crystals. In this work he made much use of illustrations and models, such as packed ball bearings to represent the disorderly structures of liquids. He also studied the structures of proteins with his student Dorothy Crowfoot (later Hodgkin), who would be awarded a Nobel Prize in 1964 for her work on the molecular structure of penicillin.

Bernal was introduced to the Hampstead set by his partner, the art collector Margaret Gardiner. Here he discussed mathematical analysis in informal groups of scientists and artists, and became close friends with Hepworth and Nicholson. Bernal's beliefs chimed with those of the Constructivist movement: he argued that science and art both had social utility and needed to work together rather than as opposing forces.

According to the art historian Anne Barlow, Hepworth's interest in science had two facets: that the inspiration it supplied to artists was a part of its social function, and that artists and scientists were both fascinated by form. Bernal wrote an introduction to Hepworth's first solo show in October 1937, in which he emphasized the mathematical nature of her sculptures and noted that 'by reducing traditional forms of sculpture it is possible to see the geometry which underlies it and which is so obscure in more elaborate work. In the hands of Miss Hepworth this geometry has taken on particularly subtle form.' Hepworth's work, Bernal said, was a combination of simple elements: the sphere and the ellipsoid, the hollow cylinder and the hollow hemisphere. 'All the effects are gained either by slightly modulating these forms without breaking up their continuity, or by compositions combining two or three of them in different

significant ways. The whole exhibition can be classified on the basis of these forms and of their combinations.'

ART AND SCIENCE FOR A BETTER WORLD

The interwar period in London was one of artistic and intellectual ferment. In the aftermath of the First World War, many intellectuals in Britain felt the need to search for a new sense of national identity, and new forms of certainty in science and art. On the European continent, with nationalism and totalitarianism on the rise and a persisting fear of renewed war, many artists decided to move to London. This influx created a rich artistic environment; Hepworth recalled that 'we all seemed to be carried on the crest of this robust and inspiring wave of imaginative and creative energy'. The deteriorating social and political conditions across the Channel, especially when the Nazi party came to power in Germany, stirred discussions and generated theories about how art and science could and should be used to deal with the turmoil. In a book published in 1937 under the title *Circle*, edited by Gabo, Nicholson and the architect Leslie Martin, the British Modernist group tried to find a synthesis of science and art, and advocated a type of abstract art that embraced new forms, materials and methods of construction. The book included essays by Bernal, Hepworth, Moore and Gabo. 'However dangerous it may be to make far-reaching analogies between Art and Science,' Gabo wrote,

> we nevertheless cannot close our eyes to the fact that at those moments in the history of culture when the creative human genius had to make a decision, the forms in which this genius manifested itself in art and in science were analogous . . . the creative processes in the domain of art are as sovereign as the creative processes in science. Even for many theorists of art the fact remains unperceived that the same spiritual state propels artistic and scientific activity at the same time and in the same direction.

Bernal, too, emphasized the similarities between artists and scientists. 'Modern art', he wrote,

> has evolved many more subtle forms, especially sculpture, which now depends on far more complex curves and surfaces . . . there is an extraordinary intuitive grasp of the unity of a surface even extending to surfaces which though separated in space and apparently disconnected yet belong together both to the mathematician and the sculptor.

Bernal challenged the perceived segregation of the two disciplines, arguing that 'scientists and artists suffer not only from being cut off from one another but being cut off from the most vital part of the life of their times. How to end this isolation and at the same time preserve the integrity of their own work is the main problem of the artist of today.'

Two years after *Circle* was published, the world was once again at war. In Britain, art and science were now put to use not to bring about the optimistic future envisaged in *Circle* but as part of a national defence strategy. Science was directed towards military needs and the development of new weapons of mass destruction. British artists became official war artists or were commissioned for propaganda campaigns or research on the development of camouflage patterns (a unit tasked with that goal included the zoologist Hugh Cott and the abstract artist Roland Penrose). Among the disruptions of the conflict, the Hampstead group dispersed. Gabo and Hepworth relocated to St Ives in Cornwall; Moore, after his home was hit by a bomb, moved to Hertfordshire. Bernal became an influential figure in the management of wartime science, shaping the development of operational research, RAF bombing strategy and planning for D-Day.

But the confluence of art and science for which the British Modernists had worked and argued was not lost for good. In the postwar period, X-ray crystallography and its focus on form and pattern once again inspired a new wave of designers and artists, as we shall see in Chapter 15.

The Age *of* Ambivalence

1940 to the present

During and after the Second World War, the development of new imaging techniques and computer modelling brought the skill of the observer back to make sense of data. Postwar prosperity, and a new hope in the civil applications of technology, mixed uneasily with uncertainty about the role of science and technology in the future. The artistic and scientific imaginations came together within the same creative culture, yet at times their language seemed more at odds than ever before. This is an age of fear and dystopia, mixed with lashings of ambition and hope.

14

Supersonic: The Art of the Possible

This supersonic plane is flying faster than its own roar!
First you see it – then you hear it!

BRITISH PATHÉ NEWSREEL FILM, 1949

In Britain during the late 1940s and early 1950s, the aircraft industry symbolized the hopes and ambitions of the postwar nation. There was pride in the aeronautical achievements of the Second World War and its aftermath, from the technical superiority of British radar and aircraft in the Battle of Britain to Frank Whittle's revolutionary jet engine, devised in the late 1930s. The sleek silver prototype aircraft that now rolled out of British factories every month testified to the nation's technological and scientific prowess. Enormous crowds flocked to air shows up and down the country to see these innovations. Test pilots became household names alongside film stars and footballers. Dan Dare, hero of Frank Hampson's strip cartoon in the *Eagle* comic from 1950, may have flown into a space-flight future, but he was clearly based on the archetypal figure of the Battle of Britain pilot.

The world's first jet airliner, the de Havilland Comet; the jet-powered Hawker Hunter fighter, breaker of the world air speed record; the aerodynamically advanced bat-winged Avro Vulcan bomber – all were products of a bloated, uncommercial postwar aircraft industry. At the same time, each in its own way displayed the design ingenuity and scientific capability of British aerospace in the 1950s, and lent credence to the belief that Britain could thrive

in the jet age. Throughout this otherwise austere decade, when resources were stretched thin, no single idea better captured the mixture of hope, faith in technology, and belief in the human capacity to transcend the limits hitherto imposed by physical laws than the marvel of supersonic flight: 'breaking the sound barrier', in the phrase that resounded through popular culture, with more drama than accuracy. (The aerodynamicist William Hilton, who at that time was working in Britain's National Physical Laboratory, claims the phrase originated when the press misinterpreted him as he was describing the 'drag' or resistance of an aircraft's wing, as it neared the speed of sound, as shooting up 'like a barrier to higher speeds'.)

The aircraft of the wartime era, with their propellers and piston engines, could never hope to travel faster than the speed of sound. Now they represented the past – albeit a past tinged with glory and nostalgia. For supersonic travel you needed the new jet aircraft, boosted by advances in aerodynamics and propulsion technologies. They were the future, and it was a future of unimaginable speed coupled to shiny glamour, a place where aviation met space flight.

VISUALIZING THE FUTURE

There is something Promethean in this desire to harness science to surpass a physical limit (however arbitrary in the end that limit, in this case the speed of sound, really is). And Roy Nockolds' painting *Supersonic* captures that spirit perfectly. It shows an almost abstract spear-like form, presumably an undefined aircraft, scarlet against a blue and white sky, piercing a cone of concentric rings as if escaping their imprisoning confines. The plane – it could almost be a bullet – is on the verge of breaking the sound barrier, flying at supersonic velocity. The rings look like a zone of turbulence, while the white supersonic zone is calm and serene.

The image is not as abstract as it looks, for it seeks to present much of the scientific knowledge that had entered popular culture about the challenges of achieving supersonic flight. Nockolds was largely self-taught, and a devotee of speed, contributing paintings to motoring magazines as a teenager in the 1920s. He became a war

artist for the Royal Air Force during the Second World War, working with the Ministry of Information to create propaganda art. *Supersonic*, painted in the postwar decade, seeks to show how, as an object approaches the speed of sound, the air ahead of it is compressed while airflow over the surface becomes turbulent. Nockolds' painting shows the plane at the moment of transition. As the aircraft approaches the speed of sound, there is insufficient time for the squeezed air to get out of the way. There is not really a 'barrier' as such, but as it attains supersonic speed the plane passes through the zone of compression and a smooth flow is restored. The transition leads to shock waves in the form of cones diverging from the aircraft's nose and causing the familiar sonic boom: the sound of progress. The shock waves were known to create instability, and some attempts to break the sound barrier ended with crashes and fatalities.

So this is a work of science but also of imagination. It is the art of the possible, but also shows a moment of transcendence. The precise geometric forms deny any hint of human agency, choice or indeed fallibility. As curator John Bagley said of *Supersonic* when the Science Museum purchased it in 1985, 'it is perhaps technically too accurate to be regarded as "real" abstract art – but it would extend our collection beyond the simply representational'. Bagley was well placed to judge, having himself been an aerodynamicist at the Royal Aircraft Establishment (RAE), Britain's principal aerospace research centre, before joining the museum.

Nockolds' prewar images of motor cars were hyper-real, capturing the speed of the technology with dramatic flair. While working in the RAF in 1942 he was given the task of improving the camouflage of night fighters. His counter-intuitive idea was to paint the leading edge of the wing and underside of the aircraft white and the top black – a notion derived from his observation that a light-coloured owl is more difficult to see against a night sky than a dark bird. All of 151 Squadron's Mosquito night fighters were immediately given this new paint scheme. After the war Nockolds returned to painting motor-racing scenes, but he continued to receive aviation commissions, particularly from RAF squadrons looking for paintings to hang in the mess room. At first these works tended to depict propeller-driven bombers and fighters on

wartime raids, but increasingly Nockolds was asked to paint the jet aircraft then entering service.

Supersonic was very different from Nockolds' normal style of romantic realism. Evidently he felt that to convey the exceptional nature of supersonic travel (which after all, from a realist perspective, looked no different from regular flight) he needed a more abstract approach, almost a hybrid of an artistic image and a technical diagram. Nockolds may have been influenced by some of the technical photographs of supersonic travel that already existed. One, taken in 1887 by the physicist and philosopher Ernst Mach (who gave his name to the Mach Number – the ratio of the speed of the object to the speed of sound), revealed the compression of air in front of a supersonic bullet. Nockolds may also have seen more contemporary images of shock waves, such as the photographs from inside a wind tunnel created for the Miles M.52 project (a British initiative to develop a supersonic jet in the 1940s), which were printed in *Flight* magazine in 1946. At any rate, *Supersonic* anticipates unnervingly well some of the wind-tunnel imagery from testing of supersonic aircraft models in the early 1960s.

Supersonic was first shown at the inaugural exhibition of the Society of Aviation Artists (later the Guild of Aviation Artists) at the Guildhall Art Gallery, London, in the summer of 1954. John Bagley called it one of the first attempts at abstract painting to be commissioned by the aviation industry. Similarly unconventional works by Nockolds appeared in 1954 issues of *Flight* magazine under the sponsorship of aero-engine manufacturer Armstrong Siddeley Motors Ltd, part of the mighty Hawker Siddeley Group, to promote its jet engines.

TOWARDS SUPERSONIC

The roots of Britain's obsession with fast jets went back two decades before *Supersonic*. Britain's first jet-propelled aircraft, the Gloster E28/39, flew for the first time in great secrecy in May 1941, when the country still stood in isolation against Nazi Germany. It was propelled by Frank Whittle's W.1 turbo-jet engine. Whittle had patented the

OVERLEAF: Roy Nockolds' *Supersonic* was an abstract departure from his picturesque depictions of motoring and aviation in the landscape.

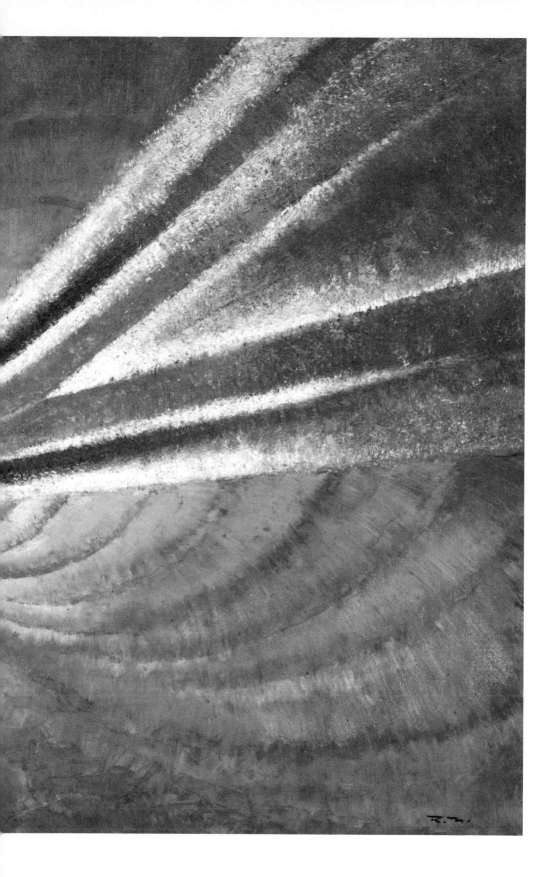

revolutionary concept in 1930, but had received little support from either government or the aircraft industry. Nonetheless, the potential for a jet engine to generate air speeds far greater than those achievable by conventional piston engines with propellers was widely recognized across Europe. Italian and German jet aircraft took flight before the British Gloster, and several German models, such as the Messerschmitt 262, made a significant contribution to the Axis war effort. However, when Allied intelligence during the war revealed the German work under way on high-speed planes and rockets, Britain's military planners feared that the country could be attacked by high-flying, jet-propelled bombers. Such bombers could only be countered with interceptor aircraft travelling faster still – that is, at supersonic speeds. Whittle's engines made that prospect imaginable, but posed radical challenges for aircraft design.

In 1943 the Ministry of Aircraft Production's new Supersonic Committee commissioned the Miles aircraft company to build a truly revolutionary aircraft, capable of flying at over 1,000 mph in level flight (over twice the existing speed record at that time) and climbing to 36,000 feet in 90 seconds. It would use an advanced version of Whittle's W.2/700 jet engine. The result of this project was the design for the Miles M.52 – a bullet-shaped, short-winged aircraft. Although the work was crucial to the eventual achievement of supersonic flight, German research obtained at the end of the war suggested that the M.52 could not be successfully translated into practice. The programme was cancelled, although the results were made available to Britain's allies. To this day, the demise of the M.52 project is cited as an example of the supposed British habit of surrendering a technological lead for others to exploit.

By 1948, a few German aviation scientists had come to work at the RAE, bringing with them experience of the so-called 'swept wing' aerodynamic design: wings that are angled back, which could mitigate the instability that pilots had already experienced at near-supersonic speeds. By this point the aerodynamics of supersonic flight itself were relatively well understood; the major challenge now was to design an aircraft that could cope with the physical demands of supersonic speeds.

David Lean's 1952 film *The Sound Barrier* presents a fictional account of the struggle to develop such an aircraft. With its combination of audacious aerial photography and allusive, lyrical imagery, along with the highly literate script supplied by playwright Terence Rattigan, it elevates a story of personal bravery, family tragedy and heroic engineering to the level of art. The film tells the story of aircraft designers and test pilots pushing at the limits of technology to create a machine that could break the sound barrier. For Lean, that goal represented the ultimate technological challenge, in the way that space flight to the moon would a decade later. 'I'd always wanted to make an adventure film about man's exploration of the unknown,' he said. 'Now here was this "sound barrier" – invisible, yet able to tear an airplane to pieces. Man's assault on this treacherous mass of air seemed to me the great modern adventure story.'

In the film, John Ridgefield (played by Ralph Richardson) is the owner of the Ridgefield Aircraft Company, attempting to create a supersonic aircraft called Prometheus. His daughter is married to the test pilot who will trial the craft, and Ridgefield tries to soothe his daughter's concerns about the dangers:

Some say the craft would go right out of control, others that it will break up altogether. I don't believe that, Sue. I believe with the right aircraft and the right man we can force our way through this barrier and once through there is a world, a whole new world with speeds of 1500 to 2000 mph . . . and Tony might be the first man to see that new world.

The film humanizes the abstract concept that Nockolds had depicted. As audiences of the time would have known, the family drama parallels the story of Sir Geoffrey de Havilland, founder of the aircraft company that bore his name, and his son Geoffrey, who died testing the beautiful DH108 Swallow in his own attempt to break the sound barrier. To add to the authenticity, the real

experimental aircraft used in the film was credited at the end as if it too were a film star.

Yet in truth the sound barrier was first broken not by a British pilot but by the United States Air Force pilot Chuck Yeager, flying a rocket-powered Bell X-1 (developed from research on the Miles M.52) over the Californian desert four years before the film's release. And the solution to the buffeting that had destroyed or damaged many aircraft at close to supersonic speed was not, as the film suggested, to 'reverse the controls'.

The Sound Barrier was drama rather than fact – but it captured the 'can do' spirit of British aviation in the immediate postwar period. The risks were plain, and never more so than when, at the 1952 Farnborough Airshow just two months after the film's release, a display of de Havilland's latest prototype, the DH110, ended in disaster. As the aircraft broke the sound barrier over the runway, it disintegrated and crashed into the crowd, leaving the two pilots and twenty-seven spectators dead and more than sixty people seriously injured. An undeterred 140,000 spectators attended the next day's display – surely a reflection of those very different times, when all manner of risks seemed worthwhile for the sake of progress.

SUPERSONIC FOR THE MASSES

Lean's film captured that same spirit in the character of the domineering industrialist John Ridgefield, and his vision of a calm, utopian future beyond these dangerous experiments in which supersonic airliners shrink the globe for everyone.

Two of the German aerodynamicists working at RAE Farnborough in the early 1950s, Dietrich Kucheman and Joanna Weber, studied a new type of wing that extended almost the entire length of an aircraft's fuselage, but with a proportionately small wingspan. This slender 'delta wing' design created much less drag (air resistance) at supersonic speeds while maintaining enough lift (which is dependent on wing area) to allow conventional take-off and landing speeds. This offered the prospect of a safe passenger airliner that could cruise at high altitudes at twice the speed of sound.

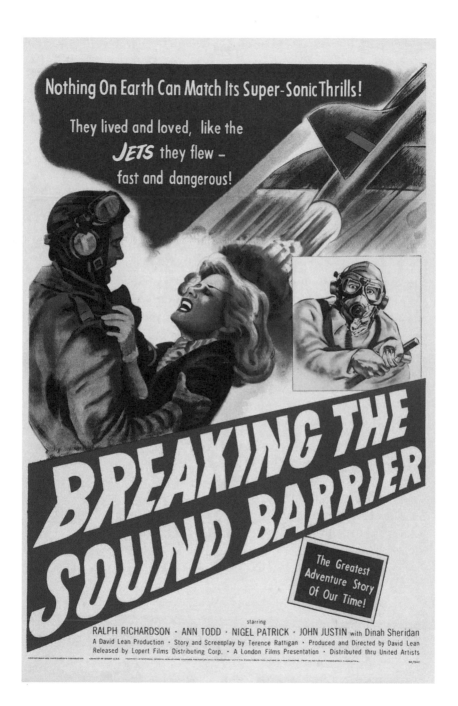

ABOVE: Director David Lean's 1952 film *The Sound Barrier* presented technological challenge as adventure.

Such an aircraft would need to take off and land with its body pointing up into the air at a far steeper angle than normal. Kucheman's and Weber's studies showed that this would allow the air passing over the wings to curl into stable rolling vortices that would assist the aircraft's lift. This approach in turn demanded a movable nose section that could be lowered for take-off and landing, so that the pilot could see ahead, and then raised when the craft was airborne. And all this is of course precisely what was adopted for the most iconic aircraft of the postwar period: Concorde.

Another leading RAE aerodynamicist, W. E. Gray, showed that the slender delta shape would be stable against side winds at low speeds, helping to convince the British government that supersonic civil aviation was possible. In 1956, the RAE Supersonic Transport Aircraft (SSTA) Committee met for the first time. With enormous optimism but almost no market research on consumer needs or transport economics, members drawn from the aviation industry, airlines and government departments began planning the necessary research and development programme for a supersonic airliner. The project was named Concorde when France joined in 1962. The name signified agreement and harmony, cementing an ambition to undertake not just a scientific and technological endeavour but a political one that united Britain and France through the prestige of cutting-edge technology.

The technological challenge of producing an airworthy civilian aircraft capable of carrying around a hundred passengers safely at twice the speed of sound remained immensely complex and expensive. The US astronaut Neil Armstrong came to Britain and flew one of the test aircraft as part of NASA's space shuttle research programme, and he later told Concorde pilot Mike Bannister that 'the Concorde project was just as great a technical achievement as putting me on the moon'.

But it was hard to sustain the necessary political support in Britain, and an anti-Concorde lobby became increasingly vociferous in the 1960s and early 1970s. Objections focused on the expense, the environmental impact and the sheer noise of the aircraft. This scepticism about the value of technological change and concern for

the environment were characteristic of the period, and in marked contrast to the enthusiasm for the air shows – and sonic booms – of twenty years earlier.

Yet when a Concorde prototype flew for the first time in March 1969, there was an outpouring of Anglo-French national pride. Concorde entered into commercial service in January 1976, prompting British Airways to claim that 'the world is about to become a smaller place'. Concorde certainly had glamour: Hollywood actress Joan Collins was a frequent flier between New York and London in the 1980s, and in July 1985 Phil Collins performed at the Live Aid concerts in the US and the UK on the same day thanks to Concorde. Celebrities and the global elite could now travel faster than a bullet, enjoying champagne and caviar en route.

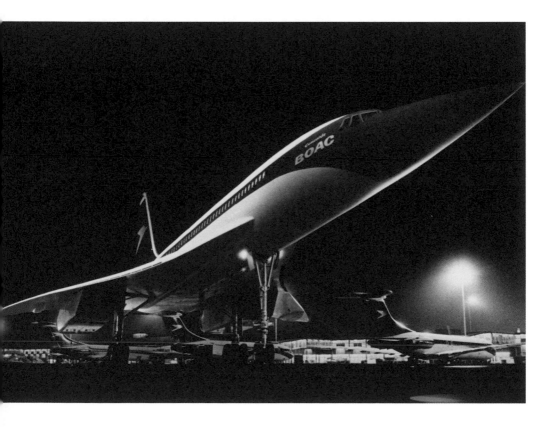

ABOVE: This artist's impression of Concorde at London Heathrow Airport in 1968 was designed to stimulate the nation's pride in its technological capabilities.

But another revolution in the skies was also taking place. What the international travel market really needed, it seemed, were wide-bodied subsonic airliners, delivering more passengers to more places at lower prices and using less fuel. The Boeing 747 'jumbo jet' may have been sluggish compared to Concorde, but it opened up air travel to the masses. Eventually the poor market research for Concorde took its toll – as did the fatal crash of one of the aircraft at Charles de Gaulle airport in Paris in July 2000. The economic downturn of the airline business following the terrorist attacks on the United States in 2001 was the final straw, and Concorde was finally withdrawn from service in 2003. Only twenty of the aircraft were ever made, compared to (so far) more than 1,600 Boeing 747s.

But if Concorde was a commercial failure, it remains a design icon. It is still remembered fondly by many who would hear it before they saw it, and who looked up to see the slender delta jet way above them. For some, the passage of Concorde overhead became a reliable timekeeper. In 1997, artist Wolfgang Tillmans caught this lived experience of Concorde with his *Concorde Grid*, a series of fifty-six photographs of the aircraft taken from the ground, which captured the popular romance of the venture.

For Tillmans, the work was all about a faded dream of technology. 'In the 60s,' he said,

> people extended their imaginations well beyond the limits of what seemed reasonable – an idea, I think, that has been taken away from later generations like mine, raised in the 70s and afterwards . . . Concorde was, in a sense, the only remaining bridge from now to an age when there was a completely different optimism about the future.

No other airliner has ever matched Concorde as a visual spectacle of modernity in the skies, during an age of technological optimism when anything seemed possible.

Supersonic flight was not only a scientific and technological feat. It became a political, social and economic endeavour based on a celebration of speed. And yet it never delivered on the democratic

promise of cheap, fast civilian flights for all. Today, supersonic aircraft are military machines: dull and grey, bereft of glamour.

Was the quest to break the sound barrier ever really about commerce and routine travel? In *The Sound Barrier*, the aircraft magnate John Ridgefield says: 'The real point is that it just has to be done. What purpose did Scott have in going to the South Pole?' The closing frames of the film show a delta-winged model aircraft against a backdrop of stars and galaxies in Ridgefield's private observatory, hinting at the still greater speeds that would open up to humankind a whole range of new destinations through the ultimate technological achievement: flight into space.

OVERLEAF: Wolfgang Tillmans' *Concorde Grid*, 1997, reflected an optimism about technology now lost in our Age of Ambivalence.

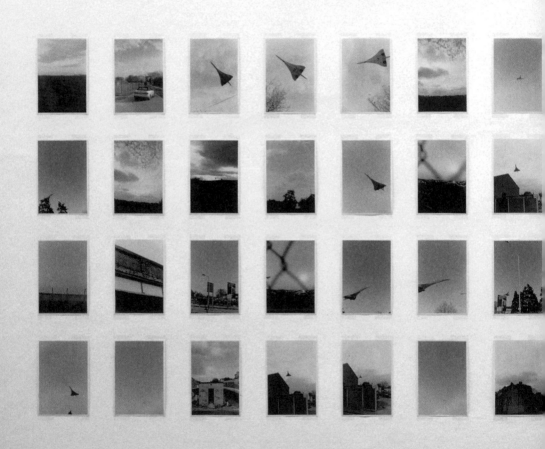

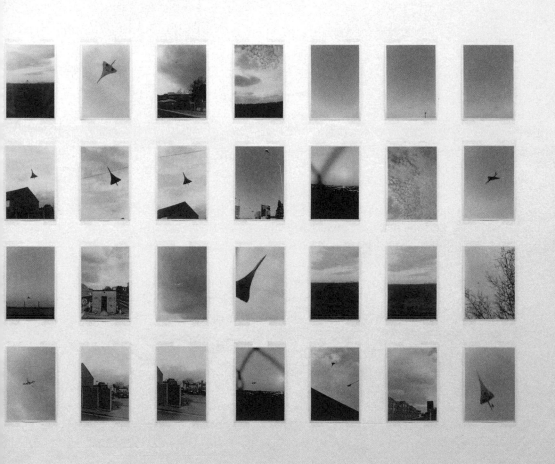

15

Patterns from Atoms: Designing the Future

For the first time textile designers have found their inspiration in a world that the eye cannot see, the world of the atom and the molecule. For the first time their prompters have been the people of science.

'The Design Story of the Century', *British Textiles*, April 1951

The Festival of Britain in 1951 – a triumphant display of British design, manufacturing and industry – happened at a time of enormous optimism about science and technology, when it became possible to look beyond postwar austerity to a brighter future. The conservatism of the prewar period, as well as wartime (and postwar) rationing, were, it seemed, finally being left behind. Consumers were being offered more choices than ever before. And at the heart of this celebration was a belief that science and design could work together to invent modernity.

But not everything was moving at the same speed, or in the same direction. Margaret Bean, who attended the opening day of the Festival and dined at its flagship Regatta restaurant on London's South Bank, recalled in the 1970s an 'odd contrast' between the restaurant's old-fashioned food and service and its novel interior design, 'derived from the diagrams made when scientists map the arrangement of the atoms in crystals studied by X-ray methods'. Margaret was neither a scientist nor an expert in pattern design – she ran a news agency. But clearly the restaurant's design made such an impression that even twenty-five years later she could remember the science that inspired it. The atomic patterns informed almost

OPPOSITE: These sample designs for the 1951 Festival of Britain were based on X-ray crystallographic patterns of haemoglobin.

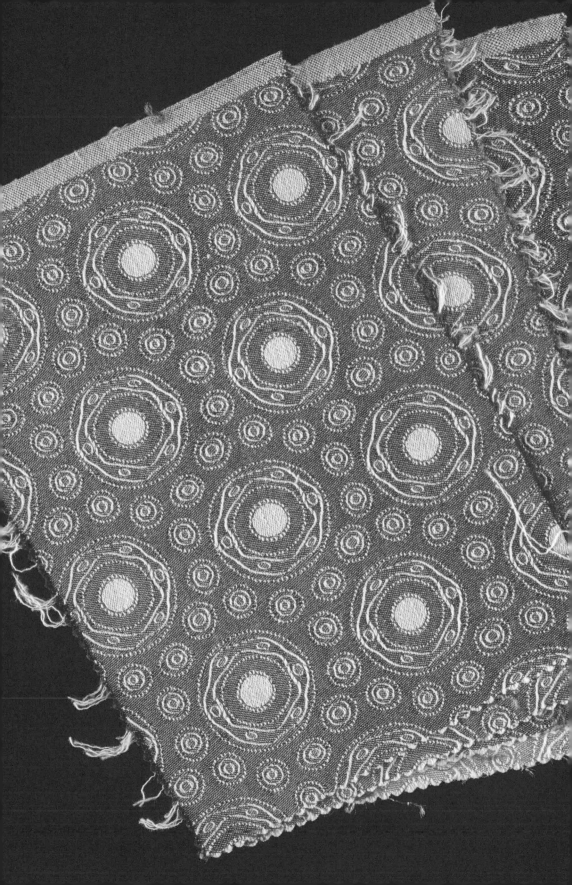

every aspect of the restaurant: its curtains, carpet, ashtrays, menus. These iconic designs epitomized the Modernist aesthetic of the Festival of Britain; and they emerged from a unique collaboration between designers and scientists at an exciting cultural moment in early postwar Britain.

INSIDE THE ATOM

The scientific discoveries that inspired these patterns began long before the Festival and a long way away from London – in Munich in 1912. A German physics professor, Max von Laue, realized that if X-rays, discovered in 1895, were electromagnetic waves like light (as many scientists believed), but with shorter wavelengths, it should be possible to see interference in the waves if a beam of them were reflected from the stacked layers of atoms in crystals. He instructed two students to focus an X-ray beam at a crystal to see if this were so – and indeed they found that the X-rays bouncing off a salt crystal formed a tell-tale pattern of bright spots on a photographic plate. The spots were in places where the wave interference was 'constructive', that is, where the peaks and troughs coincided with and reinforced one another.

As soon as they saw the results, the British scientist William Bragg and his son Lawrence realized the vast potential of these so-called diffraction patterns. They showed that it was possible to work out from the positions of the spots on the X-ray photographs where atoms sit in the crystal – and thereby to deduce the crystal's three-dimensional atomic structure. This was the start of the field called X-ray crystallography, which revealed the structures of matter at a scale far beyond what could then be seen with microscopes. The Braggs pioneered the experimental methods needed to collect X-ray diffraction patterns on film. The significance and impact of their work were so great and so immediately apparent that, just three years later in 1915, the Braggs were awarded the Nobel Prize in physics. In the decades that followed, X-ray crystallography flourished, especially in Britain, becoming one of the most important sciences of the twentieth century. The ability to deduce atomic and molecular

structures transformed chemistry and biology, and culminated in the discovery of the double-helical structure of DNA in 1953.

Parallels between the atomic structures of crystals and regularly repeating artistic pattern designs were evident right from the outset. To explain the principles of crystallography in their 1915 textbook on the subject, the Braggs drew an analogy between the repeating structures of atoms within a crystal and the motifs in wallpaper design. Lawrence Bragg was deeply interested in the arts, and he was perhaps the first to recognize the design potential of crystallography diagrams. 'When in 1922 I worked out the first crystal of any complexity,' Bragg remarked at the time of the Festival of Britain, 'I remember how excited my wife was with the pattern as a piece of embroidery. Ever since then I have been urging industrial friends to use these patterns as a source of inspiration.' His wish would eventually be realized.

The Braggs' wallpaper metaphor became a standard device among crystallographers to explain their subject to non-specialists. So much so, in fact, that in 1946 the crystallographer Helen Megaw remarked: 'I hope . . . the crystallographer is now in a position to repay his debt to the wallpaper designer.' That even Megaw used the masculine pronoun here is revealing about the reflexive gendering of the time, for the fact was that crystallography proved unusually open to women in science – several of its leading figures were female, including Kathleen Lonsdale, Dorothy Crowfoot Hodgkin and, by the time of the Festival of Britain, Rosalind Franklin.

Megaw, like Lawrence Bragg, appreciated the aesthetic quality of crystal designs. A specialist in inorganic (non-living) materials – her PhD work was on the crystal structure of ice – in her early career she had worked under the pioneering Irish crystallographer John Desmond Bernal, first at Cambridge and then at Birkbeck College, part of the University of London. Her comments about repaying the wallpaper designer's debt appear in an essay she was commissioned to write by a London consultancy, the Design Research Unit (DRU), after she had proposed to its director that designers of wallpapers and fabrics might make use of crystallography diagrams.

The DRU, originally formed in 1942 to bring together expertise in architectural, graphic and industrial design, was initially excited

by Megaw's proposition. Its director, Marcus Brumwell, an advertising entrepreneur, replied that 'I have always thought that art and science can help each other and should co-operate'. Brumwell sought the opinion of the sculptor Barbara Hepworth, who thought Megaw's idea was 'marvellous' and urged the DRU to produce patterns like this 'with their proper names – exactly as they really are'. 'To me', she added, 'they are more beautiful than any man-made pattern.' Sadly, however, the DRU did not take Megaw's suggestion further.

Two years later, Kathleen Lonsdale asked Megaw if she could borrow some of her 'beautiful' crystal-structure diagrams for a public lecture on 'Art and Architecture in Science'. And the year after that, when Lonsdale, who had begun her career working in William Bragg's research group at the Royal Institution in London, was appointed head of the Department of Crystallography at University College London – the institution's first tenured female professor – she re-used Megaw's diagrams at a lecture to the Society of Industrial Art. In the audience was Mark Hartland Thomas, chief industrial officer for the Council of Industrial Design, a body set up by the government in 1944 to promote design for the public good. Hartland Thomas liked what he saw, and moreover he knew where he might put Megaw's diagrams to use – in a project he had in mind for the Festival of Britain.

A TONIC FOR THE NATION

The 1951 Festival of Britain was many things at once: a commemoration of the 1851 Great Exhibition; a pat on the back for winning the war; a tonic (or narcotic) to a nation groaning under the austerity of housing shortages and food rationing; an advert for British exports; a Labour Party blueprint (or propaganda exercise) for a social democratic 'New Britain'; and, according to its own stated aims, a nationalistic celebration of Britain's past, present and future, emphasizing achievements in science, technology, industry and the arts.

The idea for such a festival was first mooted by the Royal Society of Arts in 1943, though it did not become a firm plan until 1948. By this time, Clement Attlee's Labour government had been in power for three years and had introduced key components of the welfare state

– National Insurance, public housing and the National Health Service – as well as nationalizing the coal, steel and railway industries. Moves were also being made to extend access to the country's cultural life. Radio was still the dominant mass medium of communication, and the BBC emerged from the war with a strong reputation for quality, launching the daring if highbrow Third Programme (now Radio 3) in 1946 to promote and nurture intellectual and artistic culture. In the same year, the arts received new state patronage through the establishment of the Arts Council, providing fresh commercial opportunities for artists through the commission of new artworks. Meanwhile, the Penguin series of 'Popular Painters' books was creating a public appetite for modern art, popularizing the work of Henry Moore, Graham Sutherland and Paul Nash.

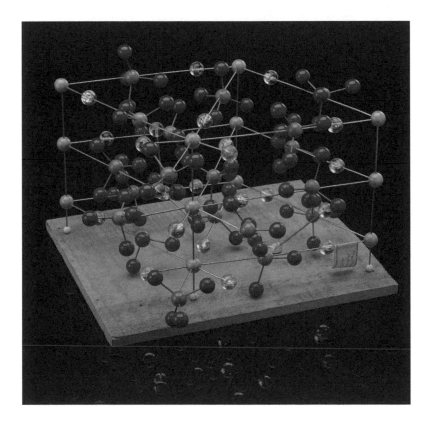

ABOVE: Female talent was nurtured in crystallography. This molecular model was inspired by Kathleen Lonsdale's research into calcium stones in the human body.

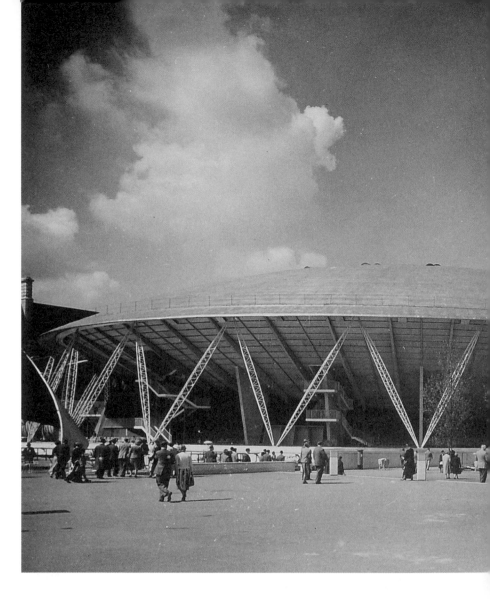

The dropping of the first atomic bombs in 1945 had ushered in a
Cold War culture of fear, but also of reverence and admiration for
the power of science; and indeed it gave the new era its name: the
atomic age. The advent in the prewar and wartime years of new and
wondrous technologies – penicillin, nylon, radar, the jet engine –
contributed to a public enthusiasm for all things modern.

Opening in May 1951, the Festival of Britain was the climactic
event of the postwar Labour government, encapsulating its optimistic
view of a scientific, well-designed future. The Festival took place all

ABOVE: The Dome of Discovery and the Skylon on the South Bank were two of the Festival of Britain's most iconic buildings.

across Britain: there were nine official exhibitions, twenty-three arts festivals and a pleasure garden in Battersea. The centrepiece was the exhibition on the Thames at London's South Bank, visited by an estimated 8.5 million people.

The South Bank exhibition was organized mostly by the Council of Industrial Design and the Council of Science and Technology – a

body established specially for the Festival. Its theme was 'The Land and its People', and it was spread across a series of Modernist buildings and sites such as the Dome of Discovery, a vast aluminium structure shaped like a flying saucer which housed a display exploring Britain's recent contributions to science and technology. There were also exhibits that catered for the 'lighter side' of the British psyche – for example, the Seaside Pavilion and an 'eccentrics' corner' in The Lion and The Unicorn Pavilion. One sculptural marvel epitomized the Festival's futuristic vision: the Skylon, a 300-foot vertical compass needle seeming to float in the air (in fact it was supported by high-tension cables), its name chosen to evoke that symbolic synthetic material of modern life: nylon.

At a planning meeting for the South Bank exhibition, Mark Hartland Thomas, who had contacted Helen Megaw about the crystal diagrams he had seen in Lonsdale's lecture, asked the architect Misha Black if there was a restaurant he could use for an 'experiment in pattern design'. Black, one of the founders of the DRU, already knew about Megaw and her patterns, and was happy to make such a space available: the new Regatta restaurant, which he was responsible for designing. Hartland Thomas meanwhile enlisted twenty-eight British manufacturing companies to take part in his project, representing a range of industries: clothing and furnishing textiles, carpets, pottery, plastics, linoleum and wallpaper. And he invited Megaw to be scientific consultant for the project, dubbed the Festival Pattern Group (FPG).

TWO CULTURES

To gather together the crystal structures she needed for the project, Megaw turned to her many prestigious scientific contacts, including Lawrence Bragg and the future Nobel prizewinners Max Perutz, John Kendrew and Dorothy Crowfoot Hodgkin. Some of these structures represented extremely significant scientific work. Hodgkin, for example, supplied details of insulin – a hormone that helps the body absorb glucose – on whose structure she would work for three decades, finally resolving it in 1969. Perutz, for his part,

deduced the structure of the protein haemoglobin, which carries oxygen in the blood. Proteins, containing many hundreds or even thousands of atoms, had been thought by some to be too complex to yield to the methods of crystallography.

Conscious of the value of her colleagues' work, Megaw stressed at the FPG's first meeting that 'in spite of their decorative character the patterns had all arisen in the course of scientific work and represented scientific realities'. All the same, insisted Ernest Goodale, director of textile firm Warner and Sons, 'it would be a mistake to attach too much importance to scientific accuracy . . . the first essential was that each pattern should appeal in itself'. There was the tension inherent in the project: how to balance good design and scientific credibility. Megaw tried to explain how these images should be interpreted, which parts were important, and how colour schemes might avoid doing the science any injustice. The FPG designs did indeed retain the names of the molecules, as Hepworth had advised – but not the names of the scientists who had done the work; they, tellingly, were left anonymous in case such use of their data might harm their scientific reputation.

There was some variation in how closely the FPG designs respected scientific accuracy. 'When I saw what they had done,' Megaw later reflected, 'my feelings were mixed . . . some were legitimate and beautiful; some were quite illegitimate and horrible; others in between.' But still, a spirit of cooperation and respect for the expertise of both sides was sustained. Arnold Lever, a producer of high-fashion textiles and former lead designer for the scarf and dress company Jacqmar, voluntarily withdrew two of his designs for the group when he was told that his interpretation had been too free with the science. Yet Lever's haemoglobin-based designs, later marketed as dress fabrics under the name 'flying saucers', were among the most eye-catching, employing psychedelic colour palettes nearly two decades before the Summer of Love. Even Megaw was impressed with his maverick style: she ordered a silk blouse that used a design based on the crystal structure of the mineral afwillite.

The FPG designs were unveiled to the press in all their dazzling variety on 17 April 1951 at the Regatta restaurant. The group's

ABOVE: Here modern molecular patterns are used in interior designs for the Regatta restaurant on the South Bank.

members all sported red and gold haemoglobin ties made by Vanners and Fennell. (After the Festival those ties were a big hit among crystallographers, who bought the entire stock.) The restaurant foyer housed a display of all the designs, centred on sets of crockery and cutlery decorated with patterns based on the structures of the minerals beryl and spinel – drawn from work conducted by William and Lawrence Bragg themselves. The restaurant's main design motif, which featured on the entrance sign and menus, was based on the structure of hydrargillite, which Megaw had solved.

The FPG designs also appeared elsewhere in the Festival, notably at the South Bank's Dome of Discovery and the Exhibition of Science at South Kensington. Crystallography, a field that Britain had pioneered and still dominated, was the perfect choice for conveying national prestige in science and technology. The crystal patterns became visual icons of the atomic age. 'For the first time textile designers have found their inspiration in a world that the eye cannot see, the world of the atom,' enthused *British Textiles* magazine.

Edward Mills, who designed an 'atomic screen' to shield the South Bank from the noise and bustle of Waterloo Station, said that 'in a sense the science background to the exhibition was the atom'.

The official public response was positive. *The Times* declared the FPG collection 'truly delightful', and the BBC featured the group on a radio programme. The response of the general visitor is harder to gauge. For many, this would have been the first encounter they had ever had with either contemporary design or crystallography; it was a lot to take in. The reaction of fashion journalist and former *Vogue* editor Alison Settle to the press launch displays some ambivalence, and in an intriguingly gendered way: 'The theme undoubtedly results in good designs . . . but how can designers have ignored women's chilled and horrified reactions to the very word "atom"?'

A few of the FPG products went into industrial production. A type of window glass bearing the crystal structure of the mineral apophyllite was sold by the company Chance under the name 'Festival'; it appeared throughout the festival sites, even being used as a screen in the lavatories. Alice Bragg, Lawrence's wife, was one of those who bought the lace designed by A. C. Gill on the basis of the beryl structure identified by her husband. Marianne Straub's 'Surrey' fabric pattern, based on afwillite and produced by Warner and Sons, became something of a classic. The wider influence of the FPG designs can be seen in the fashion for linear patterns evoking micro-organisms and molecular forms that flourished in the 1950s. In 1976 Megaw donated a large part of her personal collection to the Science Museum, where the samples were put on display.

The FPG's legacy went beyond fashion and design: it raised the cultural profile of crystallography and its practitioners. In 1978 Henry Moore produced a series of lithograph drawings of Dorothy Hodgkin's hands, and even much later artists have been inspired by molecular imagery: Damien Hirst's 1998 Pharmacy restaurant perhaps owes a debt to the Festival's Regatta. And it might be said that the Festival of Britain saw the first of the 'sci-art' collaborations that still flourish today, as scientists and artists come together to see what each can offer the other – and what they share in common.

16

Wonder Materials: Transforming Everyday Life

It wasn't intended to be a satire only at the expense of Industry. Each character of the story was intended as a caricature of a separate political attitude, covering the entire range . . . Even the central character was intended as a comic picture of Disinterested Science.

ALEXANDER MACKENDRICK, 1951

You hear it before you see it: a gurgle, rhythmic, with a regular bass-line, the epitome of what a cranky scientific apparatus ought to sound like. Then the equipment comes into view: a mass of chemical glassware with a spiral condenser (used for distilling alcohol) – the wrong way up – at its core, a flashing lamp at its heart, and liquids surging through the tubes in time to the sound. When a character fiddles with a valve, it lets out a vicious-sounding blast of steam. And, as we find out, it has a tendency to create disastrous explosions.

This sound-and-sight gag is emblematic of Alexander Mackendrick's *The Man in the White Suit*, a 1951 film all about scientific idealism and hubris, set in a postwar Britain that was seeking to relaunch itself as a high-tech nation. The scientist at the heart of the action, played by Alec Guinness, is Sidney Stratton, a young Cambridge-educated chemist who has got into the textile industry with the personal aim of making the best synthetic fibre in the world. The science is difficult, and there are many failed trials

and explosions before he succeeds in creating the white suit of the title, out of a new textile fibre that is indestructible and repels dirt.

So much for the idealism. It soon becomes clear that a product like this would be a disaster for the textiles industry: the market for new clothing would shrivel if clothes didn't get dirty and didn't wear out. Soon, Sidney finds himself caught between offers of bribes from the textile bosses to suppress his invention, and anger from the textile workers who fear losing their jobs. After a hair-raising chase by a crowd of industrialists and workers, he is saved by a classic *deus ex machina* when the fabric in his suit begins to disintegrate. The fibre is

ABOVE: Inspecting the scientific equipment for 'a special job' producing strong fibre in *The Man in the White Suit*, 1951.

clearly flawed after all – and so is Sidney's science. Will all the anarchy now just fade away like the fibre itself? Not quite. As Sidney leaves the textile town, glancing at his laboratory notebook, he has an inspiration – it is clear that he has figured out how to make the fibre *really* indestructible. Those were the days before sequels were *de rigueur*, but this one wasn't necessary anyway; *The Man in the White Suit* has already shown us the dangers of naivety in the use of science.

The Man in the White Suit is an Ealing comedy: one of a group of films made in west London between 1947 and 1958 under the direction of Michael Balcon. They were conspicuously well crafted, produced by a stable of talented directors, featured a repertory company of stars, and followed whimsical plots that often poked fun at Britain's class system and traditions. In *Kind Hearts and Coronets* (made by Robert Hamer in 1949), for example, Guinness plays all the members of an aristocratic family murdered one after the other by the film's protagonist (played by Denis Price) for disinheriting his poverty-stricken mother. *The Man in the White Suit* gave key roles to Cecil Parker as Alan Birnley, head of one of the two mills in the film, and Joan Greenwood as his daughter, Daphne. All of them, along with Guinness, were stalwarts of the Ealing films. Mackendrick had previously directed just one feature, *Whisky Galore!* (1948), also for Ealing, having joined the studio in 1946 after short spells making documentaries. He made three more films at Ealing, culminating with another classic black comedy, *The Ladykillers* (1954), before moving to Hollywood to make *Sweet Smell of Success* (1956).

Among the key elements that make *The Man in the White Suit* so effective – along with a tight script, confident pacing and charismatic performances (notably from Guinness) – is a clever and stirring musical score by Benjamin Frankel, which uses the rhythm of the weaving loom to lend an appropriate tone of urgency at the beginning and end of the film. Throughout, apposite musical 'cues' underpin key plot points. The sound of Sidney's chemistry apparatus, a leitmotif throughout the film, was made by using straws to blow bubbles in glycerine and water. A version of the music was later released on record as *The White Suit Samba* by Jack Parnell.

But what was it really that the film set out to caricature? The

ABOVE: Poster for *The Man in the White Suit*, showing Sidney Stratton, played by Alec Guinness, running away.

unnamed textile fibre at the heart of the plot faithfully reflects the promise that synthetic fibres seemed to offer: that of a miracle substance, strong, affordable, reliable and democratizing. Now that plastics and synthetics are regarded with suspicion (for the wastefulness they represent and their harmful effects on the environment) and condescension (for their vulgar presumption to mimic the 'natural'), it can be hard to remember how different they seemed when they first burst onto the textiles and fashion scene, smelling of convenience and chic modernity.

SYNTHETIC FIBRES

During the interwar period two artificial fibres were developed commercially. One was rayon; the other was cellulose acetate, made from cellulose derived from cotton waste or wood (and thus 'semi-synthetic'). Rayon was enormously profitable, as the source material, wood pulp, was cheap; Courtaulds and DuPont (previously an explosives manufacturer) were two of the largest producers. And in 1935 a third, entirely synthetic fibre was developed at DuPont by the chemist Wallace Hume Carothers: nylon (originally called, more precisely, nylon 66). DuPont had a patent-sharing agreement with the British chemical giant Imperial Chemical Industries that gave ICI the right to develop nylon in Britain. But the company had no experience in textiles. So it decided to team up with the long-established fabrics firm Courtaulds, with which ICI had signed a 'non-aggression pact' in 1928. The two firms set up a joint subsidiary called British Nylon Spinners.

DuPont thought they had the development of synthetic fibres all sewn up. But then the German chemical behemoth IG Farben entered the market with a different kind of nylon, called nylon 6, invented in 1938 by the conglomerate's scientist Paul Schlack in the course of some unauthorized research (echoing Sidney Stratton's activities in *The Man in the White Suit*). And in 1941, two chemists in a textile-printing firm in Manchester came up with a completely different type of synthetic fibre: polyester, better known in the 1950s as terylene. ICI acquired the rights to polyester, which they shared with DuPont but not Courtaulds. The synthetic-fibre industry had quickly become a highly competitive one.

Recognizing the potential of this new market, in 1937 ICI had also developed another, totally different, artificial fibre, which it called Ardil. Made from peanuts, Ardil was intended as a substitute for wool, just as nylon was a cheap stand-in for silk and polyester was regarded as a synthetic alternative to cotton. In using peanuts from British-ruled east Africa, Ardil certainly justified the 'Imperial' in ICI's name; but it was expensive, because peanuts were in short supply. Besides, the fabric was hard to cut and was eventually found,

like Stratton's suit, to degrade easily. ICI persuaded the leading physicist William Astbury, a specialist on the molecular structure of fibrous polymers whose work had been instrumental in the development of Ardil, to wear an overcoat made from the material during the war; he also had an Ardil suit made in 1951, but had to tell the company a year later that it was wearing out. Ardil was abandoned by ICI in 1957, and was replaced as a wool substitute by acrylic fibre, which had been independently developed by DuPont (under the name Orlon) and the German chemicals company Bayer (which called its product Dralon).

Although nylon had been invented in 1935 and polyester in 1941, turning them into commercial products took time, and that process was further slowed by the war. So it was not until 1949 that British Nylon Spinners began production, at a factory in Pontypool, and

ABOVE: This first sample of nylon knitted tubing was created in 1935.

1950 that ICI started producing polyester fibre at Wilton on Teesside. At the time *The Man in the White Suit* was made, there was every reason to think there would be more and different mass-produced synthetic fibres – although in the event, rather surprisingly, that hasn't happened. The new plastic Teflon (polytetrafluoroethylene), first made in 1938, has very similar properties in some respects to Stratton's fibre – high melting point, high strength and dirt resistance – but it can't be spun into fibres, working only as a coating.

The popular reception of these synthetic fibres was mixed. Some, such as nylon, were a hit, especially when used in stockings. Others were widely considered to be inferior to the natural fibres they were intended to emulate. Still, all the new fibres had several things going for them. First, at a time when clothes were still generally very expensive, they were cheaper than cotton or silk. What's more, garments made from synthetic fibres were easy to wash and dried more quickly. And they were hard-wearing.

In the 1950s and early 1960s nylon was used not just for stockings and lingerie but also for socks, shirts and bedsheets. The company Brentford Nylons, for example, made nylon bedclothes, including brushed-nylon sheets with a softer, feathery texture for winter use. Advertisements suggested that a man now only needed one shirt, if it was nylon: he could wash it in the washbasin before going to bed, hang it over the bath, and it would be ready to wear in the morning. Indeed, as Mackendrick's film foresaw, the hardy nature of new fibres did indeed pose a potential problem for the textiles industry in the prospect of greatly reduced consumption. A pair of socks might last for a decade or more. The 'problem' was solved by the introduction of mixed-fibre (such as polyester–cotton or polyester–wool) fabrics in the mid-1960s. And there was another feature of the fibre shown in the film that was also true of some of the new textiles, including nylon and polyester: it couldn't readily be dyed. So new dyeing methods had to be developed to overcome these problems.

Stratton's suit is not only white; it's also luminous. This may have been intended to hint at the radioactivity involved in his chemical process, given the popular – if mistaken – association between radioactivity and glowing in the dark. (The idea derives from the use

OPPOSITE: ICI's research and development department invented terylene in 1941, a few years before this prototype nightdress was made.

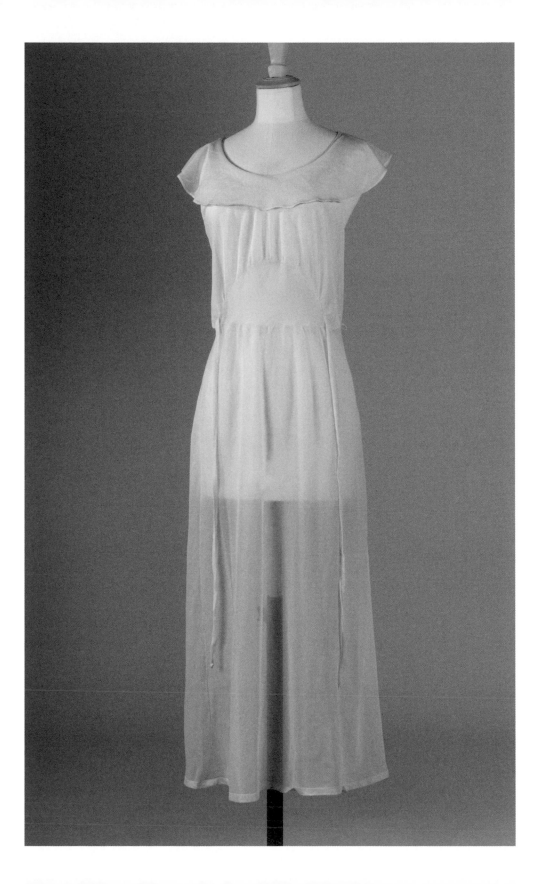

of radium in luminous watches, but in general radioactive substances don't glow.) In the film, the fabric's brilliant luminosity was achieved by using compounds called optical brighteners, another product of the chemical industry, and ultraviolet lighting. These compounds work by converting absorbed ultraviolet light into emitted visible light. They were – and still are – added to washing powders to make fabrics 'whiter than white'. All this was part of the postwar revolution in laundry agents, when soap was displaced by synthetic detergents. Other new ingredients included bleaching peroxides (the 'per' in Persil) and so-called 'builders', which were alkaline compounds such as sodium carbonate or sodium silicate (the 'sil' in Persil). In a period of coal fires and pea-souper smogs, when people took fewer baths or showers than they do today, brilliant whiteness in clothes – especially shirts – was highly prized. Advertisements for washing powders, notably Daz, were keen to trumpet their whitening power. Synthetic fibres increased the tendency to use optical brighteners, because nylon goes yellow with age and chlorine bleaching only makes the problem worse.

THE CHARACTER OF THE SCIENTIST

The script of *The Man in the White Suit* was Mackendrick's wholesale rewrite of an unperformed play by his cousin Roger MacDougall, with whom he developed several projects; finishing touches were added by screenwriter John Dighton. The theatrical script and the film were based on the same theme: the invention of an indestructible fibre and its effects on the textiles industry. But Mackendrick entirely shifted the focus of the story, as he later recalled: 'I did something really rather wicked: I took Roger's hero and gave him a minor role, and pivoted the whole story around a secondary character, the one played in the film by Alec Guinness.' That shift places the scientist at the heart of the action, and thereby makes *The Man in the White Suit* a comment on the dangers of science pursued naively, as well as a reflection on the conservatism of postwar Britain.

Like other Ealing films, *The Man in the White Suit* is a penetrating

satire on British society at the time of the Festival of Britain in 1951 (for more on the Festival, see Chapter 15). While the aim of the Festival was to celebrate British technology, in fact the public at large, as well as many industrialists and trade unionists, were fearful of the impact that technology might have on their lives and livelihoods. At the time there was little public understanding of science, and a great deal of bafflement at its accomplishments. Some of the fabrics designed by the Festival Pattern Group, for example, celebrated as a unique collaboration between scientists and designers and based on atomic-scale structures of molecules and crystals, did not catch on commercially because they were considered too outlandish.

Mackendrick had a taste for dark and sour themes: a feature of, as he put it, 'my perverted and malicious sense of humour'. The theme of scientific hubris running throughout the film has its roots in his desire, with MacDougall, to make a comedy about the morality of nuclear weapons, and an echo of that project can be heard in Stratton's use of heavy hydrogen and radioactive thorium, his concern with chain reactions, and the sequence of explosions that leads to the success of his experiment.

That use of thorium is, however, entirely spurious in chemical terms. Perhaps it is slightly beside the point to ask if a comedy represents science accurately, but in other respects Mackendrick took care to keep the science within the bounds of credibility. The laboratory is an accurate replica of a textile research lab of the period. The film had a scientific adviser: Geoffrey Myers, who worked for ICI Fibres in Welwyn Garden City, having taken a degree in textile chemistry at Manchester University. Myers approved the design of the lab apparatus, in which chemicals were turned into the polymer molecules from which the fibres were spun. This apparatus includes a device that looks remarkably like the 'Toronto arc', a powerful light source invented by physicist Alan Walsh in 1949. Stratton's description of the work doesn't actually make much sense, but his references to 'co-polymerisation' and 'amino-acid residues' convey a veneer of authenticity.

Sidney Stratton may not be the mad scientist featured in several

other films of this period, but he displays the established clichés of the scientific personality: single-minded, other-worldly and obsessed with clever stuff beyond the understanding of ordinary people. He shares the obsessiveness of the title character in MGM's *Dr Ehrlich's Magic Bullet* (1940), a biopic of the German scientist Paul Ehrlich who developed a cure for syphilis, but lacks Ehrlich's compensatory social compassion. As a Cambridge graduate and former college fellow, Sidney is even removed from most industrial chemists of the period, who tended to earn their chemistry degrees at night school. As a scientist he is regarded as an oddity by ordinary people like his landlady and the workers at the factory, even if they treat him kindly enough.

Yet by placing Stratton at the heart of the film, Mackendrick swings our sympathy behind his monstrous self-belief – a choice that one critic considers the film's 'only serious fault'. Much of this sympathy is won, however, by Guinness's performance. Only at the climax of the final chase sequence, when Sidney bumps into his landlady, who earns a meagre living as a washerwoman, do we get a glimpse of social disapprobation for Stratton's actions. 'Why can't you scientists leave things alone?' she demands. 'What about my bit of washing when there's no washing to be done?'

The full passage from which this chapter's epigraph is taken reveals that the target of Mackendrick's satirical aim was much broader than, as he called it, 'Disinterested Science'. 'Each character of the story', he said, 'was intended as a caricature of a separate political attitude, covering the entire range from Communist, through official Trades Unionism, Romantic Individualism, Liberalism, Enlightened and Unenlightened Capitalism to Strongarm Reaction.' Sure enough, hardly any of the characters come out well from the tale.

DEFIANT MODERNISM

The film's setting in the Lancashire mills was apposite. The textiles industry had been in depression since the 1920s, though some relief had come with the introduction of rayon in place of cotton in the 1930s. The film's introductory voiceover by the character Alan

Birnley explains that the mills are now spinning and weaving a synthetic fibre. But in reality there was much concern about whether, after five years of postwar austerity, with outdated buildings and machinery and a unionized workforce, the industry could really adapt to the new technologies. Large firms such as ICI and Courtaulds were bullish about the new fibres, but the smaller mills, often family-owned, in the north of England (like the fictitious Corlands and Birnleys in the film), which had been the backbone of the textiles industry, struggled.

In 1940, a voluntary association within the industry known as the Cotton Board was formed to promote the welfare of the industry through reorganization, developing exports, scientific research and propaganda. Under the postwar Labour government the Board was given statutory status. Among its promotional films was *Cotton Comeback* (1946), directed by Donald Alexander, in which a skilled worker is enticed back to the industry by investment in new facilities.

The Man in the White Suit betrays anxieties about Britain's ability to cope with the postwar future. Could the country's manufacturing industry be adequately modernized? Could workers adapt to technological change? Was Britain as a whole forward-looking or stuck in the past and too attached to its traditions? The factory laboratories are symbols of progress, but a cabal of industrialists represent the forces of conservatism, led by John Kierlaw (played by Ernest Thesiger), an asthmatic, slightly satanic senior figure who tries to buy Sidney's invention in order to suppress it. In a way, the indefatigable Stratton represents British ingenuity and determination, but the film is rather pessimistic about the ability of British industry to keep pace with technological change. Such jaundiced views may have played a part in Mackendrick's decision to move to the United States shortly after completing it.

His scepticism seems to have been at least partly justified. While it would be unfair to suggest that the public is antipathetic to innovation, the history of Britain's ability to develop and embrace new technology has been a chequered one, to say the least. The British Aircraft Corporation's military aircraft TSR-2 was scrapped in the 1960s; the de Havilland Comet airliner and the hovercraft proved

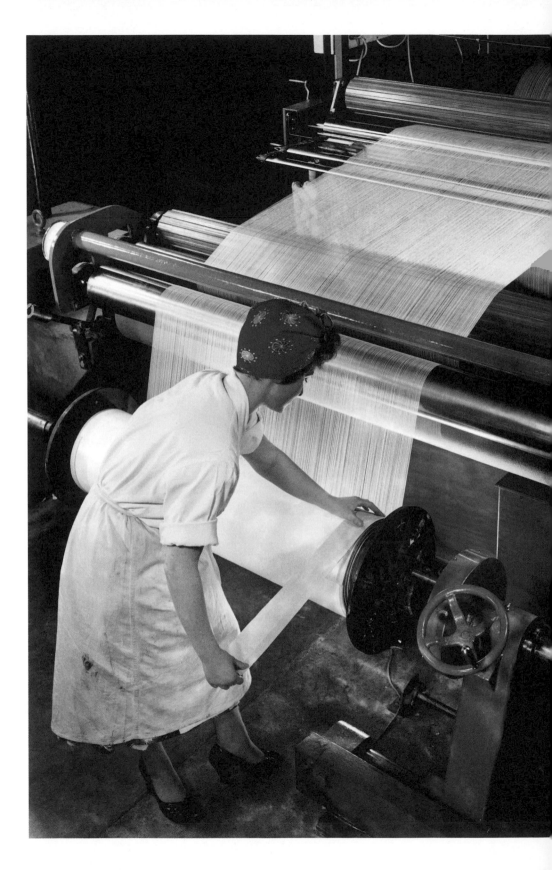

to be commercial failures; and the glory days of Concorde, as we saw in Chapter 14, were all too brief.

But perhaps it is the fate of the northern textiles industry, the milieu at the heart of Mackendrick's film, that represents the saddest failure of all. Today it has all but vanished. The breed of family-owned textiles firm shown in the film disappeared long ago, undermined by the new technology adopted in better-protected industries in the European Union and the United States, and by the use of cheap labour in Asia. ICI itself was absorbed by AkzoNobel in 2008. *The Man in the White Suit,* like all the Ealing films, is pervaded today by bittersweet nostalgia – and the bitterness can be tasted especially strongly in a sense of industrial and technological opportunities squandered.

OPPOSITE: In *Preparing a Warp* (1964), photographer Maurice Broomfield aimed to capture the striking changes that were happening in British manufacturing.

17

Polaroid Perceptions: Capturing an Instant

The camera is a medium is what I suddenly realized.
It's neither an art, a technique, a craft, nor a
hobby – it's a tool. It's an extraordinary drawing tool.
It's as if I, like most ordinary photographers, had previously
been taking part in some long-established culture in which
pencils were only used for making dots – there's an obvious
sense of liberation that comes when you realize that
you can make lines!

DAVID HOCKNEY, 1982

Photography has long played a role in virtually all scientific disciplines and in many forms of art, arguably offering objectivity and accuracy that cannot be achieved without the use of a camera. But in its early days it was either a hobby for the wealthy or an art for professionals. To pursue it you needed technical understanding of the chemistry, plenty of expensive equipment and access to a dark room. Then in 1900 Eastman Kodak released the Brownie camera – the first photographic device that the general layperson could get hold of even if they lacked money and knowhow. It sold for just $1 (about $30 today), was simple to use and required no dark room. Users would take their snapshots on rolls of ready-made film which they could then send to Kodak for processing. By 1910, Kodak had sold ten million of these cameras.

In the 1940s Edwin Herbert Land, an American scientist, businessman and founder of the Polaroid Corporation, set out to challenge Eastman Kodak's Brownie camera by eliminating the need

for development in a dark room at all: his Polaroid, first produced in 1948, developed in seconds on the spot. It became hugely popular in the mass market, but the Polaroid camera also had a significant impact on many artists working during the second half of the twentieth century. Few made more avid and inventive use of it than the British painter David Hockney.

'DRAWING WITH A CAMERA'

In early 1982 Alain Sayag, curator at the Pompidou Centre in Paris, visited David Hockney's home in Los Angeles. After much discussion, Sayag had finally persuaded Hockney to exhibit some of his twenty thousand photographs in a forthcoming exhibition at the Pompidou. Hockney's photographic albums represented every facet of his life: his family and friends, weddings, architecture, landscapes, holidays and painting references. Hockney didn't believe that photography was a true artistic medium, however, and told Sayag that the curator would have to choose the images himself.

The problem with photography, said Hockney, was that it couldn't show time; the images showed only a frozen moment from one point of view, and so no photograph deserved more than a cursory glance. Painting was entirely different, he said. Painters took hours to complete a piece, and Hockney believed it was this investment of time that made a picture worth studying. The finished product shows what the artist saw during the hours spent composing it – and that effort makes it worth the viewer's while dwelling on the work.

The same year Sayag visited Hockney, Edwin Land retired as president of the Polaroid Corporation at the age of seventy-four. The design and development of instant cameras and film back in the 1940s had launched Land on a thirty-year quest to better understand the way humans perceive colour. He was still pursuing that vision in 1982, when Hockney began to think more deeply about how photography can reflect the way humans see the world; and the Polaroid camera was the key to Hockney's exploration.

Hockney drew a distinction between the camera itself and photography. For centuries, artists have used a type of optical device

called the camera obscura, in which light from a scene enters a dark space through a narrow aperture and casts an inverted image of the scene on a screen. The same device was used by scientists interested in optics, and by illusionists – but for artists it was a means of rendering a scene accurately. They might project the image onto a canvas and trace around it. And that, too, took time. Describing how the Italian painter Canaletto used the camera obscura, Hockney said: 'As your eye moves across the surface of a Canaletto, each area of the painting is a different time; it was done at a different moment. The hand making the marks moves through time and in viewing the picture you feel this, even though you might not be conscious of it.' A photograph, in contrast, represents the same instant in the top left corner as it does at the bottom right. It is indeed a snapshot in time.

When Sayag had finally selected one hundred of Hockney's photographs, he realized how hard it would be to find the negatives from the thousands that had all been thrown into boxes – and how much time it would take to match the negatives with the photographs. So Sayag and Hockney went out and bought $12,000 worth of Polaroid film, with which they photographed each of the selected prints. Sayag would take these away to plan the exhibition, while Hockney could locate the negatives at his leisure. When Sayag headed back to Paris, he left behind the unused Polaroid film. It wasn't long before Hockney picked up his SX-70 Polaroid camera and began to experiment.

His conversations with Sayag about the merits of photography fresh in his mind, Hockney set out to recreate in Polaroid images a painting he had been working on back in London, which showed the interior of his LA home. He took photograph after photograph around the house, moving from the living room to the outside terrace and then to the swimming pool. A few hours later, he knitted these images together to create a Polaroid composite: *My House, Montcalm Avenue, Los Angeles, Friday, February 26, 1982.*

Over the next five months, Hockney became obsessed with creating these Polaroid collages, often waking in the middle of the night with a new thought or idea. He had made photographic collages before, but now, instead of taking a series of images from a

OPPOSITE: David Hockney and other artists experimented with the SX-70, one of the most popular Polaroid cameras.

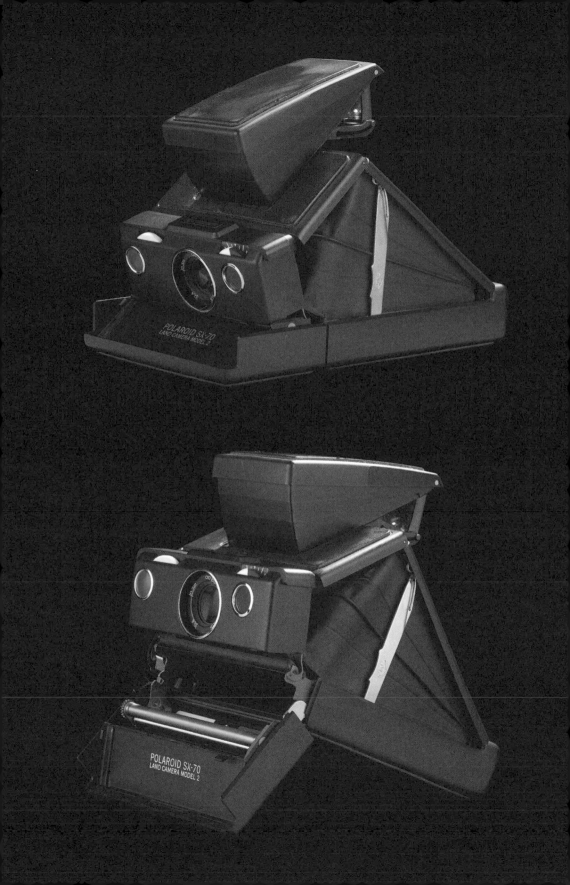

single vantage-point, he moved through the space snapping close-ups from different points of view. The composite thus showed a variety of overlapping perspectives – self-evidently a compilation of different moments in time and space.

Time, space and scale became key elements of Hockney's work during these months. The Polaroid camera made it easy to move around and capture different views of a scene, and different objects within it. 'Initially I was not concerned with space, but with time,' said Hockney, 'yet I quickly realized that one cannot perceive space without time. It takes time to perceive space, which again told me why one single photograph is essentially static – because there is not enough time within it to perceive the space that it is depicting.' This way of working with photography, Hockney believed, was much closer to how people see in real life than the images that ordinary photographs contain. He compared the way he took photographs – more than once, and from multiple perspectives – with Cubism.

He also noticed that the Polaroid camera did something odd to colour. Altering the distance between the photographer and the object in view, he said, 'had an intensifying effect on the colour; when you reduce the atmosphere between you and the subject, the colour is stronger'.

In *Sun on the Pool Los Angeles April 13, 1982*, Hockney gives the viewer the feeling of simultaneously looking down on the swimming pool and looking across it. The longer one looks at the piece, the more one can imagine Hockney moving around the pool, taking photographs of the shadows and close-ups of the sun-loungers at the far end.

Scale was also an important element. Commenting on his creation of *Maurice Payne Reading The New York Times in Los Angeles Feb. 28th 1982*, Hockney said that he consciously juggled with scale: 'There was a poster of flowers on the wall next to him; it seemed to me that one looked at the poster twice because of the bright flowers, so I photographed it twice and made it larger. It was trying to follow the way I would look at something, to give an account through time of my seeing.' The closer one gets to a subject, the more difficult it is to see.

Hockney described this way of working as 'drawing with a camera'. The whole process took several hours, and required him to make decisions, much as painting did. He had to think about composition, colour and scale, and to make corrections as he went along. He would spread the photographs out, arranging them into a composition, and then return to his subject to take more. This technology became a tool just as much as a paintbrush is. And Hockney looked upon the Polaroid collages as being akin to studies, testing out different ways of working. His five-month foray into Polaroid collages had a direct impact on the collages and paintings that he created afterwards.

CAPTURING AN INSTANT

Curiously, Hockney's way of working paralleled Edwin Land's approach to the experiments on which he worked obsessively for decades in his research into colour vision.

In his youth, Land was an avid reader and had a fascination with scientific toys such as kaleidoscopes and stereoscopes. He went to Harvard in 1926 to study chemistry, but quickly became disillusioned and left for New York, where he started experimenting with films called 'polaroids' that could filter and polarize light (transmitting only light waves that oscillate in a particular plane). Such materials are now used in all manner of products – sunglasses, pocket calculators, 3D glasses, Kodak cameras. In 1929 he filed his first patent on polaroids, and the same year returned to Harvard, where he was given a small laboratory for his work; but in 1932 he dropped out again to start his own lab, and in 1937 he formed the Polaroid Corporation.

Land was driven by scientific curiosity, but he also believed that scientific inquiry should result in practical devices and technology. He began experimenting with instant photography in 1944; four years later, the company put its first camera with instant film, the Model 95, on sale in Boston. It sold out in minutes. The photographs, in sepia tone, formed when a negative backing was pulled off the image exactly sixty seconds after the film came out of the camera. In

OVERLEAF: Hockney's Polaroid composite pieces were strongly influenced by the works of Picasso and ideas from Cubism.

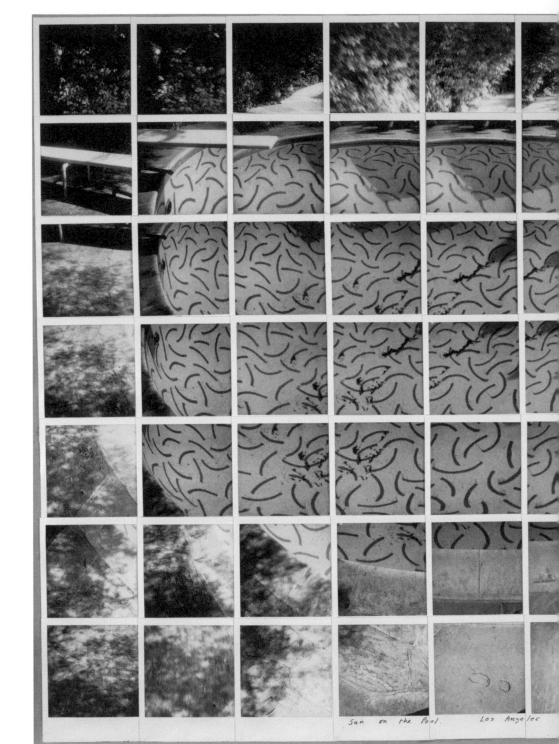

Sun on the Pool. Los Angeles

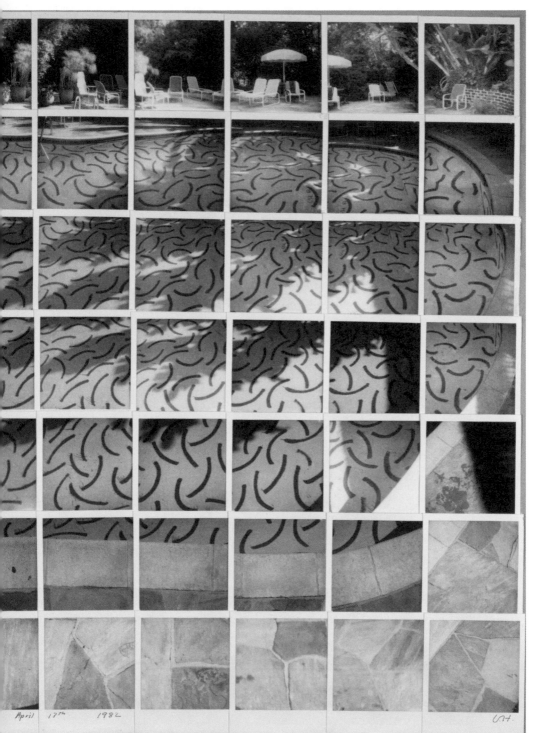

April 17th 1982 CH.

effect, Land had packed an entire dark room into a hand-held device.

Land's company lacked marketing resources, and so they sold the camera and film by demonstrations and word of mouth, one city at a time. They launched the new technology first in popular holiday destinations such as Florida, emphasizing the appeal of having your holiday snaps ready to show your friends the moment you got back home. Soon the company was big enough to afford television adverts, for which the sixty seconds' developing time was perfectly suited.

On New Year's Eve 1956, the company sold its millionth camera. It was an ideal time to be selling an affordable luxury product like this, with a boom in consumer spending after the end of the war. Everyone wanted a smart house, a fast car, a refrigerator and a television. They wanted a visual record of their special times, too, and the Polaroid camera could do that faster than anything else – and with comparable image quality.

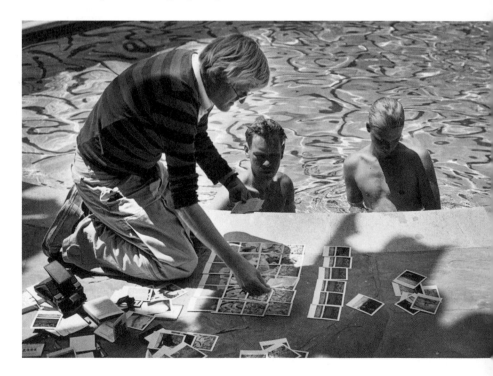

ABOVE: Polaroid instant film allowed Hockney to develop compositions in real time, fitting the photographs together like a puzzle and reshooting subjects as necessary.

But these images were still black and white, which was increasingly a drawback in the age of Technicolor cinema. Creating instant colour film, however, was an immense technical challenge. Land began to attempt it in the 1940s, and in 1953 the lead scientist of the project, Howard Rogers, made a big breakthrough in which he figured out how to combine a coloured dye with the chemical developing agent on a single molecule. Polacolor film eventually went on sale in 1963.

Land sought out colleagues who valued creativity and artistic sensibility. 'The purpose of inventing instant photography', he said, 'was essentially aesthetic – to make available a new medium of expression to numerous individuals who have an artistic interest in the world around them.' He believed that artistic inquiry would develop products in ways that scientific and technical researchers would not think of. Many of Polaroid's employees – like Land himself – did not have a high degree of formal scientific training or education, and while this obviously had some disadvantages, it did mean that the laboratories were infused with innovative thinking.

Land realized that working with professional photographers might not only push the technology further but could also make a real contribution to marketing. In 1948 he hired the landscape photographer Ansel Adams as a consultant to test and analyse the cameras and film that his team developed. Adams probably tested every one of Polaroid's camera models and film types during his time with the company, and decades later he even wrote a manual, *Polaroid Land Photography* (1981). This partnership was the prototype for other collaborations, in which artists were given free Polaroid products in exchange for some of their photographs. Eventually the company amassed works from hundreds of artists, including Chuck Close and Andy Warhol.

PERCEIVING COLOUR

The challenge of making an instant colour film drew Land into a more general study of colour and vision. This entailed doing experiments in the production and perception of colour, one of which precipitated his thirty-year journey of discovery with outcomes

that would eventually influence contemporary colour theory.

In 1955 Land projected a black-and-white image through two projectors, one with a green filter and one with a red filter. When the two images were superimposed, they showed a full range of colours – a result that had been familiar since the work of the Scottish mathematician and physicist James Clerk Maxwell in 1855. But then, in a variation on this experiment, Land removed the green filter, so that the image was projected in one case with the full spectrum of white light, and then mixed with the red-light image from the other projector. Under that circumstance Land expected the combined image to look pink. In fact, however, pretty much all the original colours could still be seen. At first Land thought this was just an example of colour adaptation, where the visual sense adjusts to differing degrees of illumination or colour tone so as to retain the original spread of colours. This is why, for instance, we perceive the colour of a ripe banana as yellow both in bright sunlight and in a room with dim lighting, despite the differing range of wavelengths that the banana reflects in the two cases. But soon he decided there was more to it.

Land set up the two projectors again, one with a red filter and the other with no filter. When he turned down the intensity of the white light to match that of the red, he got 'the surprise of his life: the screen was filled with "a remarkably extensive palette of colors," lifelike and persistent'. For years thereafter, Land worked obsessively in the attempt to figure out what was going on. 'What was special about Land', one biographer wrote, 'was his passion for doing experiments, along with his quick mind that playfully questioned everything, particularly his own hypotheses. He literally could not sleep when he found an experiment that was trying to tell him something.'

Land developed a new theory of colour vision that he thought could accommodate the phenomenon. He called it the 'retinex' theory – an amalgam of 'retina' and 'cortex', since he believed that it is the interaction between the eye and the brain that enables us to perceive colours. This was a very different view from Isaac Newton's in the seventeenth century, according to which, since each colour

has its own band of wavelengths, it is these specific wavelengths that determine the colour the eye sees. Instead, Land argued that in real life it is the context of the entire scene in front of the eyes that dictates the colour that is experienced in any part of it.

This wasn't a completely new idea in itself – the known phenomenon of 'colour adaptation' said as much, after all, and in the early nineteenth century the German writer Johann Wolfgang Goethe had pointed out that colour perception has a psychological aspect. But Land made a specific proposal about what it is that determines the perceived colour: the relative intensities of the different wavelengths that an object reflects under different lighting conditions. There are, he argued, distinct 'retinex' systems of eye and brain that are sensitive to long-wave, medium-wave and short-wave light. The colour seen can be predicted from the measured reflectance of the object in each of these wavelength bands, along with the average intensity of the light reflected from the object's surroundings. Land and his colleague John McCann used these ratios to create a computer algorithm that models the way people see colour, and although human colour vision is now known to be more complicated, this algorithm is still in use today.

In 1985, Land explained retinex theory like this:

> The great question is: How do we know the apple is red? Why does it look red? If, in particular at noon, there might be more blue light coming to the apple than there is red light? Some people thought that maybe, we got *used* to the change, or the pigments in our eye bleached and changed and then you got used to it. But, you can take a camera shutter – look out at the world through a camera shutter – and see the world in a tenth or a hundredth or a thousandth of a second, and you find the eye works in just the same way, that it does not need time to get used to it. There's no getting used to it, or adapting, involved.

To make measurements of this effect, Land went on to develop multicoloured collages which he called 'mondrians', because of their resemblance to the paintings of the Dutch painter

Piet Mondrian. The subject would view two mondrians in different light sources and then adjust the brightness of the light to match the colour of a patch in one mondrian to that in another.

Land approached his experiments and theories about colour vision from outside the usual scientific fields. When he wrote his first paper describing his experiments on colour vision in 1959, he immediately attracted critics. Some accused him of inadequate acknowledgement of the work of his predecessors. Others said he had proposed nothing new, or simply did not believe his results. It is true that Land's experiments and conclusions were often overcomplicated, and it took him the best part of two decades to outline the retinex theory clearly. But by the end of the 1980s, neuroscientists had largely accepted his work on colour vision. Today, Land's retinex theory is still used in computer algorithms to create digital colours.

THE THINKING IN SEEING

Hockney's foray into photography using Polaroid technology set him on a similar quest to Land's, investigating the way that humans see and trying to replicate this in his artwork. 'I don't believe I ever thought as much about vision, about how we see, as I have during the last several months,' Hockney said at the time. 'Working on these collages . . . I realize how much thinking goes into seeing – into ordering and reordering the endless sequence of details which our eyes deliver to our mind.'

The story of instant photography shows artists and scientists in close collaboration and dialogue. Both Hockney and Land recognized the importance of personal perspective in how we interpret a scene, and both embraced new technology and the opportunities it offered. Through the technology that Land created at the Polaroid Corporation, both men obsessively studied and experimented with photography and vision, challenging their own and others' beliefs. In his use of this technology, Hockney's art abandoned any claim to present a single 'truth' in favour of multiple dynamic perspectives and a proliferation of meanings.

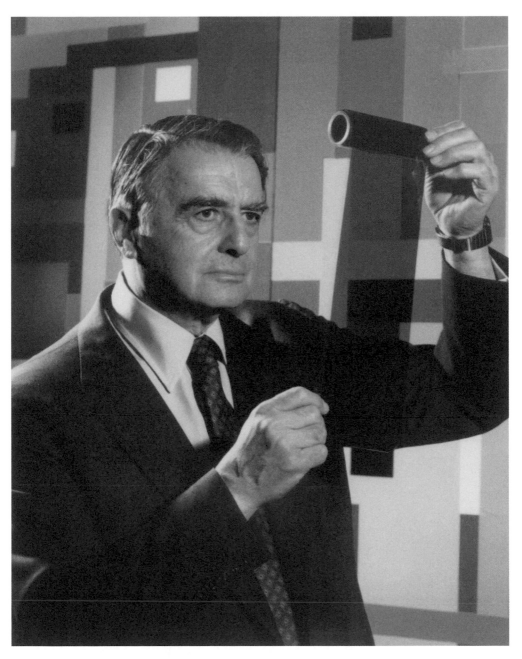

ABOVE: Edwin Land used his 'mondrian' colour experiments to investigate colour perception.

Then what is the creature like that is looking at this guitar? It's got one eye and it's got one fixed point:

Well, let's alter this diagram, let's make it closer to what *we* are like. The next diagram is a far more accurate picture of human perception – our eyes move about and there are many points of focus and many moments:

ABOVE: Hockney's work on Polaroid composites led him to examine how photography could better embody human perception.

18

Protecting the Earth: Political Pessimism on Screen

I call upon the scientific community who gave us nuclear weapons to turn their great talents to the cause of mankind and world peace: to give us the means of rendering these nuclear weapons impotent and obsolete.

PRESIDENT RONALD REAGAN, 23 MARCH 1983

The 1970s were a period of great anxiety and uncertainty, as science and new technologies appeared to be taking humanity in worrying directions. Alongside fears about the rise of nuclear power and the threat of nuclear weapons ran an increasing concern for the environment and the future of the planet. Both came to a peak in 1983, when US President Ronald Reagan went on television to present to the American people his new Strategic Defense Initiative (SDI). He appealed to them to support the higher defence spending this would entail, and he called for scientists to help make his vision a reality.

Previously the superpowers – the United States and the Soviet Union – had both subscribed to the nuclear strategy of mutual assured destruction, according to which neither side would attack the other with nuclear weapons because of the certainty of instant and catastrophic retaliation. Now Reagan's new initiative – dubbed 'Star Wars' – threatened to undermine this precarious balance with the proclamation that the United States would develop a missile

system that could 'intercept and destroy strategic ballistic missiles before they reached our own soil or that of our allies'.

Reagan's speech was made in terms of a personal appeal, in which he presented the SDI as a new form of security and a new basis for peace – albeit at great cost and with an uncertain timeline. Not everyone was convinced that so ambitious a technological departure would create harmony. Developing such a one-sided capability could be regarded as an escalation of Cold War nuclear competition, implying that nuclear war could be survivable and winnable, and thereby increasing the chance of its happening. What's more, the SDI was launched at a time of rising concerns about the environment, and such promethean ambitions for nuclear weaponry seemed the antithesis of the greater respect for the planet that many were now advocating.

In Britain, the announcement of this belligerent and hubristic policy from across the Atlantic came at a time of great transformation, uncertainty and contradiction. On the one hand was the colour-saturated and saccharine world of advertising and pop culture; on the other was the grimmer world of angry, raw and politically informed mass protest. The policies of Margaret Thatcher's

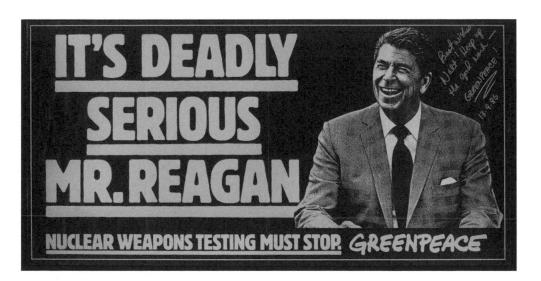

ABOVE: This anti-nuclear protest poster is part of a collection gathered by energy campaigner Walter Patterson in the 1980s.

Conservative government were bringing about fundamental structural change in society. Her promotion of market competition and economic liberalism – along the same lines as Reagan's policy programme in America – was supposed to create a stronger and growing economy; but its implementation was accompanied by disruption, poverty and unemployment, not least because of the privatization of formerly nationalized industries and the closure of centres of manufacturing and mining. These were polarized times, times to be outspoken and opinionated, whether in opposition to racism, demands for greater freedoms of sexuality, or increasing environmental awareness and activism. Even the fashion industry was becoming politicized, as for example when designer Katharine Hamnett accosted the Prime Minister at a reception in 1984 wearing a T-shirt emblazoned with the slogan '58% don't want Pershing' – a response to controversial proposals to base a new generation of American missiles in Europe.

It was in this complex, anxiety-ridden and conflict-filled context that one of the most remarkable television series ever created in the UK was released by the BBC. A multilayered artistic fusion of political and scientific ideas, it proved so popular that it was immediately repeated, and was subsequently garlanded with awards. It was called *Edge of Darkness*, and it captured the dark, fractious and paranoid spirit of the times.

THE NUCLEAR STATE

Reagan's impassioned and technocratic Star Wars speech provided the perfect spark for maverick script-writer Troy Kennedy Martin, who had previously co-created the celebrated British television drama *Z-Cars* as well as scripting the iconic, sardonic movies *The Italian Job* and *Kelly's Heroes*. Kennedy Martin was struck by how little the intensely political atmosphere of the time was reflected in the output of the BBC. The escalation of Cold War tensions between the Soviet Union and the United States had given rise to a new generation of nuclear weapons, which was met in turn by the resurgence of established peace movements such as the Campaign for Nuclear

Disarmament and the emergence of new ones, such as the women's peace camp at Greenham Common in Berkshire. The Falklands conflict between the UK and Argentina, the dislocation caused by Thatcher's economic policies, and the impending confrontation between the government and the National Union of Mineworkers had all created a deeply unsettling mood across the country. Kennedy Martin wanted to capture this uncertain time in his new series.

Edge of Darkness – originally named *Magnox* after a type of nuclear reactor used in British power stations – became a gritty, raw but nuanced thriller that explored contradictory and powerful themes: the secrecy and use of force by the nuclear state, the hopes and fears unleashed by global environmentalism, personal political passion and family love. Kennedy Martin did not have high hopes that such an intense and unsettling series would get approval from the commissioning authorities, but he felt the urgency of the issues he wanted to address, and so pressed on with the script anyway.

The series opens with policemen inspecting the premises of the nuclear company International Irradiated Fuels through a wire fence, as an ominous alarm blares in the distance. We see nuclear-fuel reprocessing flasks being transported by train under cover of night. We are introduced to the brooding and troubled Ronald Craven (played by Bob Peck), a police officer who has lost his wife and whose daughter Emma (Joanne Whalley) is shot dead in the first episode. At first Craven believes that he was the gunman's target, but then he discovers that Emma was part of an anti-nuclear activist group called GAIA that had broken into a low-level radioactive waste facility, Northmoor, because they believed it was storing plutonium for nuclear weapons. As the narrative develops, a series of personal, political and corporate storylines are woven into a complex and emotional plot. It becomes apparent that great and opposing forces are at play as a constellation of shadowy characters become involved: government officials, nuclear entrepreneurs, the intelligence agencies CIA and MI5, and environmental and political activists.

The series has a combination of pace and texture which was ahead of its time, along with an intense and melancholic score created by composer Michael Kamen and guitarist Eric Clapton. In a moving

ABOVE: Ronald Craven, played by Bob Peck, with his daughter Emma's teddy bear in *Edge of Darkness*, 1985.

scene in the first episode just after Emma's death, Craven examines her bedroom. Clutching her teddy bear and taking in the possessions that document her life, he plays the record on the turntable, Willie Nelson's 'The Time of the Preacher'. Sitting on her bed he finds her vibrator in her bedside drawer, raises it to his lips and kisses it gently. The contrast of the teddy bear and the vibrator – of Emma as a child and Emma as a woman – and Craven's response to both encapsulate a beautiful portrayal of a father's love for his daughter as he mourns her lost future. But then he also discovers in the same bedside cabinet a radiation monitor and a gun – and it starts to become apparent that Emma's death may have been more than a tragic mistake.

As the series develops, Craven and Emma emerge as deeply thoughtful, caring and intelligent characters. Craven is racked by grief and anger, desperate to find the reason for his daughter's death, while his daughter is driven by a strong sense of moral righteousness to uncover the truth about the damage being wrought on the environment. Craven encounters a series of ambiguous and compelling characters: the provocative and manipulative double-act Pendleton and Harcourt from the security forces, who are mysteriously attached to the Prime Minister's office; the simultaneously brash and conspicuous but subtle and dangerous Jedburgh, a Stetson-wearing Texan CIA operative with surprising connections; and the union official Goldbolt, whose craggy face, etched with disappointment, seems to embody both Northmoor's rocky shafts and his compromised status as a man who owes his position to political expediency.

The story was entirely fictitious, but Kennedy Martin was keen to ensure that the science was correct, and the industrial and political context realistic. He sought expert advice from Walter Patterson, who had written extensively about nuclear power and was one of its leading critics in the UK. Patterson, he later said, 'supplied us with much-needed technical assistance but also provided a robust critique of the plot and made many suggestions . . . For instance, he told us about the corrosion of the Magnox fuel rods at Sellafield as they lay in water-storage, which greatly added to the legitimacy of the Northmoor plant'. The series shows close attention to detail, both technical and personal.

Long before the connection is made explicit, the context of nuclear paranoia and the advent of a new generation of nuclear weapons is introduced as Reagan's plans for 'Star Wars' are announced on the radio in the background to a quite unconnected scene.

It is the ability to weave a narrative not just from cultural and political threads but from scientific ones too that elevates *Edge of Darkness* above other political thrillers. For Kennedy Martin, the impetus behind the series was mainly one of political pessimism, fuelled by contemporary concerns such as nuclear-waste disposal, the deployment of cruise missiles at Greenham and the Falklands War. But the growth of politically engaged networks of activism and alternative green lifestyles offered a more optimistic counterpoint. 'People were against various things but what were they for?', Kennedy Martin asked. 'As the decade progressed they gradually realized that they stood for something very important: the planet . . . and the hypothesis that seemed to legitimize it, although its creator would be reluctant to acknowledge it, was Gaia.'

This is a reference to the then little-known and controversial idea published in a book only a few years earlier by the maverick independent scientist James Lovelock. His 'Gaia hypothesis' proposed a holistic approach to understanding our planet, in which both living and non-living things are regarded as components of a single complex system. *Gaia* divided scientific opinion, but it contained the seeds of a transformation in approaches to understanding what many now call the 'Earth system'.

THE UNCONVENTIONAL SCIENTIST

James Lovelock defied convention from an early age: throughout his school years he refused to do homework, insisting that school had no claim on his evenings or weekends. He later said that he had learned most of his science from books borrowed from Brixton Library. As he showed a talent for drawing, his parents encouraged him to concentrate on the arts, taking him to the National Gallery and the V&A Museum; but Lovelock himself says he preferred to cross Exhibition Road to explore the Science Museum.

He took inspiration from novels too. 'I read very little other than fiction,' he wrote in 1981. 'Text books always seem to be out of date or if timeless out of print.' This reading ranged widely – from spy thrillers and science fiction to classic romance and poetry – and he wrote spy stories himself.

Lovelock's scientific career started at the National Institute for Medical Research in Mill Hill, north London, where he worked from the start of the Second World War through to the 1960s. His research was diverse: exploring the contagion of the common cold, for example, and how to reanimate frozen hamsters. It was at Mill Hill that he developed his 'electron capture detector' (ECD), one of his most important inventions, which he initially described as 'a fascinating distraction with no apparent use'. In fact, it was a device for detecting chemicals in air with extreme sensitivity, and could be used to measure tiny quantities of compounds called chlorinated hydrocarbons, which include some pesticide agents and chlorofluorocarbons (CFCs). The latter are now known to cause chemical destruction of the ozone layer in the stratosphere, which absorbs ultraviolet radiation from the sun and prevents it from damaging living things on the planet's surface. The ECD became a key instrument for revealing the increasing concentrations of CFCs in the atmosphere and the resulting catastrophic depletion of the ozone layer in polar regions.

In the 1960s the newly formed US space agency NASA began planning to send unmanned spacecraft to Mars to look for signs of life and to see whether the Martian surface had the conditions required to sustain it. In March 1961 the agency wrote to Lovelock inviting him to work for them on the project. The kind of instruments Lovelock had been developing – small and easy to use but extremely sensitive – were just what was needed for such missions. Lovelock admits to having been astonished by this invitation to contribute to the science of the first expeditions to the moon and Mars. But he accepted.

While at NASA he began to consider whether life could be detected on a planet without even sending a spacecraft there, simply by examining the planet's atmosphere. He suggested that any planet supporting life would have an atmosphere rich in gases produced by

living processes, such as methane and oxygen. If there were no life present, such gases would be quickly removed from the atmosphere by chemical reactions, producing a state of chemical equilibrium. So one remotely detectable signature of life on a planet, Lovelock suggested, would be a high degree of chemical *disequilibrium* in its atmosphere. The attraction of this proposal is its extreme generality, the fact that it doesn't rely on any particular theory of what kind of biochemistry extraterrestrial life is based on – *any* sort of atmospheric chemical disequilibrium can be regarded as a potential (if not clinching) signature of life.

What's more, the idea was an important step towards Lovelock's Gaia hypothesis – a theory that came to dominate his life.

A SELF-REGULATING SYSTEM

The Gaia hypothesis described the Earth as a self-regulating system that maintains favourable conditions for life. It was celebrated by some – both scientists and non-scientists – as a visionary notion, stressing the interconnection between biological life and the chemistry of the rocks, oceans and atmosphere. However, others argued that Gaia was incompatible with established scientific ideas, including our understanding of Darwinian evolution. Some regarded it as more of a metaphor than a scientific theory. That, however, was surely part of its appeal too. To environmentalists, the idea of a 'living Earth', maintaining itself in a constant state through feedback processes, offered a powerful argument for according respect to our planet and not simply plundering it as a resource for humankind. The name 'Gaia' was suggested by Lovelock's neighbour and friend, the novelist William Golding.

Lovelock initially developed the Gaia hypothesis while working at NASA, but he subsequently teamed up with the American microbiologist Lynn Margulis to take it further. Margulis had already attracted controversy years earlier with her suggestion that complex cells like those of humans had come about through symbiotic mergers between simpler cells in the distant evolutionary past – an indication of her tendency to think within a 'system-scale' framework.

OPPOSITE: This equipment was developed by scientist James Lovelock for NASA to test the function of detectors in the surface atmosphere on Mars.

This hypothesis is now generally accepted by biologists. Margulis contributed important ideas about how microbes affect the atmosphere and surface of the planet, and she thought about how one might search for evidence of the Gaia hypothesis.

Lovelock's first scientific papers on the Gaia hypothesis did not reach a wide audience. He struggled to get them accepted by leading scientific journals such as *Nature* in the face of scepticism among some other specialists. Eventually he concluded that the best way to communicate his ideas to a wide audience was in the form of popular books – a strategy that had been normal in Darwin's day but which was often regarded by academic scientists as suspect in the late twentieth century. In 1979, eleven years after the publication of his first scientific paper on Gaia, Lovelock presented his ideas in *Gaia: A New Look at Life on Earth*, written at his holiday home in Adrigole, Ireland. The book's informal style made it popular and accessible, and to date more than 200,000 copies have been sold. The 'Gaia' concept captured the popular imagination, and was rapidly adopted by green activists and the New Age movement. Some scientists looked askance at such appropriation and dismissed what they saw as a romanticized vision of a 'living Earth'. But as Lovelock sought to formulate his ideas in specific, scientific models and hypotheses, others started to take it seriously.

MODELLING THE EARTH

Some critics of the Gaia hypothesis argued that the theory implied conscious intent and self-sacrifice on the part of organisms: a type of purpose-driven, goal-oriented behaviour that had no place in neo-Darwinian models of evolution by natural selection. But Lovelock denied that such things were necessary: self-regulation of the planet, he said, could arise from 'blind' feedback loops between the biosphere (the totality of living things), atmosphere and climate. In 1981 Lovelock and his PhD student Andrew Watson devised a simple but striking computer model that demonstrated how this could work: how living organisms can stabilize environmental conditions while behaving entirely in accordance with conventional

evolutionary theory. They called the model Daisyworld.

Daisyworld is a highly simplified world. There are no clouds or oceans, and the biosphere contains just two species: white daisies and black daises. Daisyworld orbits a sun like our own that gets hotter over billions of years. White daisies reflect sunlight back into space, helping to reduce the temperature of the planet. Black daisies, on the other hand, absorb light and raise the temperature of the planet. When the planet is young, the sun is faint. But a predominance of black daisies compensates for this relative lack of solar warmth by absorbing what light there is and warming the planet. As the sun heats up, white daisies begin to dominate, cooling the planet so as to maintain a relatively constant temperature despite the greater solar input. All that is required for this to happen is for the optimal growth

ABOVE: James Lovelock's printout from the *Daisyworld* simulation (1981) shows how black and white daisies could regulate the Earth's conditions for life.

temperatures of the two types of daisy to differ, such that white daisies prosper in warmer conditions. That's the origin of the feedback: the white daisies act as a planetary thermostat, out-competing the black daisies on a warmer planet but then reducing the temperature as they spread over the surface. If the Earth then starts to cool, the black daisies begin to grow again, absorbing the heat from the sun and preserving the balance suitable for life. Daisyworld looks nothing like our planet, of course – but it illustrated the underlying principle of planetary self-regulation.

SCIENCE AND THE SPIRITUAL

The term 'Gaia' is used flexibly in *Edge of Darkness*. It is the name of the fictional environmental activist group to which Emma Craven belongs, and it has mystical, quasi-pagan associations that are alluded to throughout the series. More directly, the concept of the Earth as a system in equilibrium, and the black and white flowers of the Daisyworld model, are referred to explicitly in the final episode, called 'Fusion'. Here Emma uses Daisyworld to explain the theory to her father as she revisits him as a ghost, after he has received a fatal dose of radiation. 'Dad, it's happened before, you know,' she says. 'Million of years ago when the Earth was cold it looked as if life on the planet would cease to exist. But black flowers began to grow, multiplying across its face, until the entire landscape was covered in blooms. Slowly the blackness of the flowers sucked in the heat of the sun, and life began to evolve again. That is the power of Gaia.'

Craven responds grimly: 'It will take more than a black flower to save us this time.' But Emma offers a prospect of hope in the long term – for the planet and its biosphere, if not for humankind. 'This time when it comes it will melt the polar ice cap. Millions will die. [But] the planet will protect itself. It's important to realize that. If man is the enemy, it will destroy him.' That is Lovelock's conclusion – and warning: the planetary system (call it Gaia if you will) can look after itself, but it has no obligation to look after us.

Edge of Darkness ends poignantly on the side of Loch Lednock in Scotland: a helicopter flies overhead, having recovered stolen

plutonium, as Craven screams 'Emma!' on the top of a mountain. The camera cuts to black flowers growing amid the snow on the hillside, suggesting that the self-regulation of the Earth is already starting to occur.

With Walter Patterson's advice, Kennedy Martin did justice to both nuclear science and its attendant politics. He tried to treat the ideas contained within the Gaia hypothesis – that life will continue beyond the present, and perhaps beyond the existence of humanity itself, owing to the planet's capacity for self-regulation – with the same respect. They supplied him with both scientific and spiritual inspiration, offering a metaphor for the porous boundary between life and death. In the spot where Emma was killed, a spring of fresh water erupts: an ancient symbol of the continual renewal of life. And the original script had a different ending: Craven turns into a tree, echoing his daughter's exhortation 'You've got to be strong, like a tree' and acknowledging pagan beliefs about the sacred and magical properties of trees.

Lovelock himself was surprised at first by the spiritual elements that others found in his ideas. In 2012 he commented: 'I was puzzled and amazed that people should take an interest, a spiritual interest, in those sorts of things in it. Remember I was a fairly old fashioned, in modern terms, scientist, and anything spiritual seemed so far away from the world I lived in. I just couldn't come to grips with it at first.'

Unlike Emma Craven and her fellow activists in *Edge of Darkness*, Lovelock is to this day a strong advocate of nuclear power, believing that it provides the obvious and safest answer to our need for energy without endangering the planet by burning fossil fuels and causing global warming. He also encourages scientists to work in creative ways and not to be restricted by the divisions between disciplines. 'It's the most wonderful thing to do,' he says. 'I keep on saying that scientists are just like artists if they are creative. If you were an artist, would you want to spend your life in an institute for fine art, quibbling with other academics about the different styles of painting? You'd rather be in your garret doing your masterpiece and selling a lot of art to some tourists to pay the way. That's been my life as a scientist.'

19

Patterns of Thought: AI and Algorithms

The operating mechanism . . . might act upon other things besides number . . . Supposing, for instance, that the fundamental relations of pitched sounds in the science of harmony and of musical composition were susceptible of such expression and adaptations, the engine might compose elaborate and scientific pieces of music of any degree of complexity or extent.

ADA LOVELACE, 1843

Imagine a world where machines are capable of doing something truly human. Not just carrying out an automated task, but using that most human of characteristics, imagination, to push the boundaries of artistic endeavour. How would we feel about a computer creating a virtual world, painting an artwork, or composing a piece of music all by itself?

To a certain extent it's already happened. Today, computer programmes *do* generate music, poetry and artworks through complex algorithms, delivering on Ada Lovelace's conjecture. But algorithms are created to solve problems. Can mere problem solving and data processing really produce 'art', or does the algorithmic approach just mimic artistic creation? Computers trained on 'data' drawn from existing artworks can generate others in a similar style, which are sometimes good enough pastiches to fool us into thinking they were created by humans. But can they deliver the true 'shock of the new' that art critic Robert Hughes identified as a core component of modern art? Might we even imagine a future where computer art

worthy of the name is created not to please and delight humans but to satisfy other machine intelligences?

In the 1950s the mathematician and visionary of computing Alan Turing asked: 'Can machines think?' Some contemporary artists are exploring what 'machine intelligence' might be and what it can produce – and what the results mean for our notions of creativity, ingenuity, originality and imagination. Others are seeking to interrogate and illuminate the pervasive impact of algorithms on the world we live in: the changing patterns of movement, data, work and trade that are the result of digital machines solving thousands of problems for us on a daily basis.

All this makes Ada Lovelace's note, written a century before the development of the first digital electronic computers, remarkably prescient – not just because of what it says, but because of the imaginative leap we can discern behind the words.

IMAGINING AN ALGORITHM

Machines for calculating go back centuries – that is what the abacus is, after all. In the seventeenth century, the German philosopher and mathematician Gottfried Wilhelm Leibniz invented a mechanical apparatus that could relieve him of the need to perform straightforward but tedious arithmetical calculations. But arguably the first device that could be claimed as a lineal ancestor of the modern computer was the 'analytical engine' devised in the nineteenth century by the English mathematician and philosopher Charles Babbage. This was a mechanical device that – had it ever been actually built – would have been the size of a large room. It would have used steam power to conduct its calculations by moving a complex set of cogs, levers and punched cards. This hypothetical machine drew on the knowledge and experience that Babbage had gained designing his first calculating machine, called the 'difference engine'.

Babbage was a celebrated polymath who brought his formidable intellect to bear on some of the most pressing issues of the day, including the political, moral and economic factors involved in manufacturing. Some of his inventions, however, were rather more

whimsical: shoes for walking on water, or a cow catcher for keeping the new railway tracks free of those wandering animals. Educated at Cambridge, he was a well-known figure in London's social and intellectual elite, regularly entertaining an influential social circle of engineers, scientists, mathematicians and physicians.

Babbage was motivated to embark on his scheme to create an automatic calculating engine when he and a friend, the astronomer John Herschel, found a host of errors in some printed tables – at which he is said to have exclaimed: 'I wish to God these tables had been calculated by steam!' So in 1821 Babbage set out to create an engine that could do arithmetical calculations. He raised the extraordinary sum of more than £17,000 from the British government to support his plan, but failed to complete the machine. His reputation did not emerge unscathed.

Ada Lovelace began to collaborate with Babbage in the 1830s. She personifies a collision of two very different worlds: the flamboyant romanticism of her estranged and dissolute father, the poet Lord

Byron, and the rationalism of her highly intelligent and devout mother, Anne Milbanke. She first became friends with Babbage in her late teens, when she began to attend the famous soirées held at his house in Manchester Square, London, first with her mother and later with her mentor, the mathematician and science writer Mary Somerville. In 1833 she witnessed a demonstration of a portion of Babbage's difference engine, which her mother described as a 'thinking machine'. Despite a gap of twenty-four years in their ages, Babbage and Lovelace established a friendship based on a mutual interest in mathematics and in the rapid changes in science and industry under way at this time.

Bruised by his failure to complete his difference engine, in 1834 Babbage began work on an ambitious new calculating machine, which he called the analytical engine. He wanted it to be capable of many more types of calculation than its predecessor, which could carry out only addition and subtraction. The analytical engine would also perform multiplication and division, and its design incorporated

OPPOSITE AND ABOVE: Charles Babbage developed these punch cards as an input device for his analytical engine around 1870.

much of the architecture that we would recognize in a modern-day computer – the 'store' or memory, the 'mill' or processor, and an input and output device that used punched cards, just as electronic computers did until the 1980s. Lovelace followed Babbage's progress with great interest and began to study the mathematics underpinning this new machine.

In 1840 Charles Babbage gave a lecture in Turin on the analytical engine, and the young Italian engineer Luigi Menabrea published an account of it in French. Lovelace took it upon herself to translate this from French to English, and in doing so she added seven comments in which she elaborated on the workings and the possibilities of the engine. She realized, perhaps before even Babbage did, that this machine was not just a device for carrying out calculations, but something more. For it could in principle manipulate quantities other than numbers.

Lovelace saw that the numbers put into the device could represent abstract items such as symbols, letters and musical notes. It could therefore conduct a kind of symbolic logic, giving it a far greater generality than a mechanical calculator. It could be programmed (she did not use that word) to carry out all manner of tasks. Lovelace observed that

> the Analytical Engine does not occupy common ground with mere 'calculating machines'. It holds a position wholly its own; and the considerations it suggests are most interesting in their nature. In enabling mechanism to combine together general symbols in successions of unlimited variety and extent, a uniting link is established between the operations of matter and the abstract mental processes of the most abstract branch of mathematical science . . . Thus not only the mental and the material, but the theoretical and the practical in the mathematical world, are brought into more intimate and effective connexion with each other.

Babbage was impressed with this insight – an 'admirable and philosophic view of the Analytical Engine', as he called it. Encouraged

by Babbage's enthusiasm, Lovelace illustrated the possibilities of the analytical engine for computing the so-called Bernoulli numbers, a sequence of what are known in mathematics as 'rational numbers'. Babbage indicated how the Bernoulli numbers are calculated, and Lovelace worked out how to break down these calculations into a series of logical steps that could be entered into the machine – what we would now call an algorithm.

Lovelace was proud of her work and wanted to publicize it, but at this time there was almost no room for women in science and mathematics. So she simply published her translation of Menabrea's paper based on Babbage's talk, along with her insightful notes, under her initials A.A.L. She also sent the notes to many people, including (anonymously) the scientist Michael Faraday, director of the Royal Institution. Faraday assumed the correspondence was from Babbage, and replied accordingly – whereupon Babbage put him straight in a letter of September 1843: 'You will now have to write another note to that Enchantress who has thrown her magical spell around the most abstract of Sciences and has grasped it with a force which few masculine intellects (in our own country at least) could have exerted over it.' Lovelace hoped for a full collaboration with Babbage, whereupon she would manage his affairs and help him gain support for his work. But Babbage declined; he had already seen her independence of mind and realized she would not and need not 'become in any way his organ'. While the two did not work together again, they remained friends, and in 1851 Babbage accompanied Lovelace, now ill and frail, to the Great Exhibition: the following year she died of cancer, aged just thirty-six.

MACHINE AS HUMAN, HUMAN AS MACHINE

Ada Lovelace was a visionary who saw the possibility of the computer age; saw the potential ability of machines to solve a variety of different problems, and to undertake tasks that previously only humans could achieve. But even she probably never imagined that computing machines might evoke emotion in humans. Only now that the digital electric computer has been evolving for nearly a

Number of Operation.	Nature of Operation.	Variables acted upon.	Variables receiving results.	Indication of change in the value on any Variable.	Statement of Results.	Data.					
						1V_1 0 0 1 [1]	1V_2 0 0 2 [2]	1V_3 0 0 4 [n]	0V_4 0 0 0	0V_5 0 0 0	0V_6 0 0 0
1	×	$^1V_2 \times {}^1V_3$	$^1V_4, {}^1V_5, {}^1V_6$	$\begin{Bmatrix} {}^1V_2 = {}^1V_2 \\ {}^1V_3 = {}^1V_3 \end{Bmatrix}$	$= 2n$	2	n	$2n$	$2n$	$2n$
2	−	$^1V_4 - {}^1V_1$	2V_4	$\begin{Bmatrix} {}^1V_4 = {}^2V_4 \\ {}^1V_1 = {}^1V_1 \end{Bmatrix}$	$= 2n-1$	1	$2n-1$		
3	+	$^1V_5 + {}^1V_1$	2V_5	$\begin{Bmatrix} {}^1V_5 = {}^2V_5 \\ {}^1V_1 = {}^1V_1 \end{Bmatrix}$	$= 2n+1$	1	$2n+1$	
4	÷	$^2V_5 \div {}^2V_4$	$^1V_{11}$	$\begin{Bmatrix} {}^2V_5 = {}^0V_5 \\ {}^2V_4 = {}^0V_4 \end{Bmatrix}$	$= \dfrac{2n-1}{2n+1}$	0	0	...
5	÷	$^1V_{11} \div {}^1V_2$	$^2V_{11}$	$\begin{Bmatrix} {}^1V_{11} = {}^2V_{11} \\ {}^1V_2 = {}^1V_2 \end{Bmatrix}$	$= \dfrac{1}{2} \cdot \dfrac{2n-1}{2n+1}$	2
6	−	$^0V_{13} - {}^2V_{11}$	$^1V_{13}$	$\begin{Bmatrix} {}^2V_{11} = {}^0V_{11} \\ {}^0V_{13} = {}^1V_{13} \end{Bmatrix}$	$= -\dfrac{1}{2} \cdot \dfrac{2n-1}{2n+1} = A_0$
7	−	$^1V_3 - {}^1V_1$	$^1V_{10}$	$\begin{Bmatrix} {}^1V_3 = {}^1V_3 \\ {}^1V_1 = {}^1V_1 \end{Bmatrix}$	$= n-1 (=3)$	1	...	n
8	+	$^1V_2 + {}^0V_7$	1V_7	$\begin{Bmatrix} {}^1V_2 = {}^1V_2 \\ {}^0V_7 = {}^1V_7 \end{Bmatrix}$	$= 2+0 = 2$	2
9	÷	$^1V_6 \div {}^1V_7$	$^3V_{11}$	$\begin{Bmatrix} {}^1V_6 = {}^1V_6 \\ {}^0V_{11} = {}^3V_{11} \end{Bmatrix}$	$= \dfrac{2n}{2} = A_1$	$2n$
10	×	$^1V_{21} \times {}^3V_{11}$	$^1V_{12}$	$\begin{Bmatrix} {}^1V_{21} = {}^1V_{21} \\ {}^3V_{11} = {}^3V_{11} \end{Bmatrix}$	$= B_1 \cdot \dfrac{2n}{2} = B_1 A_1$
11	+	$^1V_{12} + {}^1V_{13}$	$^2V_{13}$	$\begin{Bmatrix} {}^1V_{12} = {}^0V_{12} \\ {}^1V_{13} = {}^2V_{13} \end{Bmatrix}$	$= -\dfrac{1}{2} \cdot \dfrac{2n-1}{2n+1} + B_1 \cdot \dfrac{2n}{2}$
12	−	$^1V_{10} - {}^1V_1$	$^2V_{10}$	$\begin{Bmatrix} {}^1V_{10} = {}^2V_{10} \\ {}^1V_1 = {}^1V_1 \end{Bmatrix}$	$= n-2 (=2)$	1
13	−	$^1V_6 - {}^1V_1$	2V_6	$\begin{Bmatrix} {}^1V_6 = {}^2V_6 \\ {}^1V_1 = {}^1V_1 \end{Bmatrix}$	$= 2n-1$	1	$2n-1$
14	+	$^1V_1 + {}^1V_7$	2V_7	$\begin{Bmatrix} {}^1V_1 = {}^1V_1 \\ {}^1V_7 = {}^2V_7 \end{Bmatrix}$	$= 2+1 = 3$	1
15	÷	$^2V_6 \div {}^2V_7$	1V_8	$\begin{Bmatrix} {}^2V_6 = {}^2V_6 \\ {}^2V_7 = {}^2V_7 \end{Bmatrix}$	$= \dfrac{2n-1}{3}$	$2n-1$
16	×	$^1V_8 \times {}^3V_{11}$	$^4V_{11}$	$\begin{Bmatrix} {}^1V_8 = {}^0V_8 \\ {}^3V_{11} = {}^4V_{11} \end{Bmatrix}$	$= \dfrac{2n}{2} \cdot \dfrac{2n-1}{3}$
17	−	$^2V_6 - {}^1V_1$	3V_6	$\begin{Bmatrix} {}^2V_6 = {}^5V_6 \\ {}^1V_1 = {}^1V_1 \end{Bmatrix}$	$= 2n-2$	1	$2n-2$
18	+	$^1V_1 + {}^2V_7$	3V_7	$\begin{Bmatrix} {}^2V_7 = {}^3V_7 \\ {}^1V_1 = {}^1V_1 \end{Bmatrix}$	$= 3+1 = 4$	1
19	÷	$^3V_6 \div {}^3V_7$	1V_9	$\begin{Bmatrix} {}^3V_6 = {}^3V_6 \\ {}^3V_7 = {}^3V_7 \end{Bmatrix}$	$= \dfrac{2n-2}{4}$	$2n-2$
20	×	$^1V_9 \times {}^4V_{11}$	$^5V_{11}$	$\begin{Bmatrix} {}^1V_9 = {}^0V_9 \\ {}^4V_{11} = {}^5V_{11} \end{Bmatrix}$	$= \dfrac{2n}{2} \cdot \dfrac{2n-1}{3} \cdot \dfrac{2n-2}{4} = A_3$
21	×	$^1V_{22} \times {}^5V_{11}$	$^0V_{12}$	$\begin{Bmatrix} {}^1V_{22} = {}^1V_{22} \\ {}^0V_{12} = {}^2V_{12} \end{Bmatrix}$	$= B_3 \cdot \dfrac{2n}{2} \cdot \dfrac{2n-1}{3} \cdot \dfrac{2n-2}{3} = B_3 A_3$
22	+	$^2V_{12} + {}^2V_{13}$	$^3V_{13}$	$\begin{Bmatrix} {}^2V_{12} = {}^0V_{12} \\ {}^2V_{13} = {}^3V_{13} \end{Bmatrix}$	$= A_0 + B_1 A_1 + B_3 A_3$
23	−	$^2V_{10} - {}^1V_1$	$^3V_{10}$	$\begin{Bmatrix} {}^2V_{10} = {}^3V_{10} \\ {}^1V_1 = {}^1V_1 \end{Bmatrix}$	$= n-3 (=1)$	1

Here follows a repetition

Number of Operation.	Nature of Operation.	Variables acted upon.	Variables receiving results.	Indication of change in the value on any Variable.	Statement of Results.	Data.					
24	+	$^4V_{13} + {}^0V_{24}$	$^1V_{24}$	$\begin{Bmatrix} {}^4V_{13} = {}^0V_{13} \\ {}^0V_{24} = {}^1V_{24} \end{Bmatrix}$	$= B_7$
25	+	$^1V_1 + {}^1V_2$	1V_3	$\begin{Bmatrix} {}^1V_1 = {}^1V_1 \\ {}^1V_3 = {}^1V_3 \\ {}^5V_6 = {}^0V_6 \\ {}^5V_7 = {}^0V_7 \end{Bmatrix}$	$= n+1 = 4+1 = 5$ by a Variable-card. by a Variable card.	1	...	$n+1$	0

		Working Variables.					Result Variables.			
0V_8	0V_9	$^0V_{10}$	$^0V_{11}$	$^0V_{12}$	$^0V_{13}$ ··············		$^1V_{21}$ B_1 in a decimal fraction.	$^1V_{22}$ B_3 in a decimal fraction.	$^1V_{23}$ B_5 in a decimal fraction.	$^0V_{24}$···
0	0	0	0	0	0					0
0	0	0	0	0	0					0
0	0	0	0	0	0					0
0	0	0	0	0	0					0
							B_1	B_3	B_5	B_7
...	$\dfrac{2n-1}{2n+1}$							
...	$\dfrac{1}{2}\cdot\dfrac{2n-1}{2n+1}$							
...	0	··········	$-\dfrac{1}{2}\cdot\dfrac{2n-1}{2n+1}=A_0$					
...	...	$n-1$								
...	$\dfrac{2n}{2}=A_1$							
...	$\dfrac{2n}{2}=A_1$	$B_1.\dfrac{2n}{2}=B_1A_1$	··········		B_1			
...	··········	0	$\left\{-\dfrac{1}{2}\cdot\dfrac{2n-1}{2n+1}+B_1\cdot\dfrac{2n}{2}\right\}$					
...	...	$n-2$								
$\dfrac{2n-1}{3}$			$\dfrac{2n}{2}\cdot\dfrac{2n-1}{3}$							
0								
...	$\dfrac{2n-2}{4}$...	$\left\{\begin{array}{c}\dfrac{2n}{2}\cdot\dfrac{2n-1}{3}\cdot\dfrac{2n-2}{3}\\=A_3\end{array}\right\}$							
...	0									
...	0	B_3A_3	··········		·······	B_3		
...	··········	0	$\left\{A_3+B_1A_1+B_3A_3\right\}$					
...	...	$n-3$								

ı́rations thirteen to twenty-three.

...	··········	··········	··········		·······	·······	·······	B_7

ABOVE: Note by Ada Lovelace showing how the Bernoulli numbers might be calculated using the analytical engine, 1843.

hundred years and has become knitted into the fabric of our society can we start to contemplate that question.

One maverick who has explored the boundary between human and machine, creativity and algorithmic computation, is the artist and musician Jem Finer. A founding member of the rock band The Pogues, Finer has worked in a range of artistic media, from photography and film to music. But it is his work on a piece of computer-generated music called *Longplayer*, which will play for a thousand years without repeating itself, that has most recently caught the public imagination.

ABOVE: Composer Jem Finer's *Longplayer* has been created using an algorithm, inviting listeners to question the nature of time.

Longplayer is simultaneously a musical composition and an installation, situated at Trinity Buoy Wharf by the River Thames in London. It relies on an algorithm that generates music according to simple, deterministic rules based on overlapping cycles that will return to their starting configuration after one millennium. *Longplayer* began playing at midnight on 31 December 1999, and the intention is that it will continue to play for a thousand years. The music is generated by computer and is played on Tibetan singing bowls, creating an ethereal and calming experience for its audience. Listeners are invited to regard it as a meditation on time's passage. By evoking a sense of time on the scale of centuries and millennia, the music draws us towards geological and cosmological time, so that our own personal deadlines, measured in minutes, hours and days, seem less significant.

Longplayer also asks us to contemplate what is implied by the fact that this potentially very moving experience is generated by computer algorithm. Most algorithms that we encounter today are unremarkable. They are ubiquitous now: making recommendations on Spotify or Netflix, finding the quickest route from A to B, creating visuals in film and video games, and delivering parcels efficiently to our doors. But they are mundane in every sense: mere extrapolations based on existing data, unable to offer anything genuinely new or creative, and in no sense forming their output in empathy with the human mind. They are not interested in artistry or aesthetics; they have no 'intentions' at all, let alone emotional ones.

But what if in the future machines were able to create songs tailored exclusively to our own tastes and sensitivities, or to generate music and art that arouses particular emotions with intensity and precision? What if machine-learning algorithms, which are initially trained on existing data but then go on to 'learn' from their own 'experience', could create completely new artistic forms? As mathematician Hannah Fry has shown, computers have already been programmed to create music that mimics the style of great composers such as Johann Sebastian Bach, and to do so faithfully enough that audiences are unable to tell the difference between 'real Bach' and 'machine Bach'. Might they some day go beyond imitation, to the

point where it would seem perverse to deny them real creativity?

The Australian musician and songwriter Nick Cave believes that in the future music composed by computers may be able to evoke great emotion, perhaps even more strongly than music composed by people. But – perhaps reassuringly – he thinks that algorithms will never be able to fully replace the human element in creating music. For Cave, what we experience when we listen to a piece of music is more than just emotion; we also experience the constraints, the failures, the dysfunction of what it is to be human. 'What a great song makes us feel is a sense of awe,' he says:

> [And] a sense of awe is almost exclusively predicated on our limitations as human beings. It is entirely to do with our audacity as humans to reach beyond our potential . . . What we are actually listening to is human limitation and the audacity to transcend it. Artificial Intelligence, for all its unlimited potential, simply doesn't have this capacity.

The German photographic artist Andreas Gursky turns this perspective on its head. He doesn't try to generate new artistic forms using machines, but seeks patterns and regularity in human behaviour itself. In this way his images interrogate what it means to be human and complicate the distinction between human and machine. Addressing issues of globalization and landscape, his images highlight the beauty and the mess of humanity. Ranging in subject matter from immense roads and uniform buildings to huge shops and sweaty raves, Gursky's vast photographs invite the viewer to see form and pattern in all human pursuits – just as an algorithm does.

In *Amazon* (2016), Gursky shows the inside of the online retail company Amazon's warehouse, or 'fulfillment center' as the company calls it. The location of products, planned by an algorithm, appears to make no sense in terms of their function or size: items placed together do not share obvious similarities in the way books do in a library. Instead their location is determined, in part, by frequency of need. Ominous messages loom overhead – 'Work Hard', 'Have

Fun', 'Make History' – giving the image an Orwellian, dystopian feel. Yet there are no people in sight. In this world, what they do seems to be dictated entirely by algorithm, as if people are mere slaves to the machine.

The work of both Finer and Gursky reflects our current Age of Ambivalence, in which we are increasingly dependent on computers to help and guide our lives but also concerned about the extent to which they might control it. Both artists play with patterns and forms in human behaviour and cognition, which algorithms both influence and reflect. Finer creates algorithms that push the boundaries of art, while Gursky illustrates the algorithmic nature of human behaviour. Both *Longplayer* and *Amazon* invite an emotional response from the audience, yet people are strangely absent from both pieces. The slow, contemplative music people hear at Trinity Buoy Wharf plays on a timescale far beyond individual human experience: no person can ever hear more than a fragment of the entire composition. In Gursky's warehouse the humans are invisible, their presence only implicit in the arrangement of the detritus of mass consumption, their physical absence showing how intertwined our world has become with the machine-driven algorithm.

Lovelace imagined machines becoming capable of creating an aesthetic output. 'We may say most aptly', she wrote, 'that the Analytical Engine weaves algebraical patterns just as the Jacquard-loom weaves flowers and leaves.' Today, the use of computer models and machine learning has become ubiquitous, even commonplace, in the sciences, and is making inroads in the arts and humanities. So far, this is all still mechanical calculation. We still do not know if machines might one day be imbued with anything we could call consciousness – and with it, the ability to perceive other minds and the potential for genuine creativity. But we have an uneasy feeling that, even if they were, we do not fully trust what a machine might choose to do with that capacity.

ABOVE: In his immense work *Amazon* (2016), photographer
Andreas Gursky explores the pattern and form of labour in the
online retailer's warehouse.

20
Imagining Matter: At the Edge of the Unknown

When the eclipse of 1919 confirmed my intuition, I was not in the least surprised. In fact, I would have been astonished had it turned out otherwise. Imagination is more important than knowledge. For knowledge is limited, whereas imagination embraces the entire world, stimulating progress, giving birth to evolution. It is, strictly speaking, a real factor in scientific research.

ALBERT EINSTEIN, 1931

E instein's general theory of relativity, first put forward in 1915, remains one of the most important scientific theories of our time. Many physicists regard it as not just deeply profound, in terms of the new view it supplied of gravity and spacetime, but beautiful. The theory was first verified as all scientific ideas are: by observation, in this case astronomical observation of the bending of the path of starlight by the sun, which general relativity predicted. But the theory did not arise out of empirical necessity; it emerged from Einstein's creative thinking. It is a classic example of how science, just as much as art, requires imagination in order to move forward.

Art has often been used to visualize science and suggest ways of thinking about ideas that in themselves seem abstract and exotic. Artists may also draw on scientific ideas for inspiration, without worrying too much whether they are being 'accurate', let alone seeing it as their duty to 'explain' the science. But just occasionally,

art seems able to assist scientific thinking itself, for example by forcing scientists to see their work from a new perspective. Scientists who have collaborated with artists have occasionally said as much, admitting that the experience confronted them with new ways of interpreting their work. Perhaps especially in areas that exceed the limits of what can be conceived and visualized in familiar terms, science needs fresh imaginative visions.

CONCEPTUAL MATERIALIST

For someone generally regarded as a conceptual artist, Cornelia Parker has an unusually deep engagement with materials. She has flattened musical instruments, turned dust from the Whispering Gallery in St Paul's Cathedral into ear-plugs, and, with the help of physicist and Nobel laureate Kostya Novoselov at the University of Manchester, turned graphite from drawings by William Blake in the Whitworth Art Gallery's collection into graphene, a material composed of a single layer of carbon atoms – and then back into artwork. Her work is about what can be done to and with materials to change their nature and their implications. In the introduction to an anthology of her work, Bruce W. Ferguson writes that Parker 'sees all material as already prepared for its next unexpected alteration, open to its subsequent transmutation'.

Parker has often drawn on ideas in physics, particularly those concerned with the properties of space. She seeks to understand and represent the abstractions of contemporary theoretical physics. She has sometimes collaborated directly with scientists, as well as taking inspiration from popular accounts of scientific work.

In a suite of works called *Meteorite Landing*, she used real meteorites heated to high temperatures to scorch 'impact craters' at significant locations on road maps. She then ground the space rocks, put the powder into firework rockets, and exploded them in displays at those locations – most notably above the brutalist Bull Ring shopping centre in Birmingham. For *Einstein's Abstracts*, made when Parker was artist in residence at the Science Museum in 1999, she took high-magnification photographs of chalked letters on a

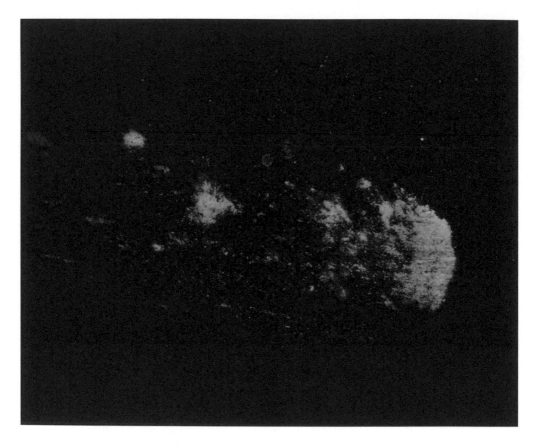

ABOVE: Artist Cornelia Parker explored the blackboard used by Einstein in 1931 and now preserved at the History of Science Museum in Oxford.

blackboard that has been preserved in the History of Science Museum in Oxford since 1931, when Einstein wrote on it while giving lectures at the university; it is one of the most popular exhibits at the museum. Seen close up, the dusty chalk grains on a black background resemble images of the Milky Way.

Parker has said that photographing the letters through a microscope brought her closer to understanding Einstein's theory. 'I struggle to understand Einstein,' she told the art critic Iwona Blazwick, 'but somehow, looking so closely at his chalk marks, which seemed reminiscent

of snowdrifts or images of the cosmos, helped me comprehend what was previously unintelligible.' Parker's route to understanding comes from engaging with the material expression of ideas rather than with their abstract technical details. She says she can imagine Einstein breaking the chalk, which itself is made of the remains of animals that lived in deep time long ago. 'Parker's sculptures and installations offer an analogy with how we experience the external world – the way in which we absorb it through consciousness and mediate it through subjectivity and memory,' says Blazwick. 'She gives material expression to this existential process through an artistic process of abstraction.'

THE COSMOLOGICAL PROBLEM

When Einstein gave his three lectures in Oxford in 1931, at the invitation of the university's Professor of Physics, Frederick Lindemann (later scientific adviser to Winston Churchill), he had been an international celebrity for over a decade. The text on the blackboard is neatly laid out, with all measures of distance and time written in German: for example, L.J. denotes *Licht Jahr*, meaning light year, the distance travelled by light in a year. *The Times* reported on one lecture that 'Professor Einstein spoke in German and without notes. Two blackboards, plentifully sprinkled beforehand in the international language of mathematical symbols, served him for reference.' The blackboard preserved in Oxford is from the second lecture, entitled 'The Cosmological Problem'.

The general theory of relativity offered a new way to understand gravity. In the seventeenth century, Isaac Newton had explained gravity as a force that acts on objects at a distance. But in Einstein's theory gravity arises from the curvature of space and time themselves. The theory is deeply mathematical, but appreciating what 'curved spacetime' actually means presents a challenge to our intuition. As the American physicist John Wheeler put it, 'space tells matter how to move and matter tells space how to curve'. Cosmologist David Spergel says that 'what this means for cosmology is that once you specify the basic properties of the matter in the universe, the past and future of the universe can be calculated and predicted'.

Einstein's theory cleared up one mystery immediately. Astronomers had observed that the path the planet Mercury takes as it orbits the sun is not fully explained by Newton's laws of motion. This anomaly in Mercury's movement can be understood within general relativity by taking into account how the mass of the sun affects spacetime around the planet. Being the closest planet in our solar system to the sun, it feels this warping of spacetime most strongly.

The theory made a second prediction that could be tested experimentally: 'the curving of light rays by the action of gravitational fields', as Einstein put it. The theory said that light passing close to a very massive object does not travel in a straight line, because it follows the distortion of space: that is, it bends.

Einstein presented his theory in 1916, in the middle of the First World War. At that time communications between scientists in Britain and in Germany were obviously difficult, but the Dutch astronomer Willem de Sitter conveyed Einstein's work to Arthur Stanley Eddington, Professor of Astronomy and Experimental Philosophy at Cambridge University. Eddington quickly became a champion of Einstein's ideas, and was keen to seek experimental evidence for them. The bending of light by the sun should be evident in starlight arriving from just behind it – but how could that be seen while the sun was shining, drowning out the stars?

The answer was to make the observations during a solar eclipse, when the sun's light was blocked by the moon. Even while the war continued, the Astronomer Royal, Frank Dyson, began campaigning to mount expeditions to collect photographs of starlight during the predicted solar eclipse of May 1919. Eddington, a Quaker and a conscientious objector, had been granted exemption from military service because his astronomical research was deemed vital to the national interest. He saw the eclipse expeditions as a chance to promote peaceful cooperation between nations: a British effort to test the theory of a German scientist.

The path of the eclipse meant that the best observation points were in northern Brazil and off the coast of west Africa. In the early spring of 1919, shortly after the war ended and while troops were still being demobilized, the expedition teams set off. Andrew

Crommelin and Charles Davidson of the Royal Observatory in Greenwich travelled to Sobral in Brazil, while Eddington headed for the island of Príncipe off the African coast. When he arrived, he described the island and its climate in some detail:

> The mountains rise to a height of 2500 feet, which generally attract heavy masses of cloud. Except for a certain amount of virgin forest, the island is covered with cocoa plantations. The climate is very moist, but not unhealthy. The vegetation is luxuriant, and the scenery is extremely beautiful. We arrived near the end of the rainy season, but the *gravana*, a dry wind, set in about May 10, and from then onwards no rain fell except on the morning of the eclipse. We were advised that the prospects of clear sky at the end of May were not very good, but that the best chance was on the north and west of the island.

Conditions for the eclipse observations did not look promising; but the team pressed ahead with their preparations. 'On the morning of May 29,' Eddington wrote,

> there was a very heavy thunderstorm from about 10 a.m. to 11.30 a.m. – a remarkable occurrence at that time of year. The sun then appeared for a few minutes, but the clouds gathered again. About half-an-hour before totality the crescent sun was glimpsed occasionally, and by 1.55 it could be seen continuously through drifting cloud. The calculated time of totality was from 2h. 13m. 5s. to 2h. 18m. 7s. G.M.T. Exposures were made according to the prepared programme, and 16 plates were obtained.

In the end, only two plates showed enough stars to yield decent data. Meanwhile, the Sobral team had their own problems. The skies over Brazil were clear, but it was so hot that the mirror used to focus the sun's image on the main telescope warped slightly, ruining the results. Fortunately, photographs taken with a smaller telescope were usable.

The observations gave Eddington and Dyson enough data to draw their conclusion. In November 1919, at a meeting at the Royal Society in London, they announced confidently: 'The results of the expeditions to Sobral and Príncipe can leave little doubt that a deflection of light takes place in the neighbourhood of the sun and that it is of the amount demanded by Einstein's generalized theory of relativity, as attributable to the sun's gravitational field.' Einstein's prediction had been confirmed. The meeting was widely reported in the press, and Einstein soon found himself an international superstar.

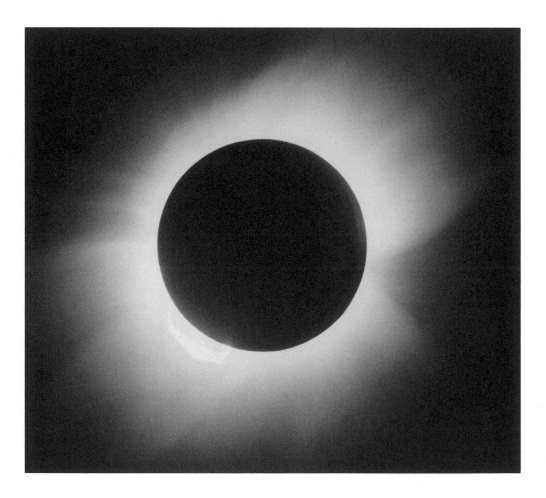

ABOVE: Photographs from the total solar eclipse at Sobral, Brazil, in May 1919 supported Einstein's general theory of relativity.

The theory of general relativity made other predictions on a cosmic scale. When Einstein used it to calculate the shape of the entire universe, he found to his consternation that the solution was not static: it insisted that the universe must be expanding. That contradicted the prevailing view, and Einstein added an arbitrary extra term to his equations to restore the static, unchanging picture.

However, other theorists such as Alexander Friedmann and Georges Lemaître were prepared to countenance the idea of an expanding universe – and in the 1920s astronomical observations vindicated Einstein's original conclusion. The American astronomer Edwin Hubble made observations of the night sky using the biggest telescope then in existence: the 100-inch Hooker Telescope on Mount Wilson in California. Hubble and his colleagues studied the radiation coming from far-off galaxies, which showed that the further away the galaxies are, the faster they are moving away from us. As the galaxies move away, the motion 'stretches' the wavelength of the light through the Doppler effect (the same effect that alters the pitch of an approaching or receding siren). This is called a red shift, because visible light gets shifted towards the long-wavelength red end of the spectrum.

In his second Oxford lecture, Einstein referred to his initial introduction of what is now called the cosmological constant – which he elsewhere called his 'biggest blunder' – and confirmed that Hubble's observations had rendered this fix unnecessary.

The discovery that the universe is expanding implies that it must once have been much smaller – indeed, in theory one can follow the equations all the way back to an infinitesimally small point, called a singularity. Cosmologists therefore concluded that the universe – all of space, time and matter – began in an explosion, dubbed (in a derogatory sense initially) the Big Bang.

But Einstein's cosmological constant has not gone away. In the late twentieth century astronomers discovered that the universe is not only expanding but is doing so ever faster: it is accelerating. One way of explaining this motion invokes the concept of dark energy, a hypothetical form of energy distributed across space that counteracts the pull of gravity. And one way of expressing the effects of dark energy invokes a cosmological constant.

No one knows what dark energy is, although it seems to account for around three-quarters of all the energy of the universe. But it's not the only big cosmological mystery. All the matter and energy that scientists can observe directly – all the planets, all the stars, all the galaxies – accounts for less than 5 per cent of the contents of the universe. Dark energy makes up most of the rest – but there also seems to be a further kind of invisible matter that interacts with ordinary matter and light only via gravity. This is called dark matter, and astronomical observations imply that it exceeds the mass of visible matter by a factor of four or five. In cosmological models of how the universe took shape after the Big Bang, dark matter plays a crucial role in the formation of galaxies and larger-scale cosmological structures. But no one knows what it is, and extensive efforts to detect it directly (as a new form of fundamental particle, say) have so far found nothing.

Cornelia Parker's best-known work, *Cold Dark Matter: An Exploded View*, first exhibited in 1991 at the Chisenhale Gallery in east London, explores these ideas. In making it, Parker filled an ordinary garden shed with various everyday objects and then asked an explosives expert from the British army to blow it apart. She then collected the pieces and reconstructed the fragments, suspending them on strings around a central light bulb that casts dramatic shadows on the surrounding walls. The title of the work refers to one theoretical idea about the nature of dark matter: that it is 'cold', which means that its particles move slowly compared to the speed of light. For Parker, cold dark matter is 'the material within the universe that we cannot see and we cannot quantify'.

Parker has said that when she made the work in 1991,

the idea of Cold Dark Matter was a very new one. It was something that was discussed in the media . . . and I loved the idea of the stuff that exists that you can't measure. So the piece is an explosion which is obviously an echo of the big bang, the piece was an attempt to try and formularise an explosion, try to categorise it and pin it down, try to give it some kind of structure.

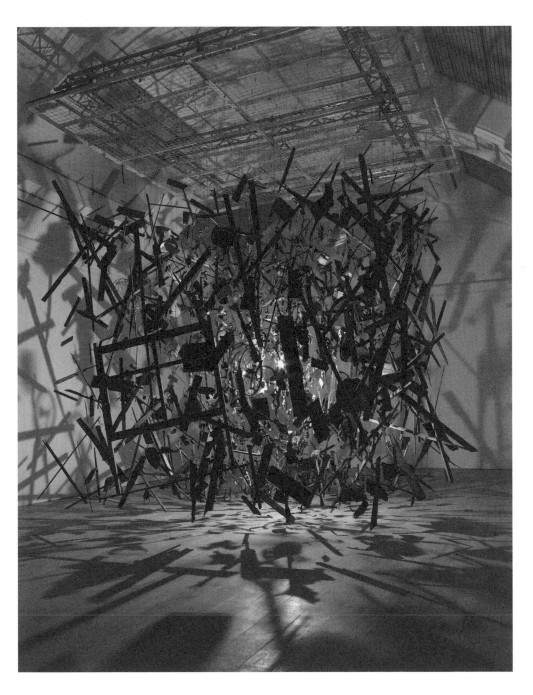

ABOVE: Inspired by the scientific concept of cold dark matter, artist
Cornelia Parker blew up a shed in 1991.

Harking back to Eadweard Muybridge's use of photography in the late nineteenth century to capture a single moment (Chapter 9), *Cold Dark Matter* plays with light and shadow to capture 'the moment of big bangishness'. The light bulb, says Parker,

> became almost like the centre of the universe . . . as the piece evolved I put all the small items by the lightbulb, and then the medium bits and the splintered wood around the edge, so it was like I had put back the shed together, and the fragments were suspended on wire around the lightbulb to make a constellation, almost like a frozen moment.

She was in effect recreating the explosion itself: 'It was like it was exploding again in a quiet, mute way.'

AN ACCIDENTAL ART

Parker has always been fascinated and inspired by ideas from science. Einstein asserted that scientific research requires imagination, which often takes visual forms; and those visual forms are the starting-points for some of Parker's work. 'What I do like about early science, or science of the twenties and thirties,' she says, 'was that there was a lot of visual analogy going on, that scientists would explain through visual equivalents . . . and that's where my access point to science was.'

Parker even feels that scientists may occasionally and inadvertently create something more magnificent than artists: 'I do think there is a link between the accidental art the sciences produce and the deliberate art the artist creates, but I can't help feeling that the innocence of the accidental art of science has a power and curious beauty that artists are hard-pressed to match.' All we have to do is notice.

Picture Acknowledgements

INTRODUCTION

Page 5: *Lunardi's second balloon ascending from St George's Fields*, by Julius Caesar Ibbetson, 1785–90: Science Museum Group Collection © The Board of Trustees of the Science Museum. **Page 9:** *Man Running*, a chronophotograph by Étienne-Jules Marey, *c.*1880: Science History Images/Alamy Stock Photo. **Page 13:** Christmas cards made by Jacob and Rita Bronowski and sent to Gritta Weil, 1951 and 1953–7: © Clare Bronowski/The Board of Trustees of the Science Museum.

THE AGE OF ROMANCE

Page 18: Detail of *Lunardi's second balloon ascending from St George's Fields*, by Julius Caesar Ibbetson, 1785–90: Science Museum Group Collection © The Board of Trustees of the Science Museum. **Pages 22–3:** *A Philosopher giving that lecture on the Orrery, in which a lamp is put in place of the Sun*, by Joseph Wright of Derby, 1766: Derby Museum and Art Gallery, UK/Bridgeman Images. **Page 27:** *Astronomy Explained upon Sir Isaac Newton's Principles*, by James Ferguson, 1785: Science Museum Group Collection © The Board of Trustees of the Science Museum. **Page 29:** Wooden pulley orrery, by James Ferguson, 1755–6: Science Museum Group Collection © The Board of Trustees of the Science Museum. **Pages 34–5:** *Coalbrookdale by Night*, by Philippe-Jacques de Loutherbourg, 1801: Science Museum Group Collection © The Board of Trustees of the Science Museum. **Page 36:** Model of cast-iron bridge over the Severn at Coalbrookdale, by Thomas Gregory, 1784: Science Museum Group Collection © The Board of Trustees of the Science Museum. **Page 39:** Set model for Peak's Hole in *The Wonders of Derbyshire; or, Harlequin in the Peak*, by Philippe-Jacques de Loutherbourg, 1779: © Victoria and Albert Museum. **Page 41:** *Philippe-Jacques de Loutherbourg's Eidophusikon during a Performance of Milton's 'Paradise Lost'*, by Edward Francis Burney, *c.*1782: © The Trustees of the British Museum. **Pages 48–9:** *Scientific Researches! – New Discoveries in Pneumaticks! – or, an Experimental Lecture on the Powers of Air*, by James Gillray, 1802: Science Museum Group Collection © The Board of Trustees of the Science Museum. **Pages 62–3:** *Cloud Study: Cumulus and Nimbus Rainfall*, by Luke Howard, 1803–11: Royal Meteorological Society/ Science Museum Group. **Page 65:** Bottle and funnel from Luke Howard's original rain gauge, made by Richard & George Knight, 1818: Science Museum Group Collection © The Board of Trustees of the Science Museum. **Page 66:** Barograph clock, by Alexander Cumming, 1766: Science Museum Group Collection © The Board of Trustees of the Science Museum. **Page 67:** Autographic curve, Tottenham, London, 1817: © Science Museum Library/Science & Society Picture Library. **Page 69:** *Cloud Study*, by John Constable, 1822: © Tate, 2019. **Pages 72–3:** *A Cloud Index*, by Spencer Finch, *in situ* at the Elizabeth Line station at Paddington, 2019: © Crossrail. **Pages 76–7:** *Rain, Steam and Speed: the Great Western Railway*, by J. M. W. Turner, 1844: © The National Gallery 2019. **Page 79:** *Cheffins's Map of the English & Scotch Railways*, by C. F. Cheffins, 1845: Science Museum Group Collection © The Board of Trustees of the Science Museum. **Page 81:** *The Railway Dragon* from *The Table Book*, by George Cruikshank, 1845: Archivist/Alamy Stock Photo. **Pages 82–3:** Sir Daniel Gooch's model of Great Western Railway 2-2-2 'Firefly' Class standard broad-gauge locomotive, by Joseph Clement, 1842: Science Museum Group Collection © The Board of Trustees of the Science Museum. **Page 89:** Herbarium sheet, by Joseph and Agnes Lister, 1883: Science Museum Group Collection © The Board of Trustees of the Science Museum. **Page 90:** Photoglyphic print of *Adiantum capillus-veneris*, by William Henry Fox Talbot, *c.*1858: Science Museum Group Collection © The Board of Trustees of the Science Museum. **Page 91:** Detail of photoglyphic print of *Adiantum capillus-veneris*, by William Henry Fox Talbot, *c.*1858: Science Museum Group Collection © The Board of Trustees of the Science Museum. **Page 94:** *Cystoseira granulata* from *Photographs of British Algae: Cyanotype Impressions*, by Anna Atkins, 1843: Science Museum Group Collection © The Board of Trustees of the Science Museum. **Page 95:** *Himanthalia lorea* from *Photographs of British Algae: Cyanotype Impressions*, by Anna Atkins, 1843: Science Museum Group Collection © The Board of Trustees of the Science Museum. **Page 98:** 'Group of Droseras at Messrs. Veitch's', from *Gardeners' Chronicle*, by Worthington George Smith, July 1875: Image from the Biodiversity Heritage Library. Contributed by University of Massachusetts Amherst. www.biodiversitylibrary.org. **Page 101:** *Foliage, Flowers and Seed-vessel of the Opium Poppy* (Painting 793), by Marianne North, *c.*1870s: © The Board of Trustees of the Royal Botanic Gardens, Kew.

THE AGE OF ENTHUSIASM

Page 102: Detail of *Man Running*, a chronophotograph by Étienne-Jules Marey, *c.*1880: Science History Images/Alamy Stock Photo. **Page 107:** *Lunar Formation: Craters under Tycho*, by James Nasmyth, 1846: Science Museum Group Collection © The Board of Trustees of the Science Museum. **Page 110:** Detail of plaster model of lunar craters Maurolycus and Barocius, by James Nasmyth, 1844: Science Museum Group Collection © The Board of Trustees of the Science Museum. **Page 112:** Plate XXI, 'Normal lunar crater', from *The Moon: Considered as a Planet, a World, and a Satellite*, by James Nasmyth and James Carpenter, 1874: Science Museum Group Collection © The Board of Trustees of the Science Museum. **Pages 114–15:** Plate XXII, 'Aspect of an eclipse of the Sun by the Earth, as it would appear as seen from the Moon', from *The Moon: Considered as a Planet, a World, and a Satellite*, by James Nasmyth and James Carpenter, 1874: Science Museum Group Collection © The Board of Trustees of the Science Museum. **Page 117:** *Earthrise*, by William Anders, 1968: NASA. **Page 121:** Mauveine acetate dye in a cork-stoppered glass bottle, prepared by Sir William Henry Perkin, 1906: Science Museum Group Collection © The Board of Trustees of the Science Museum. **Pages 122–3:** The Perkin factory at Greenford Green, *c.*1870: Science Museum Group Collection © The Board of Trustees of the Science Museum. **Page 125:** Silk skirt and jacket dyed with William Henry Perkin's mauveine aniline dye, 1862–3: Science Museum Group Collection © The Board of Trustees of the Science Museum. **Page 126:** Detail of silk skirt and jacket dyed with William Henry Perkin's mauveine aniline dye, 1862–3: Science Museum Group Collection © The Board of Trustees of the Science Museum. **Page 129:** Double cloth woven with eight different colourway sample bands, designed by Charles Voysey, 1890–1910: © The Whitworth, The University of Manchester. **Page 131:** *Le Moniteur de la Mode*, June 1865: Courtesy of Los Angeles Public Library. **Page 133:** *The Juggler*, by Oscar Gustav Rejlander, *c.*1865: © Royal Photographic Society Collection/Victoria and Albert Museum. **Pages 138–9:** *Phases of movement of a man jumping a wall*, by Étienne-Jules Marey, 1890–1: Science Museum Group Collection © The Board of Trustees of the Science Museum. **Pages 140–1:** 'Dancing (fancy)', from *Animal Locomotion; an Electro-Photographic Investigation of Consecutive Phases of Animal Movement*, by Eadweard Muybridge, 1887: Science Museum Group Collection © The Board of Trustees of the Science Museum. **Page 143:** 'Mr. Muybridge showing his instantaneous photographs of Animal Motion at the Royal Society', *Illustrated London News*, 25 May 1889: Science Museum Group Collection © The Board of Trustees of the Science Museum. **Page 148:** Rover 'Safety' bicycle, designed by John Kemp Starley, 1885: Science Museum Group Collection © The Board of Trustees of the Science Museum. **Page 150:** 'The Chelmsford Bicycle Club', by Fred Spalding, *c.*1895: Reproduced by courtesy of the Essex Record Office. **Pages 154–5:** *Dynamism of a Cyclist*, by Umberto Boccioni, 1913: Estorick Collection, London, UK/Bridgeman Images. **Page 159:** *Kartenspieler* (*Card Players*), by Otto Dix, 1920: © DACS 2019. **Page 161:** *Die Hölle* (*Hell*): *Der Nachhauseweg* (*The Way Home*), by Max Beckmann, 1919: © DACS 2019. **Page 163:** Wooden 'peg leg', *c.*1930: Science Museum Group Collection © The Board of Trustees of the Science Museum. **Page 165:** German disabled soldier (carpenter) using an artificial arm while at work at a workshop in Hindenburg's house at Königsberg, *c.*1915–18: © IWM. **Pages 170–1:** *A Manufacturing Town*, by L. S. Lowry, 1922: © The Estate of L.S. Lowry. All rights reserved, DACS 2019. **Pages 176–7:** Hand press motion study photographs, by National Institute of Industrial Psychology, *c.*1930: Science Museum Group Collection © The Board of Trustees of the Science Museum. **Page 179:** Moorrees's form board chocolate-packing test used at Rowntree's chocolate factory, 1921–39: Science Museum Group Collection © The Board of Trustees of the Science Museum. **Page 181:** Double-dialled longcase clock from Park Green Mill, Macclesfield, made by E. Hartley, 1810: Science Museum Group Collection © The Board of Trustees of the Science Museum. **Page 182:** Detail of double-dialled longcase clock from Park Green Mill, Macclesfield, made by E. Hartley, 1810: Science Museum Group Collection © The Board of Trustees of the Science Museum. **Page 185:** Hyperbolic paraboloid string surface model, by Fabre de Lagrange, 1872: Science Museum Group Collection © The Board of Trustees of the Science Museum. **Page 186:** Conoid string surface model, by Fabre de Lagrange, 1872: Science Museum Group Collection © The Board of Trustees of the Science Museum. **Page 189:** *Sculpture with Colour and String*, by Barbara Hepworth, cast in bronze in 1961 from plaster of 1939: Courtesy of The Ingram Collection of Modern British Art/Bridgeman Images. **Page 191:** Ideas for stringed figure sculptures, by Henry Moore, 1937: © The Henry Moore Foundation. All rights reserved, DACS/www.henry-moore.org 2019. **Page 192:** *South Kensington – Model of a Cubic Surface*, by Edward Alexander Wadsworth, 1936: © TfL from the London Transport Museum collection.

THE AGE OF AMBIVALENCE

Page 196: Christmas card made by Jacob and Rita Bronowski and sent to Gritta Weil, December 1956: © Clare Bronowski/The Board of Trustees of the Science Museum. **Pages 202–3:** *Supersonic*, by Roy Nockolds, *c.*1948–52: © Artist's Estate. **Page 207:** *The Sound Barrier* film poster, 1952: STUDIOCANAL Films Ltd. **Page 209:** BOAC Concorde, London Heathrow Airport, 1968: © Daily Herald Archive/National Science & Media Museum/Science & Society Picture Library. **Pages 212–13:** *Concorde Grid*, by Wolfgang Tillmans, 1997: © Wolfgang Tillmans, courtesy Maureen Paley, London. **Pages 215:** Sample designs for the 1951 Festival of Britain based on X-ray crystallographic patterns of haemoglobin, 1951: Science Museum Group Collection © The Board of Trustees of the Science Museum. **Page 219:** Crystal model of hydroxyapatite associated with Kathleen Lonsdale, 1960s: Science Museum Group Collection © The Board of Trustees of the Science Museum. **Pages 220–1:** The Dome of Discovery and the Skylon at the Festival of Britain, 1951: © The National Archives/Science & Society Picture Library. **Page 224:** Modern molecular patterns being used in interior designs of the Regatta restaurant on the South Bank, 1951: Science Museum Group Collection © The Board of Trustees of the Science Museum. **Page 227:** *The Man in the White Suit* film still, 1951: STUDIOCANAL Films Ltd. **Page 229:** *The Man in the White Suit* film poster, 1951: STUDIOCANAL Films Ltd. **Page 231:** Sample of the first nylon knitted tubing, made by Du Pont de Nemours & Company, 1935: Science Museum Group Collection © The Board of Trustees of the Science Museum. **Page 233:** Prototype terylene nightdress, made by Imperial Chemical Industries, 1948–50: Science Museum Group Collection © The Board of Trustees of the Science Museum. **Page 238:** *Preparing a Warp*, by Maurice Broomfield, 1964: © Maurice Broomfield. **Page 243:** Polaroid SX-70 Land Camera Model 2, *c.*1974–7: Science Museum Group Collection © The Board of Trustees of the Science Museum. **Pages 246–7:** *Sun on the Pool Los Angeles April 13, 1982*, by David Hockney, 1982: © David Hockney. **Page 248:** David Hockney poolside at his home in Los Angeles with Polaroids of David Stoltz and Ian Falconer, 1982: Photo by Michael Childers/Corbis via Getty Images. **Page 253:** Edwin Land portrait, by J. J. Scarpetti: Courtesy of The Rowland Institute at Harvard. **Pages 254–5:** *David Hockney on Photography*, by David Hockney, 1985: © David Hockney. **Page 257:** *It's Deadly Serious Mr Reagan*, by Greenpeace, poster from Walt Patterson archive, 1985: Science Museum Group Collection © The Board of Trustees of the Science Museum. **Page 260:** Ronald Craven with his daughter Emma's teddy bear in *Edge of Darkness*, 1985: BBC © 2019. **Page 264:** Equipment to test the function of detectors in the surface atmosphere on Mars, made by James Lovelock for NASA, 1960s: Science Museum Group/James Lovelock. **Page 267:** Printout of data from the *Daisyworld* computer simulation, by James Lovelock, 1981: Science Museum Group/James Lovelock. **Pages 272–3:** Details of punch cards for Charles Babbage's analytical engine, *c.*1870: Science Museum Group Collection © The Board of Trustees of the Science Museum. **Pages 276–7:** Ada Lovelace's Note G showing the calculation of the Bernoulli numbers, 1843: Science Museum Group Collection © The Board of Trustees of the Science Museum. **Page 278:** The score of *Longplayer*, by Jem Finer, 2000 onwards: © Jem Finer. **Pages 282–3:** *Amazon*, by Andreas Gursky, 2016: © Andreas Gursky/DACS, 2019; courtesy Sprüth Magers. **Page 286:** *Einstein's Abstracts*, by Cornelia Parker, 2000: Courtesy the artist and Frith Street Gallery, London. **Page 290:** Photograph of the corona taken during the total solar eclipse at Sobral, Brazil, 29 May 1919: Science Museum Group Collection © The Board of Trustees of the Science Museum. **Page 293:** Whitworth installation view of *Cold Dark Matter: An Exploded View*, by Cornelia Parker, 1991: Tate Collection; © The Whitworth, The University of Manchester/M. Pollard.

ENDPAPERS

Taken from *Photographs of British Algae: Cyanotype Impressions*, by Anna Atkins, 1843: Science Museum Group Collection © The Board of Trustees of the Science Museum.

Notes

INTRODUCTION

p. 2, 'What is now proved was once, only imagin'd': William Blake, 'Proverbs of Hell', in *The Marriage of Heaven and Hell* (Boston: John W. Luce, 1906), p. 16.

p. 3, an 'absurd point of view': George Gordon Byron, *Letters and Journals of Lord Byron: With Notices of His Life*, vol. 2 (New York: J. & J. Harper, 1831), p. 405.

p. 4, a 'disease of the imagination': Samuel Johnson, *The History of Rasselas, Prince of Abissinia* (1759), ed. J. P. Hardy (Oxford: Oxford University Press, 1968), p. 144.

p. 4, as the historian Christine MacLeod observes: Christine MacLeod, *Heroes of Invention: Technology, Liberation and British Identity 1750–1914* (Cambridge: Cambridge University Press, 2007).

p. 7, 'reducing it to the prismatic colours': Quoted in Richard Holmes, *Age of Wonder: The Romantic Generation and the Discovery of the Beauty and Terror of Science* (London: HarperCollins, 2008), p. 323.

p. 7, 'I change, but I cannot die': Percy Bysshe Shelley, *Prometheus Unbound* (1820) (Cambridge: Cambridge University Press, 2013), p. 200.

p. 11, 'out of control': Mass-Observation, *Report on Everyday Feelings about Science* (Oct. 1941), no. 951. Reproduced with permission of Curtis Brown Group Ltd, London on behalf of The Trustees of the Mass Observation Archive.

p. 11, 'too cheap to meter': Lewis Strauss, speech as chairman of the United States Atomic Energy Commission, 16 Sept. 1954, p. 9, https://www.nrc.gov/docs/ML1613/ML16131A120.pdf.

p. 12, 'science explores and apprehends, informs and proves': Naum Gabo, 'The constructive idea in art', in Ben Nicholson, Naum Gabo and Leslie Martin, eds, *Circle: International Survey of Constructivist Art* (London: Faber, 1937), p. 8.

p. 12, 'a tonic to the nation': Quoted in Gillian Whiteley, 'Art for social spaces: public sculpture and urban regeneration in post-war Britain', in *Designing Britain 1945–75*, https://vads.ac.uk/learning/designingbritain/html/festival.html.

p. 12, 'human activity at large': Jacob Bronowski, *The Common Sense of Science* (1951) (London: Faber, 2008), p. 126.

p. 12, 'a broad and general language in our culture': Bronowski, *The Common Sense of Science*, p. 17.

p. 14, 'dividing culture into unnecessarily fractious camps': Frank James and Robert Bud, 'Epilogue: science after modernity', in Robert Bud, Paul Greenhalgh and Frank James, eds, *Being Modern: The Cultural Impact of Science in the Early Twentieth Century* (London: UCL Press, 2018), p. 392.

p. 15, 'trained judgement': Lorraine Daston and Peter Galison, 'Trained judgement', in *Objectivity* (New York: Zone, 2007), pp. 309–61.

1. THE SCIENTIFIC SUBLIME: FROM DARKNESS COMES KNOWLEDGE

p. 20, 'your troop of philosophers!': Letter from Erasmus Darwin to Matthew Boulton, 5 April 1778, MS 3782/13/53/87, The Archives of Soho, Birmingham Central Library.

p. 20, 'overturn the empire of superstition': Letter from Erasmus Darwin to Joseph Priestley, 3 Sept. 1791, in *The Letters of Erasmus Darwin*, ed. Desmond King-Hele (Cambridge: Cambridge University Press, 1981), p. 216. (The letter is by the secretary of the Derby Philosophic Society but thought to be penned by Erasmus Darwin, as president of the Society.)

p. 21, 'the first professional painter to express the spirit of the Industrial Revolution': F. Klingender, *Art and the Industrial Revolution* (London: Noel Carrington, 1947), p. 46.

p. 24, 'the most inventive of philosophical men': *The Letters of Samuel Taylor Coleridge*, ed. E. H. Coleridge (Boston, 1895), vol. 1, p. 152.

p. 24, binary polarities: Paul Duro, '"Great and noble ideas of the moral kind": Wright of Derby and the scientific sublime', *Art History*, vol. 33, no. 4, 2010, pp. 660–79 at p. 676.

p. 25, 'must contend with infinity': Duro, '"Great and noble ideas of the moral kind"', p. 678.

p. 26, 'superintendency of the SUPREME BEING': James Ferguson, *Astronomy Explained*, vol. 1 (London, 1756), p. 1.

p. 27, 'their contemplations on nature': Joseph Addington, *The Works of the Right Honourable Joseph Addington, Esq* (London, Jacob Tonson, 1721), pp. 514–15.

p. 27, 'to decorate their tea boards & baubles!': *Letters of Josiah Wedgwood to 1770*, ed. K. Farrer (Manchester, privately published, 1902), p. 105.

p. 28, a 'planner of images': D. Solkin, 'Joseph Wright of Derby and the sublime art of labour', *Representations*, vol. 83, no. 1, Summer 2003, pp. 167–94 at p. 169.

p. 30, 'a distant View of other remote Worlds': David Jennings, *An Introduction to the Use of the Globes and the Orrery* (London, 1752), p. iii.

p. 30, 'the pragmatic methods of artisan culture': Celina Fox, *The Arts of Industry in the Age of Enlightenment* (London and New York: Yale University Press, 2010), p. 6.

p. 30, 'spinning wheels, guns &c.': Quoted in Jenny Uglow, *The Lunar Men* (London: Faber, London, 2002), p. 10.

p. 31, 'conversant in the practices in use in their time': Quoted in Paul Mantoux, *The Industrial Revolution in the Eighteenth Century* (London: Routledge, 2015), p. 206.

p. 31, 'every utensil for his convenience': David Hume, *Essays and Treatises on Several Subjects* (London: A. Millar, 1758), p. 91.

p. 31, 'they look most luminously beautiful': *The Torrington Diaries*, ed. C. Bruyn Andrews, vol. 2 (New York, 1938), pp. 195–6.

p. 31, 'All seems like one vast Machine': *An American Quaker in Britain: The Travel Journals of Jabez Maud Fisher, 1775–1779*, ed. Kenneth Morgan (Oxford: Oxford University Press, 1992), p. 253.

2. MASTERS OF SPECTACLE: SMELTING IN SHROPSHIRE

p. 32, 'would unite well with craggy and bare rocks': Arthur Young, 'Annals of Agriculture and other useful Arts' (1785), in Barrie Trinder, ed., *'The most Extraordinary District in the World': Ironbridge and Coalbrookdale. An Anthology of Visitors' Impressions of Ironbridge, Coalbrookdale and the Shropshire Coalfield* (London: Phillimore, 1977), p. 31.

p. 32, the birth of an industrial nation: Much of the material in this chapter is indebted to discussion by Stephen Daniels in 'Loutherbourg's chemical theatre: *Coalbrookdale by Night*', in John Barrell, ed., *Painting and the Politics of Culture: New Essays on British Art, 1700–1850* (Oxford: Oxford University Press, 1992), pp. 195–230.

p. 33, over 150 products on its books: Barrie Trinder, ed., *Coalbrookdale 1801: A Contemporary Description* (Ironbridge: Ironbridge Gorge Museum Trust, 1979), pp. 16–17.

p. 37, 'there is something in this contrast very pleasing': Diary of Katherine Plymley, Shropshire Record Office 567, vol. 27, repr. in Trinder, ed., *'The Most Extraordinary District in the World'*, p. 41.

p. 39, 'to take the produce of art for real nature': *Morning Chronicle*, 17 Feb. 1776, quoted in Christopher Baugh, 'Philippe de Loutherbourg: technology-driven entertainment and spectacle in the late eighteenth century', *Huntington Library Quarterly*, vol. 70, no. 2, 2007, p. 255.

p. 40, 'exhibiting a terrific appearance': Henry Angelo, *Reminiscences*, 2 vols (London, 1828), vol. 2, p. 326.

p. 42, a 'new species of painting': 'A view of the Eidophusikon', *The European Magazine*, March 1782, pp. 80–1.

p. 43, 'set apart for tremendous mysteries': Written in 1838; quoted in J. W. Oliver, *The Life of William Beckford* (Oxford: Oxford University Press, 1932), pp. 89–91.

p. 43, 'such as a bright furnace exhibits in fusing metals': William Henry Pyne, *Wine and Walnuts* (London, 1823), pp. 302–3.

p. 45, 'the last judgement that in imagination would appear to him': Charles Dibdin, 'Observations on a Tour through almost the whole of England (1801–2)', in Trinder, ed., *'The Most Extraordinary District in the World'*, p. 66.

p. 45, 'the actual progress of metallurgy': Science Museum Nominal File 8979/1/1.

3. SATIRIZING SCIENCE: GILLRAY AND LAUGHING GAS

p. 46, 'this wonder working gas of delight': Robert Southey to Thomas Southey, 12 July 1799, quoted in Adam Green, ed., *'Oh Excellent Airbag': Under the Influence of Nitrous Oxide, 1799–1920* (Cambridge: PDR Press, 2016), p. 54.

p. 47, the young scientist Humphry Davy: The uncertainty stems from the print being published in May 1802. Thomas Garnett ceased lecturing at the RI in 1801 and died in June 1802. He was replaced by Thomas Young on 6 July 1801. However, Davy does not seem to have acted as Young's assistant or to have lectured with him, and Garnett and Davy are known to have demonstrated nitrous oxide together. The print is therefore most likely showing Garnett.

p. 47, 'blue-stockings and women of fashion': Quoted in *The Collected Works of Sir Humphry Davy*, ed. John Davy, 9 vols (London, 1839–40), vol. 1, p. 88.

p. 50, 'I imagined that I made discoveries': Green, ed., *'Oh Excellent Airbag'*, pp. 27–8.

p. 51, 'And clad with new born mightiness round': 'On breathing the Nitrous Oxide', Notebook of Humphry Davy, Royal Institution, London, RI MS HD/13c.

p. 51, 'the operation of this extraordinary gas': Humphry Davy, *Researches, Chemical and Philosophical: Chiefly Concerning Nitrous Oxide, or Dephlogisticated Nitrous Air, and its Respiration* (1800), quoted in Green, ed., *'Oh Excellent Airbag'*, p. 45.

p. 52, 'the force of a flaming imagination': *The Anti-Jacobin Review and Magazine*, June 1800, p. 109.

p. 53, 'draughts of the mighty pneumatic': *The Anti-Jacobin Review and Magazine*, June 1800, p. 113.

p. 53, 'blended with it and twined round it': Quoted in Richard Godfrey, *James Gillray: The Art of Caricature* (London: Tate Gallery, 2001), p. 11.

p. 55, 'declared themselves satisfied': *The Journal of Elizabeth Lady Holland (1791–1811)*, ed. Elizabeth Vassall Fox, Lady Holland (London: Longmans, Green, 1908), vol. 2, pp. 60–1.

p. 56, 'the wild *gas*, the fixed air, is plainly broke loose': Edmund Burke, *Reflections on the Revolution in France and on the Proceedings in Certain Societies in London Relative to that Event*, ed. Conor Cruise O'Brien (Harmondsworth: Penguin, 1968), p. 90.

4. OBSERVING THE AIR: CONSTABLE'S CLOUDS

p. 58, 'of which pictures are but the experiments?': Quoted in G. Reynolds, 'Introduction', in F. Bancroft, ed., *Constable's Skies* (New York: Salander-O'Reilly Gallery, 2004), p. 19.

p. 61, 'the state of a person's mind or body': Luke Howard, 'On the modifications of clouds, and on the principles of their production, suspension, and destruction; being the substance of an essay read before the Askesian Society in the session 1802–3, Part I', *Philosophical Magazine*, vol. 16, no. 62, 1803, pp. 97–107 at p. 97.

p. 67, 'my whole practice in science and art': Notebook in the London Metropolitan Archives, Acc.1017/1517.

p. 68, 'a rigid order and classification': Quoted in John Thornes, *John Constable's Skies: A Fusion of Art and Science* (Birmingham: University of Birmingham Press, 1999), p. 185.

p. 68, 'May the world gratefully remember you': Translation in Barbara Novak, *Nature and Culture: American Landscape and Painting, 1825–1875* (Oxford: Oxford University Press, 2007) p. 74.

p. 69, 'I want to call for my raincoat': Quoted in R. Hamblyn, *The Invention of the Clouds: How an Amateur Meteorologist Forged the Language of the Skies* (London: Pan Macmillan, 2010), p. 230.

p. 70, 'until we understand how it functions': Quoted in Thornes, *John Constable's Skies*, p. 20.

p. 70, 'he has the merit of breaking much ground': Quoted in A. Lyles, 'This glorious pageantry of heaven', in Bancroft, ed., *Constable's Skies*, p. 43.

5. TRACKING PROGRESS: TURNER IN THE AGE OF STEAM

p. 74, 'a steam engine running upon a railway': H. G. Wells, *Anticipations of the Reaction of Mechanical and Scientific Progress upon Human Life and Thought*, 4th edn (London: Chapman & Hall, 1902), p. 4.

p. 74, 'secure from rash assault?': British Library, Add MSS 44361 f.278.

p. 74, a journey Turner himself made by train: See Ian Carter, 'Rain, steam and what?', *Oxford Art Journal*, vol. 20, no. 3, 1997, pp. 3–4; J. Simmons, The Victorian Railway (London: Thames & Hudson, 1991), p. 127.

p. 75, 'brought an extraordinary relish': John Gage, *Turner: Rain, Steam and Speed* (London: Allen Lane, 1972), p. 36.

p. 78, 'manipulating the landscape on a grand scale': W. G. Hoskins, *The Making of the English Landscape* (Harmondsworth: Penguin, 1985), p. 256.

p. 78, 'I come, I come . . . to eat you up!': Quoted in Carter, 'Rain, steam and what?', p. 10.

p. 78, sweeps away the old: Charles Dickens, *Dombey & Son*, Globe edn (Cambridge: Riverside, 1880), p. 319.

p. 80, 'not so fast back, if you please': *North Devon Journal*, 1 Oct. 1840.

p. 80, 'strange beyond description': *Frances Anne Kemble, Records of a Girlhood*, 2nd edn (New York: Henry Holt, 1883), p. 283.

p. 83, 'a magnetic attraction for him': James Hamilton, *Turner: A Life* (London: Hodder & Stoughton, 1997), p. 99.

p. 84, 'as if the sun itself had given in': Dickens, *Dombey & Son*, p. 319.

p. 84, 'onto Brunel's vast deck . . .': William Makepeace Thackeray, *Roundabout Papers* (New York: Harper, 1863), p. 97.

p. 84, 'downright insult to our common sense': *The Atlas*, 25 May 1844, p. 358.

p. 84, 'up Charing Cross through the wall opposite': Thackeray's review in *Fraser's Magazine*, June 1844.

p. 84, 'his detractors and admirers to settle between them': *The Times*, 8 May 1844.

p. 85, 'fury of a red-hot cannon-ball': Francis S. Williams, *Our Iron Roads: Their History, Construction and Social Influences* (London, 1852), p. 235.

p. 85, 'as human beings and not as merchandise': J. Simmons, *The Railways of Britain*, 2nd edn (London: Longman, 1986), p. 175.

p. 86, 'chaos of elemental and artificial lights and noises': Lady Simon, in John Ruskin, *Dilecta: Works*, ed. Edward Tyas Cook and Alexander Wedderburn (London: 1903–12), pp. 599–601.

p. 86, 'full of impossibilities': Gage, *Turner*, p. 16.

p. 86, the oldest inhabitant of the area had ever seen: *The Times*, 13 June 1843, p. 6.

p. 86, 'it is perfectly and wonderfully true': Lady Simon, in John Ruskin, *Dilecta*, p. 30.

6. PLANTS ON PAPER: THE ART OF BOTANY

p. 87, 'Blue, darkly, deeply, beautifully blue': Robert Southey, *Madoc in Wales*, Part I, Sec. V-48 (1805).

p. 92, preserved them on herbarium sheets: Lister's herbarium sheets are in the Wellcome Trust collection held by the Science Museum.

p. 96, 'beautiful process of Cyanotype': Anna Atkins, *Photographs of British Algae* (1843), held by the Science Museum Group, 1937-403, preface, p. 2r.

p. 96, 'accurate representations of the botany of the district': Robert Hunt, 'On the application of science to the fine and useful arts. Photography – second part', *Art Union Monthly Journal*, no. 10, 1 Aug. 1848, pp. 237–8.

p. 99, 'the lovely world which surrounded me': Marianne North, *Recollections of a Happy Life: Being the Autobiography of Marianne North* (London: Macmillan, 1892), p. 231.

7. REACHING FOR THE MOON: THE TRUTH ABOUT PHOTOGRAPHY

p. 104, 'most legitimate powers of the imagination': Letter from James Nasmyth to Josiah Crampton, 5 Nov. 1853, quoted in J. Crampton, *The Lunar World: Its Scenery, Motions, Etc., Considered with a View to Design* (Edinburgh: Adam and Charles Black, 1863), p. 130.

p. 105, 'sound practical instruction in mechanical engineering': James Nasmyth and Sam Smiles, *James Nasmyth Engineer: An Autobiography* (London, 1883), p. 97.

p. 107, 'at the same time practised my hand': Nasmyth and Smiles, *James Nasmyth Engineer*, pp. 330–1.

p. 108, 'the accurate and artistic style of [its]execution': Nasmyth and Smiles, *James Nasmyth Engineer*, p. 346.

p. 108, 'laid before his readers by any student of Science': J. Norman Lockyer, 'The moon', *Nature*, 12 March 1874, p. 358.

p. 108, 'how it went home to me': Quoted in Nasmyth and Smiles, *James Nasmyth Engineer*, p. 394.

p. 109, 'only changed the wonder to admiration': Nasmyth and Smiles, *James Nasmyth Engineer*, p. 394.

p. 109, 'most faithful representations of the original': James Nasmyth and James Carpenter, *The Moon: Considered as a Planet, a World, and a Satellite* (London: John Murray, 1874), pp. xiii–ix.

p. 111, 'educating the hands in delicate manipulation': Nasmyth and Smiles, *James Nasmyth Engineer*, p. 382.

p. 113, 'conditions for life destruction': Nasmyth and Carpenter, *The Moon*, p. 179.

p. 113, 'encircle the terrestrial sphere': Nasmyth and Carpenter, *The Moon*, p. 164.

p. 113, 'the most significant thing we're seeing is . . . the Earth': Robert Poole, *Earthrise: How Man First Saw the Earth* (New Haven and London: Yale University Press, 2008), p. 2.

8. DYEING TO DISPLAY: VARIETY AND VIBRANCY

p. 118, 'thou art a lucky and a favoured colour!': 'Perkin's Purple', *All the Year Round: A Weekly Journal*, 10 Sept. 1859, p. 468.

p. 126, 'all the family have caught it before the week was out': 'The mauve measles', *Punch*, 20 Aug. 1859, p. 81.

p. 126, 'savage nations, uneducated people and children': Johann Wolfgang von Goethe, *Theory of Colour* (London: John Murray, 1840), p. 55.

p. 126, 'sky blue scarves': 'Ce sont des soies violettes ou ponceau, des robes vert-pré et à fleurs, des écharpes d'azur . . .': Hippolyte Taine, *Notes sur l'Angleterre* (Paris: Hachette, 1872), p. 60 (author's translation; the translation by Edward Hyams in *Notes on England* (London: Thames & Hudson, 1957), p. 46, is slightly different).

p. 127, 'destroying all beauty': William Morris, 'The lesser arts of life', in Reginald Stuart Poole et al., eds, *Lectures on Art Delivered in Support of the Society for the Protection of Ancient Buildings* (London: Macmillan, 1882), pp. 174–232 at pp. 212–13.

p. 127, 'bright and hopeful cheeriness': C. F. A. Voysey, 'The aims and conditions of the modern decorator', *Journal of Decorative Arts*, vol. 15, 1895, p. 82.

p. 128, 'abominable and livid hues': Quoted in Jocelyn Morton, *Three Generations in a Family Textile Firm* (London: Routledge, 1971), p. 184.

p. 131, 'It always means they have a history': Oscar Wilde, *The Picture of Dorian Gray* (1890) (Harmondsworth: Penguin, 2003), p. 99.

9. CAPTURING TIME: VISION VERSUS REALISM

p. 132, 'independent observation from Nature herself': Quoted in Aaron Scharf, *Pioneers of Photography: An Album of Pictures and Words* (London: BBC, 1975), p. 128.

p. 134, 'a time which is not beyond the limits of measurement': William de Wiveleslie Abney, *Instantaneous Photography* (New York: Scovill & Adams, 1895), p. 3.

p. 135, 'the exposure and covering is done': *British Journal of Photography Almanac* 1873, quoted in Brian Coe, *The History of Movie Photography* (New York: Eastview, 1981), pp. 44–5.

p. 136, 'not less astounding because it was truth itself': *Photographic News*, vol. 26, no. 12228, 17 March 1882.

p. 136, 'divided by the five-thousandth part of a second': George E. Waring Jr, 'The horse in motion', *The Century Art Illustrated Monthly Magazine*, vol. 24, no. 3, July 1882, p. 388.

p. 136, 'the horse would run no more': W. G. Simpson, 'The paces of the horse in art', *The Magazine of Art*, vol. 6, 1883, p. 203.

p. 142, 'Nothing could be better': *British Journal of Photography*, 23 Aug. 1889.

p. 144, 'not necessarily mathematical truth': *British Journal of Photography*, 21 July 1882, p. 129.

10. CELEBRATING SPEED: MOBILITY AND MODERNITY

p. 146, 'contact with kindred spirits': *Manchester Guardian*, 21 Aug. 1895, p. 8.

p. 149, 'but rather to get away': W. E. Bijker, *Of Bicycles, Bakelite and Bulbs: Toward a Theory of Sociotechnical Change* (Cambridge, Mass.: MIT Press, 1997), p. 59.

p. 149, 'in some respect a social revolution': *The Times*, 15 Aug. 1898, p. 7.

p. 149, 'much the same expenditure of energy': W. K. Starley, *Journal of the Society for Arts*, vol. 46, no. 2374, 1898, p. 602.

p. 150, 'feel as if she were independent': 'Champion of her sex: Miss Susan B. Anthony tells the story of her remarkable life to Nellie Bly', *The World*, 2 Feb. 1896, p. 10.

p. 151, 'the vehicle of novelists and poets': Christopher Morley, *The Romany Stain* (New York: Doubleday, 1926), p. 35.

p. 151, 'more beautiful than the Victory of Samothrace': 'From the initial manifesto of Futurism, Marinetti, 20th February 1909, translated by Caroline Tisdall', in *Futurismo 1909–1919: Exhibition of Italian Futurism* (Manchester: Northern Arts Council, 1973), p. 25.

p. 151, 'the habit of energy and fearlessness': Quoted in C. Salaris, 'The invention of the programmatic avant-garde', in *Italian Futurism 1909–1944: Reconstructing the Universe* (New York: Guggenheim Museum, 2014), p. 23.

p. 152, 'triumphant progress of science': Quoted in R. Humphreys, *Futurism* (London: Tate Publishing, 1999), p. 24.

11. REJECTION OF RATIONALITY: ART AS PROTEST

p. 156, 'not the beginnings of art, but of disgust': Tristan Tzara, 'Lecture on Dada', trans. and repr. in Robert Motherwell, ed., *The Dada Painters and Poets: An Anthology* (Cambridge, Mass: Harvard University Press, 1989), p. 250.

p. 157, 'wrote poems with all our might': Quoted in Alan Young, *Dada and After: Extremist Modernism and English Literature* (Manchester: Manchester University Press, 1983), p. 14.

p. 157, 'offensives, peace congresses, riots': Quoted in Herbert Fall, 'The arrival of the machine: Modernist art in Europe, 1910–25', *Social Research*, vol. 64, no. 3, 1997, pp. 1273–1305 at p. 1293.

p. 166, 'mere adjustment [to] the very soul' of human life: Richard Sheppard, *Modernism – Dada – Postmodernism* (Evanston, Ill.: Northwestern University Press, 2000), p. 208.

p. 166, 'the useless parts of the body': J. D. Bernal, *The World, The Flesh and the Devil: An Inquiry into the Future of the Three Enemies of the Rational Soul* (1929) (London: Jonathan Cape, 1970), p. 38.

12. HUMANS IN THE INDUSTRIAL MACHINE: SMOKESTACKS IN SALFORD

p. 168, 'They are not free. No one is': Interview with Prof. Hugh Maitland, 1970, repr. in Shelley Rohde, *L. S. Lowry: A Biography* (Salford: Lowry Press, 1999).

p. 169, 'the degradation of a large body of producers': Arnold Toynbee, *Lectures on the Industrial Revolution in England* (London: Rivingtons, 1884), p. 84.

p. 172, 'the Industrial Revolution clamped upon the land': Quoted in Chris Waters, 'Representations of everyday life: L. S. Lowry and the landscape of memory in post-war Britain', *Representations*, no. 65, special issue on 'New perspectives in British Studies', Winter 1999, p. 128.

p. 172, 'the new industrial technology wove into workers' lives': T. J. Clark and Anne M. Wagner, *Lowry and the Painting of Modern Life* (London: Tate Publishing, 2013).

p. 172, 'the struggle against the system responsible for them': T. G. Rosenthal, *L. S. Lowry: The Art and the Artist* (London: Unicorn, 2010), p. 49.

p. 172, 'nobody had done it seriously': Quoted in Clark and Wagner, *Lowry and the Painting of Modern Life*, p. 37.

p. 172, 'The means of production': Jeanette Winterson, 'Lowry's rage against the machine', *Guardian* online, 13 June 2013, https://www.theguardian.com/artanddesign/2013/jun/13/ls-lowry-industrial-world.

p. 172, 'forced to couple with the machine': Jeanette Winterson, 'Lowry's rage against the machine', *Guardian* online, 13 June 2013, https://www.theguardian.com/artanddesign/2013/jun/13/ls-lowry-industrial-world.

p. 172, 'the iron machine which knows no weariness': Quoted in Humphrey Jennings, *Pandaemonium 1660–1886* (London: Icon, 1985; new edn 2012), p. 184.

p. 172, 'the people must work': Quoted in Humphrey Jennings, *Pandaemonium 1660–1886* (London: Icon, 1985; new edn 2012), p. 184.

p. 173, 'the most deadening, wearing process conceivable': Friedrich Engels, *The Condition of the Working Class in England in 1844* (1892) (Harmondsworth: Penguin, 1987), p. 128.

p. 173, 'serpents of smoke trailed themselves': Charles Dickens, *Hard Times* (London: Bradbury & Evans, 1854), p. 34.

p. 173, 'a broken fly-wheel, and part of a crank': Samuel Butler, *Erewhon* (1872) (Harmondsworth: Penguin, 2006), p. 82.

p. 173, a 1921 article in *The Engineer*: 'Efficiency', *The Engineer*, 11 Nov. 1921, p. 513.

p. 174, 'a cold sweat and my nerves shook': 'Workmen's nerve attacks', *Manchester Guardian*, 29 Nov. 1934, p. 6.

p. 174, 'make the workers merely a machine': 'Rationalisation in textile industries', *Manchester Guardian*, 15 May 1937, p. 16.

p. 174, attributed a 57 per cent rise in profits to improved factory efficiency: 'Richard Johnson up 57 per cent in profit', *Guardian*, 27 April 1971, p. 23.

p. 175, 'ease the difficulties which may confront him': Quoted in Kevin Whitston, *Scientific Management Practice in Britain: A History*, unpublished doctoral thesis, University of Warwick, 1995, p. 312.

p. 175, 'fellow workers in a great industry': Quoted in The Rowntree Society, *The Rowntree Legacy* (York, 2016), p. 17.

p.178, combined humanity with management science: Robert Fitzgerald, 'Employment relations and

industrial welfare in Britain: business ethics versus labor markets', *Business and Economic History*, vol. 29, no. 2, 1999, p. 177.

p. 178, in pursuit of both efficiency and welfare: Wendy Hollway, 'Efficiency and welfare: industrial psychology at Rowntree's cocoa works', *Theory and Psychology*, vol. 3, no. 3, 1993, p. 304.

p. 178, distorting the results of time studies: long synopsis for *No Sky* (1934), http://www. nigelmarlinbalchin.co.uk/books/no-sky/.

p. 180, 'unswervingly turned towards the popular and democratic': Stuart Hall, 'Jeremy Deller's political imaginary' in Jeremy Deller, *Joy in People* (London: Hayward, 2012), p. 89.

13. FORM OF KNOWLEDGE: THE MATHEMATICAL MODEL AS MUSE

p. 183, 'projecting our sensibility to the whole of existence': Barbara Hepworth, 'Sculpture', in Ben Nicholson, Naum Gabo and Leslie Martin, eds, *Circle: International Survey of Constructivist Art* (London: Faber, 1937), p. 115.

p. 184, 'objects that have three': Quoted in K. Alder, *Engineering the Revolution: Arms and Enlightenment in France, 1763–1815* (Chicago: University of Chicago Press, 2010), p. 139.

p. 188, 'contains all the elements of a new sculpture': Quoted in M. Hammer and C. Lodder, *Constructing Modernity: The Art and Career of Naum Gabo* (New Haven, Conn.: Yale University Press, 2000), p. 125.

p. 190, 'hidden away in a cupboard': Quoted in M. Hammer and C. Lodder, 'Hepworth and Gabo: a constructive dialogue', in D. Thistlewood, ed., *Barbara Hepworth Reconsidered* (Liverpool: Liverpool University Press, 1996), pp. 115–16.

p. 190, 'to see one form within another which excited me': Quoted in A. Wilkinson, ed., *Henry Moore: Writings and Conversations* (London: Lund Humphries, 2002), p. 257.

p. 193, artists and scientists were both fascinated by form: A. Barlow, 'Barbara Hepworth and science', in Thistlewood, ed., *Barbara Hepworth Reconsidered*, p. 95.

p. 194, 'these forms and of their combinations': J. D. Bernal, 'Foreword', in *Catalogue of Sculpture by Barbara Hepworth* (London: Alex, Reid & Lefevre, 1937), p. 2.

p. 194, 'imaginative and creative energy': Barbara Hepworth, *Barbara Hepworth: A Pictorial Autobiography* (London: Adams & Dart, 1970), p. 37.

p. 194, 'at the same time and in the same direction': Gabo, 'The constructive idea in art', p. 2.

p. 195, 'belong together both to the mathematician and the sculptor': J. D. Bernal, 'Art and the scientist', in Nicholson et al., eds, *Circle*, p. 121.

p. 195, 'the main problem of the artist of today': Bernal, 'Art and the scientist', p. 123.

14. SUPERSONIC: THE ART OF THE POSSIBLE

p. 200, 'beyond the simply representational': Science Museum Technical File T/1985-423.

p. 205, 'the great modern adventure story': Michael Paris, 'Promoting British aviation in 1950s cinema', in Ian Inkster, ed., *History of Technology*, vol. 26 (London: Bloomsbury, 2010), pp. 63–78 at p. 66.

p. 208, 'putting me on the moon': Quoted in Bernard Bale with Don Sharp, *Concorde: Supersonic Speedbird – The Full Story* (Horncastle: Mortons Media Group, 2013), foreword.

p. 209, 'about to become a smaller place': British Airways promotional film introducing Concorde, 1976.

p. 210, 'a completely different optimism about the future': Wolfgang Tillmans, 'My photographs', *Guardian*, 17 Oct. 2003.

15. PATTERNS FROM ATOMS: DESIGNING THE FUTURE

p. 214, 'crystals studied by X-ray methods': Quoted in in Mary Banham and Bevis Hillier, eds, *A Tonic to the Nation: The Festival of Britain, 1951* (London: Thames & Hudson, 1976), p. 183.

p. 217, 'to use these patterns as a source of inspiration': Quoted in *The Souvenir Book of Crystal Designs* (London: Souvenir for the Council of Industrial Design, 1951), p. 2, Science Museum Group 1976-644/13.

p. 217, 'his debt to the wallpaper designer': Helen Megaw, 'Pattern in crystallography', unpublished essay (1946), in Lesley Jackson, *From Atoms to Patterns: Crystal Structure Designs from the 1951 Festival of Britain* (London: Wellcome, 2008).

p. 218, 'can help each other and should co-operate': Quoted in Jackson, *From Atoms to Patterns*, p. 5.

p. 218, 'more beautiful than any man-made pattern': Quoted in Jackson, *From Atoms to Patterns*, p. 5.

p. 223, 'each pattern should appeal in itself': Quoted in Jackson, *From Atoms to Patterns*, p. 16.

p. 223, 'others in between': Quoted in Jackson, *From Atoms to Patterns*, p. 17.

p. 225, 'the science background to the exhibition was the atom': Quoted in Becky E. Conekin, *'The Autobiography of a Nation': The 1951 Festival of Britain* (Manchester: Manchester University Press, 2003), p. 51.

p. 225, 'horrified reactions to the very word "atom"?': Alison Settle, 'Woman's viewpoint', *Observer*, 22 April 1951.

16. WONDER MATERIALS: TRANSFORMING EVERYDAY LIFE

p. 226, 'a comic picture of Disinterested Science': Quoted in Philip Kemp, *Lethal Innocence: Cinema of Alexander Mackendrick* (London: Methuen, 1991), p. 46.

p. 234, 'played in the film by Alec Guinness': Quoted in Kemp, *Lethal Innocence*, p. 45.

p. 235, 'my perverted and malicious sense of humour': Quoted in Kemp, *Lethal Innocence*, p. 65.

p. 236, 'only serious fault': Quoted in Kemp, *Lethal Innocence*, p. 53.

p. 236, 'Strong-arm Reaction': Quoted in Kemp, *Lethal Innocence*, p. 46.

17. POLAROID PERCEPTIONS: CAPTURING AN INSTANT

p. 240, 'when you realize that you can make lines!': The David Hockney Foundation, https://thedavidhockneyfoundation.org/chronology/1982.

p. 242, 'you might not be conscious of it': David Hockney, *David Hockney on Photography* (1983), (Bradford: National Museum of Photography, Film & Television, 1985), p. 9.

p. 244, 'to perceive the space that it is depicting': Hockney, *David Hockney on Photography*, p. 13.

p. 244, 'the colour is stronger': Hockney, *David Hockney on Photography*, p. 14.

p. 244, 'an account through time of my seeing': Hockney, *David Hockney on Photography*, p. 13.

p. 249, 'artistic interest in the world around them': Quoted in Deborah Martin Kao, Barbara Hitchcock and Deborah Klochko, *Innovation, Imagination: 50 Years of Polaroid Photography* (New York: Henry N. Abrams, Inc., 1999), p. 8.

p. 250, 'lifelike and persistent': Victor McElheny, *Insisting on the Impossible: The Life of Edwin Land, Inventor of Instant Photography* (New York: Perseus, 1998), p. 248.

p. 250, 'trying to tell him something': F. W. Campbell, 'Edwin Herbert Land, 7 May 1909–1 March 1991', *Biographical Memoirs of Fellows of the Royal Society*, vol. 40, Nov. 1994, p. 206.

p. 251, 'There's no getting used to it, or adapting, involved': McElheny, *Insisting on the Impossible*, p. 255.

p. 252, 'our eyes deliver to our mind': Lawrence Weschler and David Hockney, *Cameraworks* (London: Thames & Hudson, 1984), p. 16.

18. PROTECTING THE EARTH: POLITICAL PESSIMISM ON SCREEN

p. 261, written extensively about nuclear power: A collection of ephemera and popular and semi-popular books on nuclear energy and nuclear policy published between 1945 and 1990 was donated by Walt Patterson to the Science Museum.

p. 261, 'the legitimacy of the Northmoor plant': Troy Kennedy Martin, *Edge of Darkness* (London: Faber, 1990), appendix 2, p. 192.

p. 262, 'its creator would be reluctant to acknowledge it': Kennedy Martin, 'Introduction', *Edge of Darkness*, p. ix.

p. 263, 'if timeless out of print': Letter from James Lovelock to Arnold Kotler, 1981, Science Museum archive, object no. 2012-118/44, source: James Lovelock.

p. 268, 'it will destroy him': Kennedy Martin, *Edge of Darkness*, appendix 2, p. 165.

p. 269, 'couldn't come to grips with it at first': James Lovelock, interviewed by Jim Al-Khalili on *The Life Scientific*, BBC Radio 4, 8 May 2012, https://www.bbc.co.uk/programmes/b01h666h.

p. 269, 'That's been my life as a scientist': Lovelock, interviewed by Al-Khalili, *The Life Scientific*.

19. PATTERNS OF THOUGHT: AI AND ALGORITHMS

p. 270, 'any degree of complexity or extent': 'Note A' by the translator, Ada Lovelace, in Luigi Menabrea, 'Sketch of the Analytical Engine', in Richard Taylor's *Scientific Memoirs* (London, 1843).

p. 273, described as a 'thinking machine': Letter from Lady Byron to Dr King, 21 June 1833, Lovelace Byron papers, Bodleian Library, University of Oxford, Box 77: f217–218. Reproduced by permission of Paper Lion Ltd and the Lovelace Byron Papers.

p. 274, 'effective connexion with each other': 'Note A' by the translator, Ada Lovelace.

p. 274, 'philosophic view of the Analytical Engine': Letter from Charles Babbage to Ada Lovelace, 2 July 1843, Lovelace Byron papers, Bodleian Library, University of Oxford, Box 168: f45. Reproduced by permission of Paper Lion Ltd and the Lovelace Byron Papers.

p. 275, 'could have exerted over it': Letter from Charles Babbage to Michael Faraday, 9 Sept. 1843, IET Archives, Institution of Engineering and Technology, London.

p. 275, 'become in any way his organ': Letter from Ada Lovelace to Lady Byron, 8 Aug. 1843, Lovelace Byron papers, Bodleian Library, University of Oxford, Box 42: f73–80. Reproduced by permission of Paper Lion Ltd and the Lovelace Byron Papers.

p. 279, 'real Bach' and 'machine Bach': Hannah Fry, *Hello World: How to be Human in the Age of the Machine* (London: Transworld, 2018), pp. 188–9.

p. 280, 'simply doesn't have this capacity': Nick Cave, 'Considering human imagination the last piece of wilderness, do you think AI will ever be able to write a good song?', *The Red Hand Files*, no. 22, Jan. 2019, https://www.theredhandfiles.com/considering-human-imagination-the-last-piece-of-wilderness-do-you-think-ai-will-ever-be-able-to-write-a-good-song/.

p. 281, 'the Jacquard-loom weaves flowers and leaves': 'Note A' by the translator, Ada Lovelace.

20. IMAGINING MATTER: AT THE EDGE OF THE UNKNOWN

p. 284, 'a real factor in scientific research': Albert Einstein, *On Cosmic Religion: With Other Opinions and Aphorisms* (New York: Covici, Friede, 1931), p. 49.

p. 285, 'open to its subsequent transmutation': Bruce W. Ferguson, 'Introduction', in Iwona Blazwick, *Cornelia Parker* (London: Thames & Hudson, 2013), p. 11.

p. 287, 'what was previously unintelligible': Blazwick, *Cornelia Parker*, p. 144.

p. 287, 'an artistic process of abstraction': Blazwick, *Cornelia Parker*, p. 106.

p. 287, 'served him for reference': 'Dr Einstein at Oxford', *The Times*, 18 May 1931, p. 14.

p. 287, 'matter tells space how to curve': John Wheeler, in Charles W. Misner, Kip S. Thorne and John Archibald Wheeler, *Gravitation* (San Francisco: W. H. Freeman, 1973), p. 5.

p. 287, 'calculated and predicted': David Spergel, *Relatively Einstein*, BBC Radio 4, 18 Jan. 2005.

p. 288, 'the action of gravitational fields': Albert Einstein, letter published in *The Times*, 28 Nov. 1919.

p. 289, 'the north and west of the island': F. W. Dyson, A. Eddington and C. Davidson, *A Determination of the Deflection of Light by the Sun's Gravitational Field from Observations made at the Total Eclipse of May 29, 1919*, read to the Royal Astronomical Society, Nov. 1919, in *Philosophical Transactions*, vol. 2220, 1920, pp. 312–13.

p. 289, '16 plates were obtained': Dyson et al., *A Determination of the Deflection of Light by the Sun's Gravitational Field*, p. 314.

p. 290, 'attributable to the sun's gravitational field': Dyson et al., *A Determination of the Deflection of Light by the Sun's Gravitational Field*, p. 332.

p. 292, 'we cannot see and we cannot quantify': Quoted on the Tate website: https://www.tate.org.uk/art/artworks/parker-cold-dark-matter-an-exploded-view-t06949/story-cold-dark-matter.

p. 292, 'try to give it some kind of structure': *Relatively Einstein*, BBC Radio 4, 18 Jan. 2005.

p. 294, 'exploding again in a quiet, mute way': *Relatively Einstein*, BBC Radio 4, 18 Jan. 2005.

p. 294, 'where my access point to science was': *Relatively Einstein*, BBC Radio 4, 18 Jan. 2005.

p. 294, 'artists are hard-pressed to match': Jonathan Glancey, *Guardian*, 13 March 1999.

Acknowledgements

This book, the radio series and the exhibition have drawn on the knowledge and expertise of so many wonderful colleagues. In particular, we would like to thank the BBC Science Unit, especially Deborah Cohen and Adrian Washbourne, the Commissioning Editor for Radio 4, Mohit Bakaya, and Ellie Caddell, Commercial Rights and Business Affairs manager, who have been generous in the professionalism, expertise and time they have offered the project.

We would also like to thank editorial director Andrea Henry and copy-editor Gillian Somerscales at our publishers, Transworld, who have guided this book from an initial idea through to final delivery, making it a much richer experience along the way. Others have helped with the editing, design and marketing of the book: Marianne Issa El-Khoury, Katrina Whone, Tom Hill, Emma Burton and Bobby Birchall. We are also grateful to our agent, Luigi Bonomi, for bringing the Science Museum and the BBC together with Transworld.

The art critic Louisa Buck and science writer Phil Ball provided unlimited expertise and enthusiasm for the project. Louisa offered inspiring artistic insight for the radio series, and Phil provided invaluable editing experience that made this a much better book than it otherwise would have been. We have also benefited from the advice and input of Jonathan Vernon, John and Mary McCann, Rosalind McKever and William Manners.

A number of people at the Science Museum Group, including colleagues across our wonderful group of museums at the Science Museum in London, the National Railway Museum in York, the Science and Industry Museum in Manchester and the National Science and Media Museum in Bradford, have contributed along the way. In particular, we would like to thank Rachel Boon, Katy Barrett, Abigail MacKinnon, Zoe Palphramand, Lorraine Ward, Martha Clewlow and Roger Highfield who have helped this project to grow, develop and be delivered. We would also like to extend our thanks to Ben Russell, Doug Millard, Alex Rose, Rupert Cole, Hattie Lloyd, Tim Boon, Andrew McLean, Katie Belshaw, Geoff Belknapp, Ali Boyle, Stewart Emmens, Karen Livingstone, Jane Desborough, Toni Booth, Richard Dunn and Kendra Bean, who have contributed to the book or radio series, or both. The library and archives team, Nick Wyatt, Prabha Shah, Elizabeth Waeland, Silvia De Vecchi, Venita Bryant, John Underwood, Doug Stimson and C. J. Crennell all provided research support. We have also enjoyed administrative support from Jade Kirton-Vaughan, Harriet Addy and Margaux Wong.

We have also relied on the knowledge and generosity of the Science Museum extended family, including past colleagues Peter Morris, David Rooney and Boris Jardine.

Finally, we would like to thank our husbands, Jeremy Rosenblatt and Andrew Chitty, whose combination of fine wine, good cheer and enormous patience makes everything possible.

Index